You Can Sell Your Photos

$25,325

That's what photo buyers have paid for the six photos on the front cover of this book.

The sunset alone has so far earned Mark Helterline, a Rhode Island grocer, the royalties on $1,850. The waterfall has generated an astounding $10,940 in sales.

Look at those photos. The only difference between them and the ones *you* may have taken is that they were put in front of the *right* person at the *right* time.

How did these photographers do it? More important, how can you?

This book, written by a photographers' agent who in just the last few years has sold more than one million dollars' worth of photographs to buyers all over the world, explains *exactly* what you need to know to sell your photos—on your own, through a personal agent, or in conjunction with a stock photo agency.

Henry Scanlon has proven time and again that with the proper knowledge nearly anyone who can use a camera with skill can learn to take saleable photos and, by using the strategies in this book, can turn those photos into cash—even on a part-time basis.

You Can Sell Your Photos

A Comprehensive, Easy-to-Understand Guide for Amateur and Professional Photographers

by Henry Scanlon

HARPER & ROW, PUBLISHERS, New York
Cambridge, Hagerstown, Philadelphia, San Francisco,
London, Mexico City, São Paulo, Sydney

1817

Cover photo credits (clockwise from upper left): Mark Helterline; Tom Grill; Judy Yoshioka; Tom Grill; Jack Elness; Christopher Stogo

FIRST EDITION

Designed by Tom Grill and C. Linda Dingler

Library of Congress Cataloging in Publication Data

Scanlon, Henry
 You can sell your photos.
 Includes index
 1. Selling—Photographs. I. Title
HF5439.P43S3 770′.68′8 80–7854
ISBN 0–690–091G2–5 80 81 82 83 10 9 8 7 6 5 4 3 2 1
ISBN 0–690–091G3–3 (pbk.) 80 81 82 83 10 9 8 7 6 5 4 3 2 1

Contents

Color photographs follow page 170.

Acknowledgments

As with so many books, the singularity of the term author is misleading. A combined effort of research and experience has gone into this manuscript and I am indebted to so many people.

My thanks go to Tom, my partner and friend; to Faith for her unwavering encouragement; to Lynne and Judy and Michael for their support and comments and input; to Lucie, whose labors were thankless and essential and done with characteristic forbearance and goodwill.

There is no way I can express my gratitude to my brother, Mark, for his assistance. Even the word assistance is inadequate, failing to indicate the long, arduous hours spent editing, rewriting, cajoling, restraining and encouraging. He knows how much he did; I hope he knows how much I appreciate it.

Preface

Early in the last decade, as I became more and more deeply involved in producing and selling photography in my capacities as a photographer, a photographers' agent, and executive director of a large stock photography agency, a scene began to occur with ever-increasing frequency in my office: A photographer would come in and want to know how to go about earning money from the photos he or she had taken.

These photographers fell into roughly three categories: ambitious beginners investigating career opportunities; experienced amateurs who wanted to turn professional; and working professionals who wanted to land more assignments or who had in their files thousands of saleable photographs but who realized they did not have the expertise to sell them.

I well knew the frustration they were feeling. In the course of launching my business I had confronted at one time or other many of the same problems they were facing. I had combed the stores and the libraries, vainly seeking books that would explain the inner workings of the photography marketplace. I had approached "insiders," only to be rebuffed by their vague and sometimes misleading answers.

Moreover, I knew from bitter experience the hazards facing anyone entering the highly competitive photographic marketplace without being adequately forewarned of its pitfalls. The amount of money being spent for photographs had become staggering, amounting to many millions of dollars each year. The majority of participants in the photo marketplace are honorable men and women, but any time stakes are that high, disreputable and unprincipled "sharks" are attracted. The average photographer has little formal business experience and is almost certain to be easy prey.

Although I felt a sincere obligation to help prepare those photographers who approached me for the marketplace, the day-to-day operations of my business really had first call on my time. As the number of photographers seeking advice continued to increase, it became more and more difficult for me to answer their questions with the degree of detail they desired. I wanted to give them accurate, comprehensive information, but too often I was being required to devote an entire

afternoon to answering questions I had been asked a hundred times before.

So, in an effort to help, I looked for a book I could recommend that would adequately prepare photographers for the commercial marketplace in general and the stock photography marketplace in particular. Rather naively, I assumed that in the years since I had looked someone would have put together a book that would come to the rescue.

I was wrong. Certainly books on selling photos were available, and more were appearing all the time, but each suffered from serious shortcomings and major problems. In some cases the information was outdated. Sophisticated mareketing strategies had come to dominate the commercial marketplace, yet many of the books available were no more contemporary than a box camera. Worse, many of the books contained information that at best could be described as misleading.

One book I saw, for example, purported to be the definitive work on selling photography. In that book the author advised photographers to do things that every ounce of my own experience told me were utterly *wrong*. Years earlier, many of the author's suggestions might have been valid, but in the contemporary world the information was not only useless but actually counterproductive. (The book, incidentally, is still on bookstore shelves as of this writing.)

As the decade progressed, while continuing to help photographers as best I could, I also watched for a book on selling photos that I could recommend in good conscience—but to no avail.

The problem, I came to conclude, stemmed from two sources. The authors of how-to-sell-your-photos books, despite what must be assumed are good intentions, see things from limited perspectives. The experience of the authors was primarily in selling themselves or their own work, with the result that the books naturally reflected their own particular backgrounds. When venturing into areas in which they had no personal experience, they either make recommendations based upon theories or they perpetuate erroneous ideas obtained from other books.

The second source of the problem lies with the people who *do* know the stock photography marketplace—*they're not telling*. Some may not have the time, but most don't have the desire. They enjoy the corner they have on an increasingly lucrative part of the commercial market, and they have no in-

tention of admitting any newcomers if they can prevent it. In other words, a major reason no book with accurate information had been forthcoming was that the people who possessed the information preferred to monopolize it, and still do.

Perhaps because I am a photographer myself I have always believed strongly that the only obstacle to a photographer's success should be the limitations of his or her own talent, not a lack of knowledge of the rudiments of producing and marketing the work itself. Too many of the photographers who approached me for answers to their questions had been unable to achieve success in photography only because they lacked the necessary inside information to gain a foothold. At the same time, although most of the top professionals had achieved their successes based on merit, a few mediocre or downright untalented photographers were living fantasy lifestyles made possible by cronyism and the manipulation of a few closely guarded but simple marketing techniques.

Plenty of room existed for gifted, enthusiastic, and *knowledgeable* photographers to share in the market's bounty. In fact, as time passed, I became more and more convinced that a continuing infusion of new, energetic talent could only help the business of photography in the long run. Those in the business who believed otherwise were not only feathering their own nests, they were also being shortsighted.

Ultimately, I decided that if a truly accurate book, one that told the inside story about commercial photography, was to be written, I would have to do it myself. I recognize that in doing so I am revealing the inside information many of my colleagues deem sacrosanct, but I cannot imagine anything resulting but good.

For most photographers, it takes at least five years of trial and error—with much accompanying tribulation—to gain a solid foothold in the photographic marketplace.

This book is the result of my firm conviction that it doesn't have to be that way.

Introduction

This book is about how to sell your pictures—for money.

This book is *not* about how to take pleasing images of your vacation that will entertain your neighbors.

This book is *not* about how to take photographs that will be displayed in the Museum of Modern Art.

Perhaps you take photographs for the sheer joy of it but would like to know how to pick up some spare cash from your hobby. This book will tell you how you can.

Perhaps you are an amateur who is serious about photography and is considering turning professional. This book will offer you a means of doing so, on a full- or part-time basis.

Or perhaps you are already a professional but would like to improve your income. This book will help you do just that, and at the same time make you aware of aspects of the *business* of photography you probably never knew existed.

How is all this possible? Through commercial "stock" photography.

Does selling photographs for money strike you as crass? It does some photographers, those who like to feel they are creating images that have "value" but who, despite the fact that money is one way to assess that "value," feel the only *legitimate* way to earn an income from photography is by having a collection of their work bound and published.

The fact is that the chances of getting a book of photographs *published* (much less living off the proceeds) are slim at best. Pragmatic photographers recognize that the desire to be "creative" and "artistic" by no means precludes the ability to make money. Thus, they apportion a certain percentage of their time to producing photography that has as its main goal the production of income.

Such an attitude is not without precedent. Historically, artists have often relied on institutional or individual patrons to provide the resources necessary to sustain their artistry and allow them the freedom to pursue their art. The Medicis in Florence, the church, the Ford Foundation—all have been patrons of the arts of one sort or another at one time or another. In a sense, the world of commercial photography is fulfilling that role of "patron" to modern photographers. Not an altru-

istic patron and certainly not a disinterested patron (any more than were the Medicis or the church), but a patron nonetheless. In fact, many of the most renowned and respected photographers in the world have used the commercial marketplace as the foundation for their entire careers.

However, simply announcing to the world that you and your work are available for commercial use is not sufficient to assure that your new "patron" will support you. You will also need certain skills, knowledge, and—very important—an appropriate outlook.

Time and time again I have met with young photographers in my office. They come in with their portfolios and announce by their demeanor that whereas they consider themselves artists-cum-camera, they will nonetheless deign to allow their photographs to be used for commercial purposes. I explain that although the photos in question certainly deserve praise, they have absolutely no commercial application. How can I not recognize the worth of their work? the photographers want to know. If they had ever had firsthand experience in the commercial marketplace, they would understand how futile their anger is. Instead, they cling to the self-defeating notion that the market will adapt itself to their own personal style. Rather than agree to shoot photography for which there is a use, they remain bitter because the market will not create uses for that which they choose to shoot.

Well, it simply doesn't work that way. Photographers who are to be successful in the commercial market have got to be able to accept the fact that they are engaged in producing photographs whose primary purpose is *to sell products or services*. American Airlines is not about to use a photo in one of its ads merely because the photo has artistic value. They'll use it because it helps sell airplane tickets. If the photo also has artistic value, so much the better; but from the airline's point of view the artistic merit of the photograph had better not get in the way of its ability to sell tickets.

In short, *if you try to succeed in the commercial marketplace but forget that your work is expected to sell products, you aren't going to go very far very fast.*

Does this mean that you must abandon your creative instincts when shooting film to make money? Certainly not. The best commercial photographers are also the most creative. They are the ones who are constantly finding new ways to "say" visually the things advertisers *need* to say in order to

get their messages across. These photographers have learned from experience that it can be just as difficult—and just as satisfying—to produce a good commercial photograph as it is to produce an "artistic" one.

As a general rule, then, if you combine a firm knowledge of what advertisers need with energetic, creative talent, you will be likely to produce photographs that will have appeal in the commercial marketplace.

Crass? Perhaps. I think of it in terms of making your camera *work* for you, of putting yourself on top of your financial situation so that you can pursue your art during the rest of your time with a freedom unknown to the artist whose sales are dependent on the whims of professional critics of sometimes dubious qualification.

Producing saleable photos is only half the story, however. In order to be sold, photographs must be properly marketed; that is to say, *they must be placed in usable form in front of the people who are in a position to pay money for them.* Despite this obvious fact, and although the potential to produce substantial earnings is there, most photographers still have no conception of how to market photos. I am constantly meeting photographers who have spent years perfecting their craft and possess a seemingly infinite understanding of *f*-stops and zone systems yet have no grasp of the procedures involved in selling their work and having it published.

Even some top professional *assignment* photographers are just as misinformed or uninformed about how to market their existing stock photographs as the most inexperienced amateurs. But those photographers who understand how to market their photos effectively are out there very quietly making thousands upon thousands of dollars yearly with relatively minimal effort.

WHAT WILL THIS BOOK DO FOR YOU?

In this book I will share with you the knowledge I have gained as I have cultivated stock photography markets—markets that each year yield photographers hundreds of thousands of dollars in sales of their existing photographs. You'll learn how to evaluate any photographs you have on hand for those photos most likely to sell. More important, step-by-step you'll learn how to *take* photos that will sell. Then you'll learn *how*

to sell them, *where* to sell them, and *how much* to sell them for. In the process I'll be revealing to you little-known but essential information about the one area of photography that is far and away the most lucrative: the commercial marketplace.

Some of the things I'm going to tell you will surprise you. For example, despite the fact that you may have been led to believe that advertising agencies are a market too tough to crack, I'm going to show you how to do it. How do I know it can be done? Because I know pure beginners who, following my suggestions, have sold photographs to ad agencies for use in *national* ads.

Some things I'm going to tell you won't even seem important to you initially—how an ad agency is structured and works, for example—but let me assure you that they are. Without such basic background information—much of which has never before been available to photographers—you won't have the knowledge you need to maneuver effectively in the marketplace or to know how to get the highest price possible for what you sell. But remember: If you're going to earn money from your photography, you're going to have to

- Discard any pretensions you may have
- Train yourself to produce not just pretty or artistic photographs, but *usable* photographs
- Cultivate the markets

The first you'll have to do on your own. The other two this book will help you master.

PART I
Shooting Photographs That Will Sell

1

"I Can Take a Better Photo Than That One"

Have you ever flipped through a magazine and spotted a photograph similar to one you'd taken *and known at once that yours was better*? It could have been a dramatic sunset or a forest scene or even a snapshot of a small child running in a field. And did it also occur to you that someone was paid for that photograph, and since your photo was *at least* as good, that person could have been you?

The fact is, it *could* have been.

Some of those photographs you have stacked in boxes in your closet might be publishable, income-producing shots. Remember the photographs you took on that trip to Morocco or Yosemite or Rio? If you had read this book before you left, you might have been able to pay for the trip *with income from those photographs*. How is this possible? Because you would have known how to take saleable photographs while you were there and, just as important, how to market them properly when you returned.

In essence, all you really need to earn money from your photos are (1) the *ability* to take saleable photographs, (2) the *knowledge* of how to market them. Make no mistake about it, though, step two is no less important than step one.

How are you going to develop these two skills? Through the information contained in this book as it opens opportunities up to you in the exciting and rapidly growing field of "stock" photography.

WHAT IS "STOCK" PHOTOGRAPHY?

Buyers who need a photograph really have only two methods available to them to obtain it:

1. They can hire a photographer to go out and shoot exactly what is needed. In so doing, a buyer is said to be giving the photographer an "assignment," and the buyer can then select

any of the photographs produced on the assignment for use in the project.

2. Or, buyers can purchase the *use* of a photograph that already exists. They can search through a photographer's stockpile of existing photographs and select one for use in the project. That photograph, as well as all the others in the photographer's files, are called *stock* photographs. Some photographers' files of stock photographs consist of a few discards from assignment shootings; other photographers' files of stock photographs consist of many thousands of photographs that they have actively and energetically accumulated over a period of time with an eye to building a comprehensive library of saleable stock material. Some of these photographers have never been given an "assignment" by a buyer, yet they earn tens of thousands of dollars each year from their sales from stock.

In other words, assignment photographers sell to buyers their *abilities* and agree to apply those abilities to the buyers' projects; stock photographers, on the other hand, sell to buyers their existing *photographs* and let the buyers apply them to the projects.

Is stock photography a new concept? Hardly. It's as old as photography itself. Mathew Brady, the famed Civil War photographer, spent much of his time actively taking photographs for his stock files—photos which he later sold for publication. William Henry Jackson, a contemporary of Brady's, lugged hundreds of pounds of photo equipment to document the natural beauty of the western United States—photos that directly led to the proclamation of Yellowstone as the first National Park. When Jackson later sold the photos for stereocards and to publishers who made illustrations from them, he, too, became one of the first stock photographers.

THE FIELD OF STOCK PHOTOGRAPHY IS BOOMING

Today, those of us who are intimately involved with stock photography have witnessed an explosion in the demand for already-existing photographs. The field of stock photography is expanding so rapidly that photographers who are on top of the stock photography situation have earning potential limited only by their ability to shoot good-quality photographs.

To bring the role stock photography can play into closer fo-

cus, let me give you three examples of photographers I know, each of whom has had a typical experience.

The gentleman who took the photograph of the sunset on the cover of this book is a friend of.mine who owns a grocery store. When he became interested in photography a few years ago, he asked me for recommendations on camera equipment, lenses, film, etc. He had spent some time pursuing a career as an artist and had a natural sense of composition, color, and detail but no real desire to sell his photographs. When I suggested some equipment, he told me that what I was recommending really cost more than he wanted to spend. I told him that if he just spent a small portion of his time producing saleable photographs based on principles I knew from experience would work, he would not only be able to pay for his equipment, he'd be able to make enough extra money with his camera to cover all the other costs incurred in producing the more artistic images in which he was primarily interested. The camera equipment cost approximately $750. In the intervening three years since he bought it, although he started out as a novice and still is only an occasional photographer, he has sold over $7,000 worth of his photographs.

Here is another example. Through a chance meeting in Central Park, a colleague of mine met a pilot whose hobby was photography. The pilot flew internationally for one of the major airlines, and over the years he had accumulated a whole cabinetful of travel photos. In the hope that he could sell a few, he approached the advertising agency that produces brochures for his airline. Sure enough, they bought one, and the pilot was delighted to see his photograph in a brochure they produced.

What he didn't know at the time was that the price they paid him for the photograph was approximately one fifth the amount they normally pay. But he was happy to have been published and he continued taking photographs.

Eventually, as a result of the chance meeting in the park, the pilot came to my stock photo agency to inquire about being represented. Although he had quite a number of photographs, most were unmarketable because he had no real grasp of what the marketplace was actually looking for. However, we began to teach him the principles outlined in this book. Much to his credit, he was able to take these principles and through a great deal of work, enthusiasm, and dedication apply them to what he was doing. He is now an extremely suc-

cessful photographer, producing better and better material all the time. He still works full-time as an airline pilot, but in only four years he has sold over $45,000 worth of his photography, some of which is reproduced in this book.

The third photographer, an established professional who makes his living by specializing in still lifes and industrial photography, also loves to travel and take general scenics for his own pleasure. For a while he had these photographs placed with a stock photo agency, but since no sales had materialized he felt that there was no market for what he was doing. In fact, however, he had placed them with the wrong agency. There was nothing wrong with the agency and there was nothing wrong with the photographs; the two just didn't go together. The same photographs have sold for over $20,000 at another agency. The point here is twofold: Even professional assignment photographers can use stock photography to good advantage, and even professional photographers must exercise care in determining how their work can best be marketed.

As you can see, each of these three photographers started out in stock photography with a different level of expertise, desire, and commitment, yet each was able to realize a substantial number of sales.

HOW THE PHOTOS YOU SHOOT CAN BE LIKE MONEY IN THE BANK

As soon as you sell a single photograph, you become by definition a professional photographer. Assuming that you plan to sell *more* than just one photo, let's discuss the concept of financial stability, since it has great importance to people who earn money from photography.

Traditionally, professional free-lance photographers are about as secure financially as their last assignment and must constantly scramble for new assignments. If you are acquainted with any professional photographers (or are one yourself), you know that they spend a great deal of time sitting by the phone, convinced that it will never ring, sure that they will never work again. In fact, there's an old adage that photographers rely on to temper their overinflated enthusiasm on the one hand and to bolster their flagging confidence on the other. It goes: "No matter how well things are going, be careful—

it's eventually going to get worse. And no matter how badly things are going, take heart—it's going to get better."

Unfortunately, free-lance photographers often forget that adage. I've seen photographers who land a particularly lucratice account and then assume they're home free for the rest of their careers. Based on their newfound wealth and security, they commit to vast quantities of equipment, studio space, assistants, etc. Eventually, of course, the pendulum swings the other way, and they are destroyed by an overhead they can't possibly sustain. Does this happen only to novices and fools? It's happened at one time or another to almost every photographer around—including some with very recognizable names.

Likewise, when times are hard and a few clients have drifted away, photographers find their unoccupied minds dwelling incessantly on the idea that their careers are over, that something has happened, they've lost their touch, they're out of style—whatever. They're convinced they'll never work again. Whereupon the phone rings, they get another assignment, and the cycle starts all over again.

A rather precarious, insecure existence, don't you think? But it doesn't have to be that way, and that's why more and more photographers are turning to stock photography—the compiling and selling of existing photographs—to furnish some financial security in their lives. (And it's also why many amateur photographers who have no interest in obtaining photographic assignments are finding stock photography an attractive way to enter the ranks of the professionals.)

A photograph held in stock (that is, in a photographer's ever-increasing library of photographs) can generate income for years. Such a photo has *lasting* value inasmuch as it can be sold for profit at any time. In addition, once produced and placed in the files, it costs virtually nothing to "maintain." In essence, when photographers decide to cultivate a stock file of their own photographs, they are establishing *equity* in their own careers. Even if they become debilitated and can no longer shoot, if they have built up a solid library of marketable photographs, it's like having money in the bank. There are photographers who haven't picked up a camera in years who continue to make very handsome livings on the revenues from their past photographs. In short, stock photography offers photographers a level of financial stability heretofore available only to a few top professionals.

How to Use This Book

As implied by the earlier stories about the three photographers, your personal skill level, as well as your particular circumstances, will affect how you should enter the field of stock photography. So let's discuss in detail how you can best use this book, based on your current level of expertise.

The Beginner

Is it possible that a book about selling your photographs can apply even to a beginner? The answer is yes, just as a Little League ballplayer can learn valuable lessons from seeing how major-leaguers do it. The fundamentals are the same in both leagues, it's just that Little Leaguers have yet to develop their skills to the degree that the major-leaguers have. *But the skills are essentially the same in both cases.* Little Leaguers who take as a model for their own swing that of Joe Dimaggio could do much worse. No, they can't actually swing like Dimaggio, but by aspiring to his near perfection, Little Leaguers automatically set themselves on a path that can't help but improve their own swings.

As a beginning photographer, you can improve enormously by striving to emulate expert photography such as that you see and admire in magazines. No, you are not likely to accomplish your goal right away, but in the attempt you push yourself to your limits and sometimes beyond, all the while expanding your capabilities.

Beginners are often so distracted by the mechanics of taking photographs (that is, how to snap the shutter, load the film, set the exposure, focus the lens) that they completely lose sight of what they are really trying to accomplish with their cameras. This book concentrates on the images themselves—what makes them communicate effectively and how you can train yourself to observe the world around you in such a way that you will learn to spot opportunities for effective photography as they appear. The livelihood of professional photographers *depends* on their ability to do these things; as a novice, these are the skills you will need to develop if you ever want to grow out of your beginner status.

The principles involved in shooting travel scenics, children, sports, models, animals—all of which are explained in this book—are as appropriate for you as a beginner to adhere to as

they are for an established pro, especially the concept of learning to "say" things with your camera and the importance of understanding that a photograph's greatest function is its ability to communicate visually. All these things will help you get off on the right foot. Furthermore, you can make the various self-assignments I suggest as challenging as you wish—or as simple. Either way, they will serve to prod you on to new levels in your work. How far you go is up to you. Nonetheless, if you aspire to nothing more ambitious than taking better, more evocative snapshots of your own children for your family album or improving your vacation pictures, following the principles outlined in this book will help you do exactly that. But if, like millions of photography buffs throughout the country you also dream of one day selling your shots and having them published, then this book can help you on the road to fulfilling that dream.

The Advanced Amateur

Those with the potential for making the greatest use of this book are the advanced amateurs who are becoming more and more confident in their skills as photographers and who have been thinking more and more about the possibility of selling their photographs—but who have no idea how to go about doing it.

If you are an advanced amateur and are serious about your work, the first half of this book will help you discover how to apply your skills toward shooting photographs that have market value. Then, in the second half, you'll learn how to go out and market them.

Before you focus on any specific aspect of the information contained herein, I suggest you skim the book quickly from cover to cover to try to develop an overview. Why are people willing to buy photographs? How do they go about finding them? Where do you fit into the greater picture? Until you have this overview you're like a would-be golfer whose only exposure to the game has been on a driving range. You can whack the heck out of the ball, but you have yet to learn how that skill can actually be applied out there on the links. Hitting the ball well simply isn't enough; you've got to learn how the game itself works, where the sand traps are and how to get out of them, how each aspect of the challenge combines to

create the game, and, finally, how to apply your skills to produce a successful score. So, read through this book once fairly rapidly in order to survey the general landscape. Try to grasp a sense of just what photography-for-sale is all about, who constitutes the cast of characters, and how you as a would-be professional photographer fit in.

Then go back. If you're interested in travel photography, reread that section in chapter 3 until you have a firm understanding of its implications. As recommended and described in that chapter, give yourself a travel photography assignment. Then be tough on yourself. Analyze your efforts. Start thinking like a professional.

This book is arranged so that once you roll up your sleeves and get to work seriously, you can proceed systematically from chapter to chapter. When you're ready to begin offering your work for sale, make sure you fully understand the selling principles outlined in chapter 5. They'll stand you in good stead no matter how limited or how broad your aspirations.

The Professional

A common misconception about professional photographers is that they automatically know just about everything there is to know about the *business* side of photography. After all, they *are* professionals. And it is true that some professionals are extremely astute and accomplished business people. Most of those, however, have learned the hard way and have spent more than their share of time making mistakes, mistakes that have cost them money. Behind the aura of cool accomplishment and studied savvy, there often lies a heart racing in sheer terror when it comes to the "business" and negotiating aspects of their chosen profession. This is especially true when it comes to selling their existing photography, their stock photographs. Through either timidity or lack of knowledge, professionals too often sell their work for a much lower price than it could have commanded, or they don't even try to sell it at all. Or not understanding the commercial market and its needs and the relationship of their work to it, they entrust their work to the wrong agent or the wrong agency. No matter what the reason, the result is the same: diminished income.

Enough big-name, well-established photographers have admitted to me that they have not a clue about how to market their existing work that I can conclude that to most photogra-

phers the ways and means of selling their existing stock photographs are a complete mystery. If you are a working professional photographer, I would therefore suggest that you use this book to bridge the gap that probably exists between your already-established technical skills and the more tedious marketing side of the business, mastery of which is vital if you are to maximize your rewards for having developed those skills. Although this book is primarily oriented to selling photos from stock files, many marketing procedures can easily be adapted to assignment situations. Concentrate especially on the book's latter chapters to gain insight into the thinking of those on the other side of the fence—the agents, photo agencies, and advertising agencies with whom you must deal daily. In short, use this book to round out your skills, to complete your education, and to provide you with a source of income you may never have properly exploited.

WOMEN AND COMMERCIAL PHOTOGRAPHY

In view of the emerging influence of women in the business world, it is appropriate to address their role in photography. The fact is that women have always played an extremely large and important role in the world of photography and some of the most respected names in all photography are women: Anna W. Brigman (1869–1950) and Gertrude Kasebier (1852–1934) are included among the early masters; some of the highest paid and most accomplished modern photographers, including Deborah Turbeville and Jill Krementz, are women. They are fashion photographers, travel photographers, still-life photographers; they wield tremendous influence in every area of photography today.

If you are a woman, no other aspect of commercial photography offers you more in the way of opportunity and equality than does stock photography. A photo buyer who needs to use a particular stock photograph could not care less whether it was taken by a man or a woman, and if the shot comes through a stock photo agency, the buyer has no way of knowing the gender of the photographer anyway.

In addition, since it remains true that women more often than men are saddled with the burdens of raising a family or running a household, stock photography becomes attractive as being one of the few lucrative work opportunities that can be

arranged to fit almost anyone's circumstances. For example, suppose you are a woman with children. While taking your children for a stroll you could easily encounter situations to photograph that will generate stock photographs to add to your files. If you have been able to get your work represented by a stock photo agency (and this book will tell you how to do that), you have only to send your shots off to the agency and let them take care of the rest. If you have absolutely no free time during the day, there is no reason you couldn't shoot for an hour or two at night if your husband or someone else can look after the kids. You might even want to *specialize* in night photography.

As much for you as for a man, stock photography can accommodate diverse levels of commitment. For example, one woman my agency represents is a full-time professional specializing in fashion photography for advertisers. Although her assignment work keeps her fairly busy, she manages to find time to shoot some stock photographs, which she then places with our agency.

Another woman we represent spends the majority of her time raising children, keeping a house, and doing all those things that can monopolize anyone's time. Yet occasionally she manages to venture out with her camera and shoot whatever she can think of that might be saleable or interesting. Since she spends so much time with children—her own and others—over the years she's developed a sizable file of child-oriented photography. Although she doesn't travel much, she is constantly on the lookout for a particularly striking sunset or a small detail in her neighborhood that might make a general statement (changing leaves on a backyard tree, icicles from a snowy rooftop).

You might be surprised to learn that both these women, the highly accomplished pro and the busy homemaker do equally well with their stock photography, each earning a few thousand dollars per year. There's room for everybody, and any woman has the option to make photography as large or as small a portion of her life as she wishes or has time for. *It is entirely up to you,* and you can tailor your efforts to conform to almost any life-style.

And, if you're like most of the photographers I know, as soon as you start making a little money onlookers are not going to feel very safe if they are standing between you and your camera. You'll be well on your way toward making photogra-

phy a significant and rewarding part of your life. You may even find a new sense of independence, creative satisfaction, and, of course, a valuable source of income.

THE TAX ADVANTAGES OF BEING YOUR OWN BUSINESS

As long as we're discussing photography as a moneymaking enterprise, I should make some mention of taxes. If you take a trip to Yosemite to have fun camping, you're going to have to pay for that out of your own taxable income. But if you take a trip to Yosemite in order to take photographs that you will then sell for profit, your trip—as much as 100 percent of it—can be tax deductible. The fact is that if you can demonstrate to the government that you are conducting the business of photography on either a full-time or part-time basis, you can become eligible for some substantial tax breaks.

I'm not an accountant and I'm not a lawyer, and the tax laws are subject to local and regional legislation as well as to individual interpretation. My suggestion is that if you are now or intend to become a serious photographer engaged in the production and sale of photographs, you should seek the advice of a qualified accountant. If you do start spending any significant amount of money and can prove that these expenditures are related to a viable business endeavor, you would be foolish not to avail yourself of the tax advantages that are rightfully yours. Seek the advice of a professional tax person.

The field of stock photography offers exciting—even unlimited—opportunities to many people who seek to obtain not only pleasure from their craft but also some money. Bear in mind, however, that I can't give you talent if you have none. If you have talent to begin with, this book will show you how to hone it—and how you can spend only a small portion of your time producing saleable photographs, and have the proceeds from that time support all your other efforts.

The remainder of this book shows you step-by-step how to. successfully enter the commercial photography marketplace. If you have the basic talent, with a little effort on your part, this book will show you how to make that talent *work* for you.

2

How to Shoot Photographs That Will Sell

FILMS AND FORMATS PHOTO BUYERS PREFER

My guess is that photographers are the only group of professionals more obsessed with the technical aspects of their trade than airplane pilots are with theirs. Two photographers in a room together can and often will discuss for hours their opinions on the relative merits of various brands, bodies, lenses, accessories, films, papers, techniques, etc., so I enter the fray with a certain amount of trepidation.

But the intent of this book is to help you make money from your photographs, and I would be doing you a disservice if I were to fail to make some comments and recommendations on those technical aspects of photography that not only are important to the quality of your photographs but also have a direct bearing on your ability to sell them.

Keep in mind that my comments are based on what I have *found* to be true rather than on what you or I might *like* to be true. My intent is to present you with some technical guidelines to follow, so that when potential buyers are presented with one of your photos they will be more likely to *judge it* based on its merits than to *reject it* based on a technical deficiency.

B&W vs. Color

Many stock photo agencies, which are of necessity very closely attuned to the demands of the photography marketplace, now accept only color transparencies. There are three main reasons for this:

- Ease in maintaining workable files. B&W prints are cumbersome and must be cross-indexed with negatives. As a result, they take up more space.
- Versatility. Color photos can be sold for B&W usage (for example, every B&W photograph in this book was convert-

ed from color), whereas B&W negatives cannot be sold for color usage.

- Profitability. The most lucrative segments of the marketplace buy color photography.

In general, B&W files are more difficult to administer and yield less income than color files. Just as clients are prepared to pay more to print a full-color brochure, so they are usually prepared to pay more for the photography that goes into it. In fact, in today's market, the mere fact that clients are using black-and-white film is an immediate indication that they are working on a tight budget and are unlikely to be willing to pay much for the photographs they purchase.

I'm not going to tell you not to shoot B&W film, but I can tell you this: I'm in the business of selling photography in the most cost-effective and efficient way I know how—and I accept *only color photography*. This is not to say that photos for B&W usage cannot be sold—I do it all the time. The clients simply convert the color photos I send them to a black-and-white print. But those photographers I know who are doing the best in this field are shooting color.

There exists, of course, the never-ending debate over whether or not real artistry in photography can be achieved in anything other than B&W. But this is not a book about how to shoot photos for museum galleries, it's about how to shoot photos that will generate income. And the simple truth is that, in the long run, color photography generates more income—a lot more—than black-and-white.

If you *must* shoot B&W in any given situation—say you are attempting to sell shots to your local newspaper and you know the editor will accept only B&W negatives—try to shoot *some* color also. If you fail to do so, you might very well sell the B&W for the $20 or $30 the newspaper offers—but miss the sale for $500 that arises down the road for a color shot of the same subject.

But what about the cost? Is color *really* that much more expensive than black-and-white? As of this writing, a 20-exposure roll of black-and-white film costs $1.59, while a similar roll of Kodachrome runs to $6.51 after processing. These are superficial differences, however, when you consider the following:

- The cost in time and materials (chemicals, paper, water, etc.) required to process black-and-white film, not to men-

tion the initial outlay for a darkroom and darkroom equipment, adds significantly to the cost of producing the final print.

- Color photographs can be converted to black-and-white, but not vice versa.
- There is a larger market for color photos than for black-and-white.
- Color sales earn significantly more money than do black-and-white sales.

In short, by shooting color you are increasing both your likelihood for sales and the money you will earn from those sales, while saving the expense of running and maintaining a darkroom. Any money you save by buying black-and-white film will be more than surpassed by the revenues you stand to lose through fewer and less lucrative sales. In the long run, it's more cost-effective to shoot color.

Color Negatives vs. Positive Transparencies

Except in *extremely* rare circumstances, I know of absolutely no reason for the professional or would-be professional to shoot color negative film. Remember, we're not talking here about wedding or baby photography, where the profits lie in running off many prints from the same photo; we're talking about selling photos for commercial or editorial reproduction. Despite what you may have read elsewhere, the vast majority of magazines and advertising agencies prefer positive color transparencies (slides), and the vast majority of working professional photographers are shooting positive film when they're shooting color.

As a result, many picture buyers are reluctant even to look at color prints made from negatives, because they are convinced that photographers who shoot negative film are amateurs and unlikely to know what they're doing.

Yes, it's true that some of the best-known professionals do shoot—and sell—everything from color negatives to Polaroid instant-developing color. But the main reason they can do so is that they *are* so well-known that buyers are interested in virtually any photographs they take—*especially* those that are experimental. Unless and until you have the type of reputation that will open the door of any ad agency in America, your best bet when shooting color is to stick to transparencies.

Format: 35mm? 2¼ x 2¼? Larger?

In my agency, where we deal on a continuing basis with every major advertising agency and publication in the country and our only interest is in selling photography the best way we know how, *we accept only 35mm transparencies.*

That's not to say that there is no place in commercial photography for larger-format films, but one thing is certain: 35mm film has revolutionized the business of photography.

It is an interesting fact that 35mm *film* was invented *before* the 35mm still camera. The film was originally developed for use in making movies, and it turned out to be such an extraordinary product that a camera was invented to take stills with it. And shortly after 35mm appeared on the scene, the single-lens-reflex (SLR) camera was developed, whereby photographers could look directly through the lens to see exactly what they were shooting—right side up.

The 35mm film was to photography what the automobile was to transportation. Suddenly, photographers were enjoying an incredible freedom of movement and ease of handling. Nonetheless, for quite some time there was a prejudice against 35mm film. The image was thought to be too small to produce sharp enlargements.

I have a theory about how this prejudice originated and why it has persisted so long. I think it came from printers. Printers claimed that it was impossible to produce good-quality, sharp images from film as small as 35mm. For years they blamed it on the film size, whereas in fact the real problem was that these printers had invested large quantities of money in equipment that was geared specifically for film of 2¼″ x 2¼″ format or larger. All of a sudden, photographers started shooting 35mm, and the printers, rather than buy the equipment necessary to handle it, insisted that the film was too small. So the prejudice against 35mm was born.

Eventually a few forthright printers began to invest in equipment for the new, smaller format and to produce printing from 35mm transparencies that compared favorably with anything produced from the larger formats. In order to stay in business, other printers gradually followed suit to the point where today printers worth their salt can routinely produce excellent-quality work from 35mm transparencies.

Old prejudices die hard, however, and there are still those who insist that fine reproduction can be obtained only from

2¼″ transparencies or larger. Consider, however, that even some professional still-life photographers, who traditionally prefer the exquisite detail they can achieve with large-format cameras, are now shooting 35mm film. Why? Because they're willing to sacrifice extra detail and sharpness for the versatility and spontaneity the smaller format provides.

In today's marketplace, a photograph that is shot on large-format film is *not* more likely to sell than a photo of the same subject shot on 35mm with one notable exception: calendar companies. Many companies that produce calendars (although certainly not all) still prefer photography shot on formats larger than 35mm. Nonetheless, since so many of the best photographers are now shooting exclusively 35mm, even those companies are relaxing this restriction somewhat.

To be sure, 35mm can still be considered something of a compromise. But more and more photographers and more and more photo buyers are increasingly eager to trade a questionable amount of increased sharpness in the larger format for the more relaxed and versatile "look" of 35mm. And the photographers who are out there actively shooting stock photography on a regular basis—and selling it for big money—are loading up 35mm cameras with color-transparency film.

Does this mean you should start using your 2¼″ x 2¼″ Hasselblad for a doorstop? That you should pack away your larger-format film in a closet? Of course not. Good photography on subjects for which there's a need can be sold no matter what the format. Just keep in mind that if someone tells you 35mm photography will unduly limit your market—don't believe it. From a commercial point-of-view, the advantages of 35mm photography far outweigh the disadvantages.

And don't forget, if you decide you want to submit your work to a stock photo agency, some accept *nothing but* 35mm.

Kind of Film

The area of film and processing is ever-improving, constantly changing, and highly competitive. There are many films on the market, each with its own advantages, disadvantages, peculiarities, etc.

However, there is one film that is used by professionals to such a great extent that it has become the film against which all others are compared. That film is Kodachrome, made by Kodak—specifically, Kodachrome 25.

In the opinion of many, Kodachrome is the sharpest, most grain-free 35mm film on the market, and it is therefore the most successfully competitive with the larger-format films. Photo buyers often expect it, printers tend to prefer it.

Many beginning photographers shoot all their work on 35mm Ektachrome. They feel that since Ektachrome is "faster" than Kodachrome it is easier to work with. This may be true, but, like all faster films, Ektachrome is also grainier. And while photo buyers who are sticklers for sharpness might well accept 35mm Kodachrome, they might draw the line at 35mm Ektachrome.

There are situations where graininess can enhance the effect of a photograph and is therefore desirable. In such instances, though, the choice of film is dictated not by the film's speed but by the effect desired. While you should certainly be familiar enough with the tools of your trade to know when the use of a grainier film is appropriate, be aware that Kodachrome 25 is, in the main, the film of choice among working pros.

Like most things in the world of photography, the question of which film to use is surrounded by great quantities of technical data, manufacturer's hype, photo-magazine debates, personal opinion, and conjecture. But as you try to assess this information, you should also bear in mind that most of the ads and articles about film are aimed at amateur photographers—who want to know how to take pleasing photos of Aunt Gertrude—rather than at professionals. If you want to make money from your photos, you not only have to *be* a professional; you must *think* like a professional. Aunt Gertrude doesn't give a hoot whether a printer has trouble reproducing her photograph or if it fades a little in five years—but you'd better care. Also, Aunt Gertrude's photo probably won't be blown up and used on a billboard, but yours might be. And if it is, the grain had better hold together.

There is tremendous room for debate on all questions of film choice—color versus B&W, film size, and film brand. Photographers do make money working with every format and every kind of film. As a general rule, however, if you wish to maximize the possibility for profits from your work and are forced to choose between shooting exclusively B&W or color and between using 35mm and larger-format, load up a 35 mm SLR camera with Kodachrome 25 and start shooting.

HOW TO RECOGNIZE AND EXPLOIT A SALEABLE SUBJECT OR SCENE

One of the most common refrains of would-be stock photographers is, "I just don't know what to shoot." Usually such photographers have a vague idea that they enjoy shooting photographs within a particular subject area (flowers, women, landscapes, etc.) but have no idea of how to identify and handle specific subjects that will also have market value.

The ability to recognize saleable scenes and subjects is neither easy to teach nor simple to learn. Nonetheless, there is a simple mental trick you can employ that will help you begin to differentiate between the merely "pretty" or "interesting" scene and the "saleable" one.

"Saying" Things with Your Camera

Some people believe that the opposite of "visual" is "verbal." They feel that photographers are concerned with images while writers are concerned with words. Actually, both photographers and writers usually share a common goal—the communication of an idea, a mood, a feeling, or a thought. Are the goals of Yousuf Karsh, the brilliant Canadian portraitist, significantly different from the goals of a great biographer? Is a reporter who writes about a distant land any different from the photographer whose in-depth reportage describes the same country?

Think of all the different types of writers: novelists, essayists, biographers, pornographers, copywriters, poets. Each category has its counterpart in photography. Yet many beginning photographers forget (or never realize) that, just as the writer must effectively communicate, so must the photographer. In the vast majority of cases, a writer can't merely string words together simply because they sound good; those words must convey a message. So it is with the photographer. Pleasing, "pretty" images may have a personal value, but in the commercial marketplace that isn't enough; the images must also mean something. The elements comprising an image must be constructed in such a way as to project a statement, an idea, or a mood.

What is the trick, then, that you can use to take advantage of this similarity between the verbal and the visual? You must combine the two disciplines by imposing verbal criteria on

It's as important for a photographer to learn how to "say" things with the camera as it is for a writer to learn how to "say" things with words. As you shoot, try to illustrate specific words and concepts rather than simply create pretty images.

In this photograph the photographer was trying to create a sense of "power" and "primal energy." So far it has earned over $2,250.

Photo: Christopher Stogo

your visual images; that is, you must train yourself to select and execute effective images that illustrate certain words—words that represent verbally the very statements, ideas, and moods you wish to convey visually.

Once you start shooting to illustrate specific words, you will find that you have a yardstick by which to evaluate every scene you come across or try to set up. Analytical questions will automatically come to mind: Does the scene in front of me illustrate the word or doesn't it? What must I do to make the scene more clearly illustrate the word? (Change position? Add a model? Use a different lens? Come back at a different time of day?) Or, Is there a statement/idea/mood/word that the scene *does* convey?

Consistent use of this mental exercise will quickly and dramatically affect your photographs. First, you will soon be able to identify the types of scenes that have the greatest appeal to your own personal sensibilities and recognize how to use these scenes to communicate statements, ideas, and moods. Second, your photographs will begin to exhibit a simplicity and directness of purpose that is sadly lacking in most photographs and that is essential for success in the commercial marketplace. Third, you'll start to develop the ability to analyze a scene instantly, evaluate it for its content and marketability, and decide whether you should spend time, effort, and film on it.

This gimmick may sound deceptively simple, but of all the techniques I know, this one will most effectively lift you head and shoulders above the mass of everyday photographers—your competition. Anyone can take a cluttered, unfocused (as opposed to out-of-focus) photograph. It's the disciplined, precise, eloquent photograph—the one that speaks to the viewer clearly and concisely—that makes its mark.

An example of this technique might be helpful. Imagine yourself driving around the countryside looking for pictures to shoot. Previously, you would have randomly stopped to shoot whatever struck your fancy, even though you wouldn't have been able to identify the specific qualities in the scenes which appealed to you. This time, however, you decide instead to try this mental technique and use your camera to illustrate the word "desolation." As a result, you find that the scenes you choose to shoot are different from the scenes you might otherwise have photographed. The way you "see" your surroundings is influenced by your self-imposed objective. You find you are automatically beginning to evaluate the scenes before

you on the basis of their *communications* potential. You are being critical, using the word "desolation" as your criterion for whether or not to shoot. Equally important, your ability to decide that a scene does *not* impart a sense of desolation becomes the first step toward discovering what the scene *does* impart. Because you are *thinking* about your images and *critiquing* them before you release the shutter, you're discovering how to communicate—*communicate*—with your camera.

What words should you choose? Any words or phrases will do, though some are better than others when it comes to marketability. While you are mastering this technique, though, your real concern is to learn to illustrate *any* word. Later you can choose words specifically because the subjects are likely to sell.

Refining Your "Eye"

As you become better at expressing a single statement, idea, or mood in your photos, you can progress to the next stage in developing an eye for the saleable subject or scene. Specifically, you can learn to watch for, or create, photographs that not only convey a concise message but do so in a manner characterized by universality, timelessness, simplicity, and versatility. Complex ideas, these, so let's look at some examples of what I mean.

Everybody admires sunsets. Sunsets are fabulously colorful and have grandeur that is impossible to ignore. For these reasons, there are millions upon millions of photos of sunsets on the market. Now, take a look at the two sunsets on the next page. Both are pretty pictures. Both convey a mood. Both were taken by the same photographer. On the surface, neither appears to be unique.

The one on the top has never sold. The one on the bottom has sold thirty times for total revenues of $10,000.

Why is the one sunset a flop while the other one is a superseller?

First of all, as nice as the sunset on the top might be, it is like thousands of others. True, it effectively conveys the idea of "sunset," but its message ends there.

Now let's examine some of the uses to which the other shot has been put. It was used

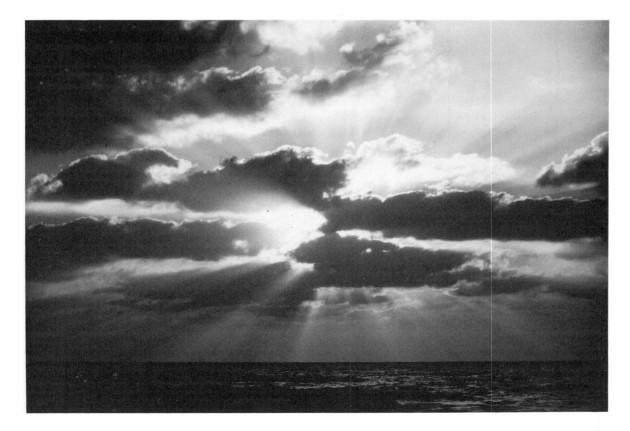

- in a condominium sales brochure
- in a medical trade ad
- on the cover of a brochure for a jet manufacturer
- in a hotel ad
- by Sony for a product brochure
- in a cosmetic ad
- on the cover of a religious magazine
- for editorial use in an aviation magazine
- as background on a sales brochure for a skylight manufacturer

—and in many other ways as well

Why? What is it about this shot that gives it such extraordinary marketability? In essence, the photograph conveys, in an extremely powerful and immediate way, a specific mood—cosmic tranquillity. And that mood is widely recognized as desirable; therefore, it is a mood many photo buyers need to communicate. Often the buyers don't even know exactly *how* they can communicate the idea, but once they see this photo they realize it will do the job.

The jet manufacturer wanted to convey the enormous pleasure of flying, the religious publication sought to express the inspirational qualities the photo implied, the hotel wanted to get across the idea that a stay at that hotel would lead to the kind of peaceful relaxation suggested by the photograph. Corny? Maybe. But the point is that the photo made a statement and that the statement was both universal *and versatile.*

The photo of the desert is more than simply a "Western scenic." It strongly conveys the concepts of dryness and extreme heat and is therefore adaptable to the uses of countless photo buyers wishing to demonstrate those ideas. It is not a specific desert (imagine how inclusion of a pyramid would have changed this photo's message), it is a universal desert, and its message is timeless.

Or consider the photo of the daffodils blooming in the woods (top of page 26). With the bare trees yet to emerge from winter, the flowers in their early spring bloom and the life-generating sun promising the advent of a new season, this photograph powerfully conveys the message "Spring." Its statement is pure, simple, and clear.

What does the photo (bottom of page 26) of the young boy and his grandfather say? With the inclusion of the model ship and the contrast of the expression of wide-eyed curiosity and unrestrained admiration on the boy's face with the bemused,

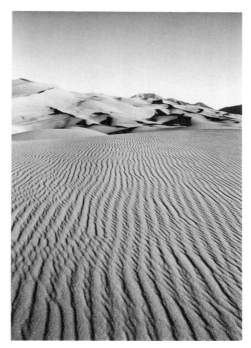

This photo is more than simply a "Western scenic." It strongly conveys the concepts of dryness and extreme heat and is adaptable to the uses of countless photo buyers who need to demonstrate those ideas.
Photo: Mark Scanlon

The difference between a photograph that is very marketable and one that is not can be quite subtle. Both these photographs were taken by the same photographer. The one on the opposite top has never sold; the one on opposite bottom has sold over thirty times for revenues of over $10,000.
Photos: A. J. Hartman

A good stock photograph's message is pure, simple, and clear. With the bare trees yet to emerge from winter, the flowers in their early spring bloom, and the life-generating sun promising the advent of a new season, this photograph successfully conveys the message "Spring."
Photo: H. Scanlon

A good stock photographer can often tell a whole story with just a few strokes of the brush. This photograph eloquently evokes the age-old relationship between grandfathers and their grandchildren. A specific subject and situation is being used to convey a universal and highly marketable idea.
Photo: Tom Grill

sea-weathered visage of his grandfather, an entire story emerges. The photograph eloquently states the age-old relationship between grandfathers and their grandchildren. A specific subject is being used to convey a universal idea, one with virtually endless application.

What appears to be a much simpler photograph, but which in actuality is equally well-planned and executed, is the waterfall reproduced at right.

It looks like a simple waterfall casually snapped by a photographer who happened by, but it again demonstrates the qualities of simplicity, proper execution, and universality that characterize the truly versatile stock photograph.

The photographer in fact, after locating the scene, returned several times during different seasons in order to get the shot he wanted. He knew that green leaves are most lush shortly after they emerge in spring and that at the same time the water level would be swollen due to snow melting in the mountains. He brought along a tripod, because if he was going to get a large depth of field—which he decided he wanted—he would have to close his aperture way down and thereby induce an extremely slow shutter speed. But not too slow, because he didn't want to have the water appear too milky, as happens with a very long shutter speed, nor did he want it to be too sharp, as occurs with a very short shutter speed. Thus, after calculating all these factors and anticipating how bright the light would be at different times of day, the photographer trundled through the woods and got the shot.

Was it worth it? The photograph has been sold 37 times for total revenues of $10,940.

Why? Consider all the ideas this photograph can communicate. It has been used in the following ways:

- On the cover of a waste-water treatment brochure
- In an annual report for a company that makes water filters
- For a poster advertising a cosmetic company's moisturizer cream
- As a label on crème-de-menthe-type liqueur
- On billboards in Canada for a tobacco company
- On the cover of an air-filtration manufacturer's dealer catalog
- On a promotion brochure for a company that makes water-coolers
- In a direct-mail promotion piece for a faucet manufacturer
- In a window display unit for a company that makes hearing

This deceptively simple shot of a waterfall contains all the essential elements of a good stock photograph: simplicity, proper execution, and universality. Its message is clear but versatile and it has sold thirty-seven times for revenues of almost $11,000.
Photo: Jack Elness

aids. (The hearing aid will allow the user to hear the rushing water.)
- In a chemical company trade ad that states that the company didn't pollute the waters

You get the point. This photograph, though seemingly simple, can successfully communicate several ideas that photo buyers need to convey. Its message is clear but also versatile. In fact, had the photographer been less determined to create the perfect "babbling brook of pure clean water," had he introduced unnecessary elements like a fisherman, or a conspicuous log, the photograph would have become a picture of the fisherman or the log and, accordingly, would have had fewer applications. The photographer knew he wanted to "say" things like "pure water," "cool water," "refreshing." By isolating the waterfall, the photographer produced a clearly focused photograph that does indeed "say" those things graphically, immediately, and with unmistakable impact. The result: an extremely marketable and successful photograph.

Does that mean that if you see a river you never want to put in a fisherman? Of course not. It simply means that if you place a fisherman in the photograph you must be aware that you will be attempting to "say" something entirely different from "babbling brook" or "clean water." You will likely be conveying the idea of "vacation" or "relaxation," or even "frustration" if the fisherman is unsuccessful. The point is that you must be certain your photograph has a communicative focus and that this focus is the one you intend. If *you* don't know what you are trying to "say," chances are that no one else will, and you will be producing an ineffectual image.

Is it possible to overregiment and overanalyze your photography? Yes, it is, because photography is *visual* and not verbal. This imposition of a verbal discipline on your photographs is merely an *exercise* designed to help you develop your technical facility and skill in composition and learn to focus the message of your photos. With practice, you'll find that you will develop a "sixth sense"; you will know almost immediately when you have come across something that "works," or you will know how to change it so that it does.

Using Small Details to Make Broad Statements

In searching for the saleable subject or scene, one of the most effective skills a stock photographer can develop is the

ability to use small details to make broad and universal statements. Many photographers think only in terms of panoramic vistas and epical canvasses painted with broad strokes. In fact, however, some of the most sublimely effective images can encompass no more area than a few square feet or even a few square inches.

Let's look at some examples. Suppose you want to convey the idea of marital commitment. You could set up a photograph of a couple in wedding apparel standing in front of an ornate altar, surrounded by friends, family, and flowers and the attendant pomp and circumstance. Or, you could do what top commercial photographer Judy Yoshioka did and take the photograph below of the two hands, one male, one female, with the ring about to be placed on the woman's finger, as a

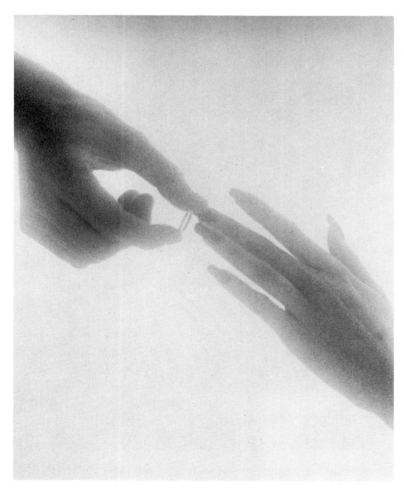

One of the most effective skills a stock photographer can develop is the ability to use small details to make broad, universal statements. This photograph does more in one simple stroke than a complicated photo of a church wedding scene ever could.
Photo: Judy Yoshioka

symbol of the commitment. That photograph captures with one simple stroke what could not be portrayed as effectively with the massive setup of the church scene—and it is a vastly more effective image. It is effective not only because it captures a revealing detail, but also because it is extremely simple. Art directors who might buy this photograph have plenty of empty space in which to insert type, and they can be assured that the image will convey the idea graphically, quickly, and without being so "busy" that it confuses the reader or detracts from the product or service being promoted.

Now take a look at the shot of the ferns. Fairly ordinary and straightforward, right? But in fact, the photographer had a very calculated objective in mind when he took the shot—he wanted to convey the idea of "wet jungle." Is the result a sale-

This small detail of some jungle ferns was sold for background usage for $1,500. It was shot in an out-of-the-way corner of the San Diego Zoo. Photo: H. Scanlon

This small detail spotted by an alert stock photographer can be used to relay messages such as "forest," "trees," "pristine purity," "rain," "moisture," and so on.
Photo: Derek Sasaki

Grand openings, weddings, New Year's celebrations, beginnings, endings—all can be illustrated with this imaginative shot. This is an excellent example of using a single image to evoke a broad spectrum of ideas.
Photo: R. Michael Stuckey

able shot? Our agency sold this photo to a company that manufactures commemorative medallions and needed a shot of Ghana to serve as a background for one of their coins. Other photos the company examined were either too "busy" or simply did not conform to one's expectations of what Ghana should look like. So they bought this shot—which is actually a small detail of a section of the San Diego Zoo. And they paid $1,500 for it.

Consider the photograph of the dewy evergreen bough—it isn't really even a whole bough—shown above. This photograph relays the message of "forest" and "trees" and "pristine purity" and "rain" and "nurturing" and so on. One simple little photograph, and it is adaptable to innumerable applications.

Or the champagne bottle above with the cork bursting forth. It looks like a simple photograph (actually, it was ex-

ceedingly difficult technically), and if you begin to think about it, its applications are endless: grand openings, weddings, New Year's celebrations, beginnings, endings. Almost any kind of occasion could be illustrated with this simple shot. It "says" something and needs only to find the buyers who can make use of its message.

If you've thought about this concept of imposing a "verbal" discipline on your photographs, you may also have recognized that any two photographers who set out to illustrate the same word will come up with very different photographs. Therein lies the true joy of photography: It is a route to self-expression. The photographs you take are yours and yours alone. The way you use images to convey ideas is your way and only your way; if you try to do it the way someone else would, you will fail. As a result, despite the imposition of this admittedly artificial verbal discipline, the very act of taking pictures will become an act of discovery for you. You'll discover how *you* feel and how *you* see—and you will be well on your way to developing your own particular "eye," the very special way you see the world around you. As you fine-tune your "vision" and learn more and more about yourself through your photography, you will hone your communicative skills to the point where your "eye" becomes the unconscious guiding force behind your photographs. At that point, the quality of your work will be limited only by your determination to pursue its rewards.

THE IMPORTANCE OF CONSIDERING POTENTIAL USAGES OF YOUR PHOTOGRAPHY

People who buy photography do so for many different reasons and these buyers bring to their work an infinite variety of graphic sensibilities. And in all likelihood several art directors working independently on the same project and given the same photograph to work with would each use the photograph very differently. One would put the type at the top; another might put it at the bottom. Still another might place the photograph within a border and place the type around the border, thereby leaving the photograph essentially intact. Still another might use no type at all. One art director might use only a section of the photograph, and by this "cropping" create a whole new range of possibilities. An art director creating a

wraparound label for a paint can will need a photograph that is composed very differently from the art director looking for a similar photograph that will be used in a tall, narrow rack-folder.

If you are going to create a workable collection of stock photographs, then when you find yourself in a promising situation (that is, when you have found a subject that seems to lend itself to "saying" important things or communicating ideas), you should learn how to "shoot around" that subject in anticipation of all the varying uses to which that subject might be put. Your chief tool in so doing is what I call "anticipatory composition."

Anticipatory Composition: How to Compose Your Photographs with "Dead Areas" to Increase Sales

There is no question that your first priority should be to learn how to compose effective photographs that can stand by themselves, and probably you have already read one of the scores of books on that subject. The way you compose a photograph is part and parcel of your own development as a photographer. As you know, a well-composed photograph will have good balance and effective lines of flow. It will make skillful use of contrast, it will direct the viewer's eye, and ultimately it will form a completed image. Until you have mastered the ability to produce such a photograph, you will not be able to practice anticipatory composition, which essentially asks you to break the rules.

I stated earlier that this book is not about how to take pictures for museum walls but about how to take pictures you can sell to photo buyers in the commercial and editorial fields. A photograph for a museum is completed, final. It exists, for better or worse, exactly as you, the photographer, leave it when you have finished your work. A photograph sold to a photo buyer, on the other hand, will often be altered, retouched, cropped, and frequently have type placed over it that conveys the buyer's intended message. In other words, the buyer will often be adding new elements to your composition. *The ability of your photographs to accommodate new elements while retaining effective composition will have tremendous impact on the saleability of those photographs.*

Take a look, for example at the two photos of the reeds at the right. These photographs differ primarily in terms of com-

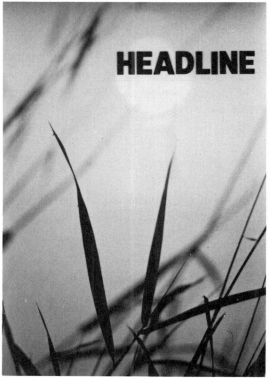

Photo A is a "finished" photograph, superior
compositionally to B, which seems to have too
much empty space at the top. A good stock
photographer, however, will shoot the photograph
both ways in order to "anticipate" the frequent
need of photo buyers to add type or another inset
photo of a product. Photo C shows how photo B
becomes "completed" by the addition of the type.
How well your photographs can accommodate
new elements while retaining effective composition
will have a tremendous impact on their salability.
Photos: H. Scanlon

position. In the classical sense, photograph A is far superior compositionally to photograph B. At the top of photograph B there is too much empty "negative" space that serves no aesthetic purpose. If photograph B were executed with the purpose of framing it and hanging it on the wall, it would be unquestionably inferior to photograph A.

Nonetheless, it is quite possible that photograph B is the more promising of the two as a *stock* photograph. Photograph B has greater potential for sales *because* of its lopsided composition. Why? Because art directors working with photograph A would have no place to put their type (or an inset photograph of the product or a diagram or whatever). Photograph B, on the other hand, is "begging" to be worked with. Art directors given empty space like that to work with immediately visualize how they can place type to balance the composition. Photograph C illustrates how the photograph can be "completed" with the addition of type.

The point? In many ways a good stock photograph is an *unfinished* photograph compositionally. It is intentionally left to the photo buyer, the person who is going to make *use* of the photograph, to finish it.

If you are going to create these unfinished photographs successfully, when you shoot them you are going to have to *anticipate* how an art director might use a photograph so that you create a workable image rather than simply a poor photograph. As you shoot, actually visualize type placed in the frame. Imagine type at the top and then shoot it that way. Imagine type on the side and shoot it that way.

HOW TO "COVER" A SALEABLE SUBJECT OR SCENE

Keeping in mind that there are various ways an art director can make use of your photographs, you should achieve three main goals as you "cover" a subject.

1. Be sure to come away with a well-compositioned image that can stand on its own—a good photograph in and of itself.
2. Capture images that will lend themselves to the inclusion of other elements—type, insert photographs, etc.
3. Treat the subject in ways that anticipate various croppings and formats; that is, shoot it vertically, shoot it horizontal-

ly, shoot it so that it can be cropped in any way at all: square, extreme horizontal, extreme vertical, even a circle.

At first you'll have to discipline yourself to think consciously of these requirements even as you look through the viewfinder. With time, the process will become automatic.

Each time you get your film back, go over it carefully and critically. Take the photograph you think is the most compositionally complete and imagine you have sent it to an art director. If the art director were to call you and say the photograph is good but needs more room at the top for type, would you have a photograph that would fit the bill? Or if the art director were to say that the photograph will be on a bus poster—one of those long, narrow cardboard promotions that you see over the windows on the inside of buses—would you have a photograph that would work for that?

Needless to say, not every scene or subject will lend itself to being covered for every eventuality. But the closer you come to exploiting the possibilities thoroughly, the more likely that you will have created photographs that you can turn into sales.

THE IMPORTANCE OF HAVING YOUR CAMERA READY AT ALL TIMES

In my experience, stock photographers who are most successful never allow themselves to be caught without a camera. You never know when a saleable subject or scene will present itself, and you only have to miss a few of them before the idea of schlepping your equipment along wherever you go becomes less and less cumbersome. I even know some photographers who will set an approximate exposure for the general situation they're in. (Driving along in daylight, for example, such photographers might set their cameras for 1/250 second and f:5.6 before they put it in the bag.) That way, if a fleeting shot does appear they've already got approximately the right setting and won't waste time.

This type of behavior can become obsessive, of course, and most people draw the line when they find photography becoming a chore. My advice is that as long as you're having fun with your camera, keep shooting and have it ready and available when you need it.

3

How to Shoot Photographs for the Commercial Market

TRAVEL PHOTOGRAPHY

Travel photography is probably the most competitive area in all stock photography. *Everybody* has travel photographs, and it seems that *nearly everybody* is trying to sell them.

Balanced against this is the fact that the market for travel photography is enormous; it is, in fact, the largest single market for stock photography. Every tour company, from the big ones like American Express and Cook's Tours to small local travel agencies, uses stock photography to illustrate its destinations. Then there are the airlines, big, small, and in-between, the hotels, the national tourist bureaus from all over the world, the cruise lines—just about every business even remotely related to the travel industry has a continuing need for photography. In short, the brochures, posters, and catalogs produced every year that require stock photography number in the thousands.

Nor is that all. Most companies have what are called in-house incentive programs—"sell the most policies" (or cars or houses or blenders or whatever), "and win a trip to Tahiti" (or Paris or Nova Scotia or Chicago or whatever) —which they promote with posters, brochures, flyers, etc., all of which use stock photography to enhance the appeal of the program. Unless you're employed by these companies, you'll never see this material; but if you're a photographer you should be aware of this area as a source of substantial sales of your travel photography.

In fact, there are entire companies that specialize in creating these incentive programs for other companies, and they can be voracious buyers of stock photography.

The point is this: Yes, the market is vast. But the competition is fierce. There are so many people trying to peddle travel

To shoot travel photographs successfully, you must anticipate the needs of the art directors who will mold your photographs into an effective layout, ad, or brochure. Wherever you go, be sure to get at least one "key" shot, such as the large one of London, that immediately tells the viewer where he or she is. It is the "key" shot upon which the layout will be built. In addition to the "key" shot, art directors will probably need a number of supporting, or "satellite," shots that illustrate some of the sights and activities a visitor might take advantage of. Notice how the shot of Harrod's reminds the viewer that London is noted for its shopping opportunities. Doing one's homework first can be crucial.
Photos: A. J. Hartman

photography that most photo buyers who are in a position to purchase travel shots are simply inundated.

And one of the problems is that they're inundated with mediocre photography—because in travel photography a poor photographer can be "carried" by the subject matter. It's hard, for example, to take a truly horrible photograph of the Eiffel Tower or Niagara Falls, or the Grand Canyon. And it's easy to take a mediocre one or even a "good" one.

Despite the competition, however, a number of photographers do make good money selling their travel photography. They are successful not because they're creating photo masterpieces, but because they know the needs of the travel industry extremely well. By applying their knowledge, they maximize the effectiveness of their work and thereby increase its potential marketability.

How can you give yourself an advantage over the crowd? One of the best ways is to develop a coherent approach to

travel photography that capitalizes on the hard-won experiences of those who have been most successful in the past:

Do Your Homework

Find out what it is about the place you're visiting that makes it distinctive. Remember, the person who buys your work will be looking for photographs that encourage people to travel there. Decaying slums might be as much a part of a place as a beautiful beach, but vacationers will be lured by the beaches, not the slums.

Take a trip to the library to do research. Check everything from encyclopedias and atlases to histories and guidebooks to learn the background of the area you will visit. Use the *Guide to Periodic Literature* to find magazine articles that will inform you of recent developments that can be important to cover in your photographs.

Identify the ''Key'' Shots in a Locale

Pick up some catalogs and brochures at a local travel agency. If you look closely at them you'll find that all travel literature uses two basic types of photos:

The first type of photo is the all-important ''key'' shot. It is a photograph—usually the largest one on the page—that ''says'' the right place quickly, graphically, and as attractively as possible. A key shot of Paris, for example, is likely to be the Eiffel Tower. A potential vacationer flipping through the brochure will know immediately that the destination being suggested is Paris. The brochure, by the use of a powerful, attractive photograph must ''say'' the place immediately and maximize the pleasant aspects of the city.

Make a list of the ten most important subjects you want to cover in the location you visit. This list can include anything from specific buildings, monuments, stores, museums, and parks to more general ''ideas'' or concepts that are associated with the area. An area might be known not for any particular site but rather for an industry or a way of life. A photograph that ''says'' Idaho, for example, might be a simple scenic view of a flowing wheat field or rows of freshly plowed, rich topsoil.

Thus, your list should include not only the buildings and obvious attractions but also scenes that convey the emotional

Note how these "key" shots have immediate
graphic impact. An art director has plenty of
room in each to place type, and yet each photo
can stand on its own and serve as the centerpiece
around which an entire spread can be built.
Photos: A. J. Hartman

qualities and ideas and concepts that characterize your area. It is your job as a photographer to illustrate these ideas effectively. And, to a large extent, the challenge and many of the satisfactions of photography lie in succeeding at this task.

Identify the Satellite Shots

Supporting the "key" shot in a travel brochure are usually a number of supporting or "satellite" shots that illustrate the things a traveler might do or see during a visit. For example, some of the attractions of Paris might be visiting the Louvre, Montmartre, or Notre-Dame, sipping wine in an outdoor café, and wandering around bohemian Pigalle. Photographers who want to take saleable travel photos must first identify the special attractions of any given place and set about illustrating them with their cameras.

All this may sound obvious, but I'm constantly confounded by photographers who go on a trip and come back with nothing but very arty, highly stylized shots. While these shots may be fine photography, they have no real marketability because they cannot be recognized as coming from any specific place. For example, a close-up of apples taken in Paris is worthless as a travel shot because there is nothing in the photo to differentiate them from apples shot in New York. Sometimes the subject matter of these photographs is so esoteric that the saleability of the shots is reduced to almost nothing.

Take, for another example, a shot of an ornate detail on Notre-Dame. The photograph may be saleable, *but only in conjunction with other more recognizable shots.* Most probably, anyone who buys your shot of the Notre-Dame detail will have already bought a key shot as well as some other more obvious shots. So unless you set about getting those other shots yourself, someone else will take them—and sell them.

It's not that you can't have fun with your camera. One of the great joys of traveling for photographers is the opportunity to apply their own sense of vision to the places they visit, to seek out the nuances and details that can make a great photograph. But don't forget to tend to business also. Get those key shots. Find out what a city, place, or region has to offer, and make sure you illustrate it. Those are the shots that are going to pay for your *next* trip.

In Paris or London, the key shots and satellite shots are easy to determine. In other places they may not be so obvious.

If you expect to wander around aimlessly and have the right scenes and right subjects simply materialize as if by magic, you're going to be disappointed. It's your job to find out what's important and discover the key shots. In this regard, conscientious research can make all the difference in the world. Suppose you are planning a trip to Lancaster County, Pennsylvania. You've seen some photos from that area and know that it is beautiful countryside, rich in the age-old culture of the Amish. You could simply take off across the area shooting whatever you found of interest. And you'll probably come back from your trip with some nice scenes and a few good shots of bearded people driving horse-drawn carriages—which is to say you'll come back with the same photographs everybody else comes back with.

But if you had done your homework first and spent some time at the library reading about the area and its people, you might have gotten the really extraordinary shots that would set your work apart and give you the decisive edge in the marketplace.

For instance, you might have found out that your trip would be much more productive during harvesttime. Or that a little-known farmhouse is the oldest—and most picturesque—in the area, and that it exemplifies the whole region. Through research, you might have become aware of the photographic potential of a traditional Amish barn-raising and been able to ask the right questions that would lead you to one. If you had learned in advance that the Amish people are reluctant to be photographed, you would have packed telephoto lenses in your bag so you could shoot unobtrusivley from long distances.

In short, the better you know your subject the greater the likelihood that you'll spend your time effectively and get the shots that "say" the area.

Select the Equipment to Bring

Once you know basically what you're going to be shooting, you can make some decisions about what equipment you'll need.

Travel photography can be a fast and furious affair; it's essential to strike the correct balance between bringing the equipment you need and remaining unencumbered by extraneous items that will only slow you down. Most travel pho-

tographers like to bring along only the minimum amount of equipment necessary, so that they don't have to lug heavy, bulky items that never leave the camera bag. Imagine yourself actually taking the shots on your list and try to anticipate the equipment you'll use. Now go back and reduce what you *might* need to the bare bones—probably less than 50 percent of what you first selected. Leave the rest at home (or, better yet, at the camera store). Then, loaded up with plenty of film, carrying only the equipment you really need, and with your preliminary list of "key" shots in hand, you're fully prepared to be on your way.

Upon Arrival, Get to Know Your Subject Firsthand

When you arrive, immediately get to know your "subject." Find out when the sun goes down and when it rises. Many would-be professional photographers miss the finest shots simply because they're too lazy to get out of bed and take advantage of the sunrise—often absolutely the best time to shoot.

As you've heard many times, successful photography depends on an understanding of light. Orient yourself to the sun. *Where* does it set? Rise? This will help you when you're mapping out a shooting schedule. Remember that a view that at noontime is crowded with people, unappealing, and contrasty, might be the perfect "key" shot under the soft, golden light of dawn.

One of the easiest ways to become familiar with an area is one of the most obvious. It's also the most frequently overlooked—taking a commercial tour. It's as simple as that. Plunk down your five dollars, get on a tour bus, and pay attention to the tour guide.

If you've done your homework properly, the tour will cover many of the locations on your list; you may also see some additional key-shot possibilities, and almost certainly you'll pick up ideas for satellite shots. And if for some reason you haven't done your homework, taking a tour will quickly give you an excellent idea of what the attractions are and what you should photograph.

You can schedule the tour during the good shooting light in the hope of getting shots while you're on the tour, or you can schedule it for harsh, midday light and plan on coming back to the locations you like. Naturally, since you're a photogra-

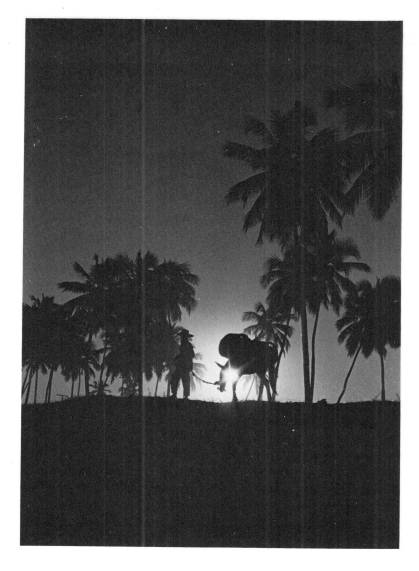

Orient yourself to the sun. Where does it set? rise? Learn everything you can about the light conditions and timetables, then take advantage of them.
Photo: Tom Grill

pher, you will be constantly analyzing when the best light conditions will exist, what the best angles are, etc.

Pay attention to the tour guides. They can be the quickest source of information about the relative importance of the places you're being shown. A good guide knows the territory thoroughly and, if you ask, will often be able to recommend specific photo locations.

Plan on coming back to the most appealing spots to shoot at your leisure or when conditions are better. If you need a tri-

pod, you'll have determined that in advance. You will have taken copious notes on the tour that will enable you to map out an itinerary that takes into account everything from light conditions to the amount of time each shot will demand.

If you conscientiously follow these suggestions, you will be so efficient that after taking your saleable shots you'll still have plenty of time to do that personal photography—just for yourself—which might otherwise have filled *all* your time.

But what do you do if there are no tours, or if the idea of taking one is so abhorrent that you simply can't bring yourself to do it?

The only answer is to have done your homework before you left.

Apportion and Allocate Your Time

On the basis of your research and touring plans, decide how much time you're willing or able to spend on your photography, then schedule your day or days accordingly. Your schedule shouldn't be so rigid that you are constantly fighting it, but remember that the bane of the photographer is lack of self-discipline. Chances are your photos will stand out from the crowd only if *you* stand out from the crowd. So set your priorities and try to stick with them. It's the photographers who ply their trade *exceptionally* who will come back with the most marketable shots.

One factor that will affect your schedule is sure to be the weather.

In my office I have a file drawer that I call my "excuse file." When the photographers I represent come in with their tales of woe about all the problems they had as they traveled around shooting stock photography, I ask them if they came back with anything for the stock files or just the excuse file. I tell the photographer not to worry, because if a client calls up looking for shots of the subject the photographer missed, I'll tell him that although I don't have any film to send him I have a whole drawerful of excuses he can take a look at. You get the point.

Far and away the largest section of my excuse file is devoted to "bad weather" and variations thereof. The fact is that *bad weather is no excuse.* The best photographers always come back with something saleable no matter what the weather conditions.

Here's an example: A cosmetics client assigned Tom Grill to produce a photograph of Monte Carlo to be used in a national ad. He was flown to Monaco and given one day to shoot—which was fine except that on that particular day Monte Carlo was completely overcast with intermittent rain and occasional heavy showers.

Grill could not wait for better weather because he was due back in New York to shoot another assignment. He might have cursed the cosmos, decided the shot was impossible under the circumstances, and returned home empty-handed. Instead, he decided to proceed under the assumption that the weather wasn't going to get any better.

He rented a car and drove throughout the city and the surrounding hills looking for angles, points of interest (especially extra-colorful ones, to compensate for the drabness of the light)—any point of view that would characterize the city while minimizing the dreariness of the day. He looked for the details that would say "Monte Carlo," such as the Casino, framed by the fenders of an expensive limousine.

He knew that sometimes the beautifully diffused light of an overcast day can produce flattering effects on the details of the cityscape. (If you doubt this, the next overcast day place a bowl of fruit outside and watch the way subtle shades of color are brought out and how the soft light "models" the textures and shapes.) For overviews he experimented with colored filters to offset the overall grayness of the day. He looked for any areas of light contrast he could find—few and far between on a cloudy day, but there if you look for them—such as a white building against a dark hillside.

Grill knew that he was handicapped by the weather, and that unless it cleared he wouldn't get some of the shots he wanted, but he continued working until he felt confident that his assignment was covered and that he would return to the client with shots that would work. In addition, he planned to take some shots of the city in the evening when the weather would be much less of a factor.

Once he knew that even if he didn't get any more shots he had satisfactory—perhaps excellent—material to present to the client, he sat down and tried to determine the one shot he would like to get if the weather cleared. It turned out to be a scenic view overlooking the city and harbor from a nearby hillside.

He drove to the spot, set up his camera (using cellophane to

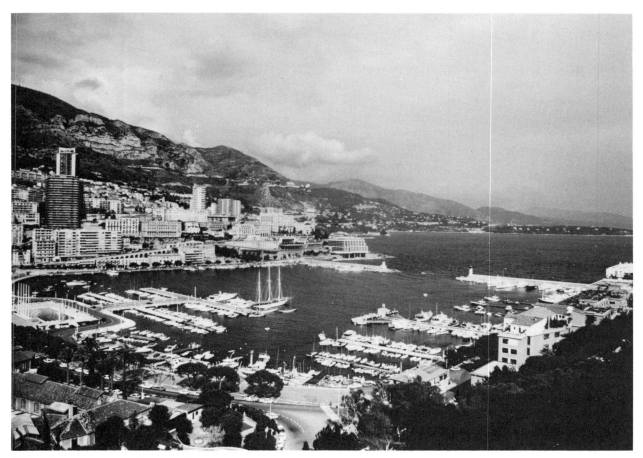

Bad weather is no excuse. There *are* things you can do. Tom Grill shot this photograph of the harbor at Monte Carlo during an exceptionally rainy spell. Total time of sunlight his entire stay? Fifteen seconds.

protect it from the rain), and waited. Several times it seemed as if the clouds might break, but no luck. The hours went by. Finally, in the late afternoon, the sun broke through for just a brief moment. Since he was completely set up, in exactly the right spot, he was able to get the shot. Total time of sunlight the entire day: approximately fifteen seconds.

That night he went ahead as planned and shot the night photos, not only to give the client a greater selection but also to build up his stock file for future sales. (The client liked the night shots so much that he eventually used one in his ad.)

Despite extremely adverse weather conditions, Tom Grill completely covered his bases. Upon arrival he had sized up the situation and figured out what had to be done; he then went ahead and completed the assignment.

The ability to produce saleable photos consistently—which is due largely to this combination of flexibility and self-discipline—is one of the major differences between a professional and an amateur. A professional is *expected* to produce the necessary shots *no matter what.* Photo buyers are not interested in hearing about bad weather, equipment failure, or technical problems—they are interested only in the final result, and they are paying top dollar because the photographer has a proven track record for delivering high-quality shots on time.

How does this apply to you? You should be your own art director. The photographers who are out there making money in stock travel photography are as hard on themselves and as demanding as any art director. They give *themselves* assignments and they carry them out.

Think Like a Photographer

People see things in different ways, and the fact that you have your own sense of design and composition is probably what made you a photographer in the first place. You might see fifty tourists busily taking snapshots of a building; what they're getting is exactly that—snapshots. It's your job to look at the subject not as a tourist, but as a photographer. The tourist doesn't notice if there's a garbage can sitting in the lower left corner of the frame—but you'd better notice. Move it if you can. Change your angle.

The following example illustrates the importance of thinking like a photographer: Millions of the tourists who visit New York City every year immediately head for the Empire State Building so they can photograph the city from above. But for a photographer, that would be the wrong move. Why? Because if you're on top of the Empire State Building, that building—probably the most recognizable in New York and the one that most epitomizes the New York City skyline—*will obviously not be included in your photographs.*

Photographers who "think through" their pictures will go to the top of the RCA Building—not as tall, but tall enough—so that they can include the Empire State Building in their shots. Again, think like a photographer, not like a tourist.

Out of your preliminary list of ten subjects, your tour might have shown you that you can reasonably expect to cover perhaps three of them in the time you've got. Pick the three and *make sure* you get them.

Learn to "think through" situations before you arrive at a location. The canny photographer who took this photo went to the top of the RCA building to take this shot of New York's most recognizable landmark. Remember, think like a photographer, not like a tourist.
Photo: A. Savitski

Above all, don't be lazy. Decide what you want and go get it. You'll make more money from one terrific shot than from one hundred mediocre ones.

Shoot Places and Things, Not Crowds of Tourists

If there is one mistake that spoils more travel photographs than any other, it is the inclusion of milling tourists in otherwise fine shots.

The rationale I've heard time and again from inexperienced photographers is that because the crowds were there, were part of the scene, they therefore belong in the shot. Well, it's simply not true: Nothing will detract more and more quickly from the graphic impact and overall appeal of your travel shots than a crowd of guide-map-laden tourists crawling all around your subject. Avoid shots with crowds in them.

How? If you're thinking the way you should be, you will be able to figure out a way. Change your angle. Or frame your subject with something (like foliage) that will serve not only to augment your subject but also to hide those people. The best technique, however, and the one that seems to be used most often by the more successful pros, is to choose a time to shoot when the crowds have gone home—or are still in bed. Photographers come into my agency time after time with roll upon roll of film taken on their trips, and out of all the shots, far and away the best ones were almost always taken at the crack of dawn. As a general rule, the undeniable advantage in hauling yourself out of bed and catching the sunrise is that you will avoid crowds.

Naturally, some shots can be enhanced by crowds, for example, a busy market scene in Taiwan, where throngs of voracious buyers add to the excitement of the locale. But unless you're absolutely certain that your photograph will be *improved* by including people in it, remember that crowds will ruin an otherwise fine shot. At no time can they be considered simply a neutral element in the composition of a picture.

And bear something else in mind: As soon as you include even one recognizable person, you must get model releases.

Obtain Model Releases on Recognizable Persons

In the section Shooting with Models, later in this chapter, we'll deal directly and at length with the importance of model

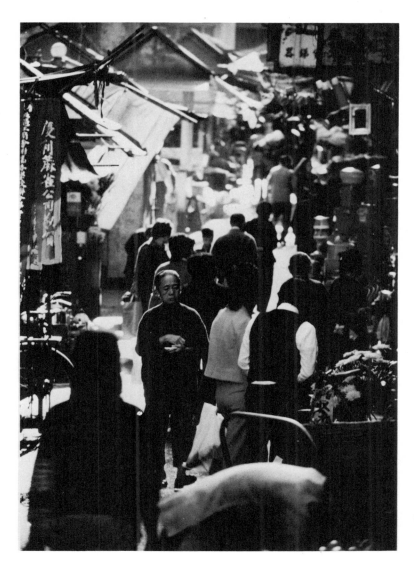

Some shots can be enhanced by crowds, but avoid throngs of map-laden tourists at all costs.
Photo: A. J. Hartman

releases—when you need them, how to get them. Let me just point out here that there is not an airline, tour company, hotel, or any other client I know of who will buy a photograph that contains the recognizable image of a person *unless* the photographer can present documented proof that he or she has a model release on that person. Thus, if you shoot a photograph with a person who can be recognized in the photograph and don't have a model release, you have reduced the potential sale of the photograph to just about zero.

Why do clients take such a hard line on this? If they like the shot well enough, won't they buy it anyway? No. They've been sued—and lost—too many times.

Editing—The Final Touch

So you've planned your trip, shot your film, and are just starting to view the film that's come back. You've handled the operation professionally every step of the way. Don't fall down on the job now. Be reasonable, rational, and ruthless in your editing. Look at your photographs just as critically as a potential buyer would.

Imagine you have a client who's depending on you to produce material for a brochure to convince others to travel to the area you're covering. Out of the many rolls of film you have shot, the client will pick out three to five shots and publish them in the brochure. That means you've got to "say" the area quickly and effectively, you've got to demonstrate the attractions—and you've got to do it with a maximum of five photographs. If you had to put together this brochure from your film, could you do it? Have you got a "key" shot? If you took just five of your shots and showed them to a friend, would the friend be inclined to say, "Gee, I'd like to go there"? If not, you've just failed the assignment.

But even if you don't have the right photographs, don't get discouraged. Try to determine where you went wrong, what you might have done differently. Your main obligation to yourself is *not to make the same mistake twice.*

Chances are, though, if you've followed the suggestions outlined here, you've got the shots you, and a potential client, were looking for. The best shots, and only the very best, are the ones to save and submit.

How to Give Yourself a Travel Photography Assignment

If you've followed the principles discussed so far, you've certainly stacked the deck in your favor. The only additional suggestion to keep in mind now deals with your overall approach.

Remember, as soon as you start earning money from your photos, you become a professional photographer. How suc-

cessful you are will then depend in large part on how "professionally" you approach your work. One way to develop a truly professional approach is to give yourself an "assignment," then complete the assignment just as if you had been hired by a client. Set high standards for yourself, then live up to them.

To go on a travel "assignment" doesn't mean you need a ticket to Paris or Pago Pago or Bangkok. Travel photography is nothing more than photography designed to illustrate a place people might like to visit. Any place. It can be ten thousand miles away from where you live—or ten miles away at the local nature center or amusement park. The more consistently you maintain this "assignment" approach and the more closely you follow these guidelines, the more rapidly the quality and the chances for a sale of your photographs will improve.

Guidelines for Successful Travel Photographs

1. Research your subject thoroughly.
2. Have a clear idea of what you're going to "cover" before you arrive; even those "lucky accidents" happen more often if you've set up a basic outline in advance.
3. Plan your shooting time.
4. Make sure you get at least one good "key" shot every place you visit.
5. Bring only the equipment you really need.
6. Orient yourself to the sun.
7. Get out of bed for the sunrise (and don't forget your camera).
8. Avoid shots with crowds of people milling around; change your angle or come back for the shot later when the crowds are gone.
9. Get mode! releases from all persons who are recognizable in the photograph.
10. Edit your work ruthlessly.
11. Train yourself, and keep in practice, by giving yourself assignments and making yourself live up to your own high standards.

SCENIC PHOTOGRAPHY

Every day your eyes are exposed to an almost infinite number of impressions. Thousands upon thousands of fleeting images register on your brain. How do you determine which of those images is worth photographing? When do you stop the car and take the time to set up your camera? If it is true that selection is a form of creation, how do you cultivate an eye for the good scenic photograph?

The first step toward answering these questions and toward taking good scenic photographs is to recognize that there is an important distinction between "travel" photography and "scenic" photography.

Travel photography is photography that depicts a specific place or locale. It can be highly journalistic or it can reflect a more artistically interpretive viewpoint, but its intention is to capture the flavor and nuances of a particular location.

Scenic photography, on the other hand, is photography that finds and captures meaningful images wherever they exist, and unlike travel photography, there is no need for those images to be identifiable as having been taken in a specific location. Scenic photography seeks to create general moods or convey universal ideas, and good scenic photographers concern themselves more with an image's ability to evoke a sense of mood than a sense of place.

These definitions may seem slightly misleading at first since a good travel photo usually includes some of the same qualities of a good general scenic. But in their purest sense, the two terms reflect distinct differences in the purpose for which a photo is taken and in the way it can ultimately be used.

Since travel photographers' intentions are to produce shots that depict a particular place, their photos are intended to appeal primarily to the travel industry, for all those uses discussed in the previous section. The market for those photographs is vastly more restricted than the market of the scenic photographer, who shoots scenes to illustrate an *idea* and who therefore has many opportunities to sell photos to markets far broader than the travel industry alone.

An illustration might be useful. In our stock agency files, we have well-crafted but unspectacular photos of rolling mountains in Pennsylvania that sell ten times more effectively than breathtaking panoramas of the Matterhorn. Why? Be-

Photo: Al Hartman

Unlike travel photos that depict a specific location, scenic photographs try to create general moods or convey universal ideas. A good scenic photographer is more concerned with a photograph's ability to evoke a sense of mood than a sense of place.
Photo: F. Willems

cause for every client I have who wants a shot of the Matter-horn, I have a hundred who want shots of generic, simple, un-specific mountains which are suitable for anything from background shots for their products to unspecific mood pieces in their annual reports or sales brochures.

Furthermore, knowing how to take good scenics can be of value even when you are working in the more limited field of travel photography. Recently, the state of North Carolina hired a photographer to take travel photos of its various tour-ist attractions. The state used the photos in travel brochures and an ad campaign. An important reason for the campaign's outstanding success was that the photos were not only good *travel* photos but also good *scenic* photos. Had the photogra-pher focused attention solely on the travel aspect of the as-signment, the results would have been far different, and prob-ably far inferior. Significantly, the photographer ended up producing excellent scenic stock shots.

In sum, though the difference between travel shots and general scenics is somewhat blurred, remember that the criteria for taking good photographs in each category are your intention when taking the photos and the eventual usage to which the photos can and will be put.

In this section, as well as in the following four which deal with shooting specific subject areas, I will be emphasizing over and over again the concept of "saying" things with your camera (as discussed at length in chapter 2) and the concept of remembering while you are shooting how your photographs will eventually be used. Both of these concepts are essential if you are going to be able to shoot *saleable* stock photographs consistently. Once again, I'm not talking about "pretty" pictures or "artistic" pictures—although some excellent stock photographs will be both pretty and artistic—I'm talking about *marketable* pictures. If you skip these sections on how to take the kind of photographs that will sell, there's really little need for you to read the second half of the book on how to market your work—because chances are you won't have much to market. (Likewise, if you follow the advice set down here about how to shoot saleable shots but don't read the marketing sections, you'll be like a Grand Prix driver who has a Formula One race car but has no idea how to get to the track.)

Knowing What to Shoot

For a photo to interest stock photo buyers, it must make the same statement *the buyers* wish to make. So if you have a firm understanding of how your work might eventually be used, you'll increase your likelihood of spotting the saleable scenic when you come across it.

As indicated earlier, it is a mistake to think that the only outlets for scenics are calendars and travelogues. The truth is that scenics have a myriad of applications all across the editorial/industrial/commercial spectrum. Scenics are frequently used for no other or more specific purpose than to add a splash of color or inject a hint of a desired mood into an otherwise lifeless piece.

Annual reports, for example, often use generic scenics to separate their various editorial sections. The photographs don't have to be directly related to the company; instead, they are selected because they successfully convey a change in

mood or a shift in emphasis. Many companies use scenics in their promotional material to establish or enhance their reputation; the consumer comes to identify qualities of the photos in the companies' ads with the firms themselves. For instance, a company might suggest its global connections by using an extreme aerial shot of an endless expanse of ocean extending to a curved horizon. Or, a company with an image of solidarity and longevity might choose a sunrise (to suggest inevitability) or a mountain scene (to suggest immovable strength). (The classic example of this is the Prudential Life Insurance Company's "piece of the rock" campaign.)

Scenic Photography as Background for Product Shots

One of the most extensive uses of scenic photography—and therefore one of the most potentially lucrative areas you can cultivate—is that of scenics used as background for product shots.

A product shot is just what the name implies: a photograph of a specific product. Suppose, for example, I am a manufacturer of life rafts and I want to produce a brochure showing my product. The first thing I would do is hire a photographer to come in and snap a few frames of the product. Now, I've got my product shot and can go ahead and have it printed in the brochure.

However, if I'm like most manufacturers, I'd like to add some drama or excitement or mood to the shot. So what I might very well do is purchase a stock photograph of an appropriate scene to use behind my shot. Since my product is a life raft, I might choose a beautiful ocean scenic. By so doing, I improve the overall impact of my brochure, and inject some attention-getting color that will help sell my product more effectively.

Promotional brochures, sales sheets, ads, fliers, and packages all frequently employ generic scenics as background for products. And, more often than not, the photos used are selected more for the mood they capture than their subject. For example, a pharmaceutical company designing an ad for a tranquilizer will very likely be looking for a photograph that conveys a sense of "calm" and "peace." The producers of a moisturizer might need a shot that says "dry" in order to emphasize the attributes of their product. And so on. Almost ev-

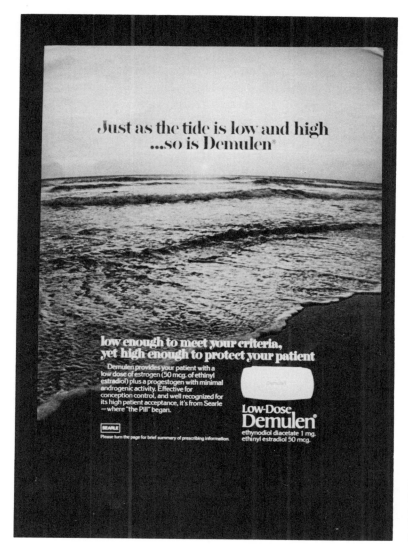

Stock photographs are often used as background for a product that is strategically placed over the stock photo as above. Usually, it is the mood of the photo rather than its subject matter that causes it to be selected.

ery product and every service has certain characteristics that can be illustrated with scenics. Once you start thinking in terms of *ideas* and *moods* instead of simply making "pretty pictures," you will begin to produce the kinds of photographs that can be successfully sold to this vast market.

By *anticipating* the various possible uses of your photos while you're shooting, you will be gaining an advantage in the marketplace and at the same time sharpening your observational skills. For example, if you're walking in the woods and

This photograph was shot specifically for use as *background*. It was never meant to stand on its own and is therefore "incomplete" until a buyer places type or other material in front of it. If you like shooting flowers, try composing in this way for background usage.
Photo: Judy Yoshioka

come across an interesting meadow, rather than randomly photographing everything and anything take a moment to consider how a buyer might use this scene. What image might a buyer need to communicate to a consumer that could be evoked by this meadow, and how would the buyer design it? Could this scene be used as a greeting card? What would this scene have to say to a greeting card company? If you have already sold photographs to certain clients, think of each of them now, individually, and try to imagine how this scene could apply to them or their products.

And as you shoot, you should bear in mind not only what the scene "says"; but also pay special attention to certain *technical* requirements of composition that relate directly to the way an art director will physically place a scene in an advertisement.

As you view scenes, think of them both as individual shots that must stand on their own and as potential *secondary* shots that can be used to enhance and support a main product shot. Note, however, that planning for different potential usages can also affect your compositional decisions.

Ideally, if the scene lends itself to it, shoot it both ways— once as a calendar-type scenic that could stand on its own and once as a background. It's important to not underestimate how lucrative background photography can be; the potential uses for a good background shot often far outstrip those for even the most dynamic calendar-type scenic.

Flowers

Take a look at the shot of the floral arrangement on this page. It is a nicely executed shot, but not extraordinary in any way. It doesn't "say" a whole lot other than "flowers," and in essence it is nothing more than a wash of shape and texture. However, the photographer purposely took the shot this way—leaving it compositionally "incomplete"—because she wanted to use it specifically and exclusively as *background*. It was never meant to stand on its own, and it is therefore "incomplete" until a buyer places either type or other material in front of the shot. The photograph is specifically intended to serve a supplementary and supportive role. And for such a purpose, though it is deceptively simple, it is extremely effective.

Compositionally complete pictures of individual flowers have relatively little saleability. Once in a while, encyclopedias buy individual photographs of specific flowers to illustrate and catalog the botanical kingdom of flowers. In these cases, they are interested in showing what specific flowers *look like* rather than in creating a mood or conveying a message. With this rare exception, though, the vast bulk of floral photography is used either for backgrounds or to get across a season or event—for example, poinsettias signify Christmas, daffodils signify Easter, etc.

How is this important to you? If you like to shoot flowers and intend to build up a marketable portfolio, remember to treat flowers not only as individuals to be cataloged but also as elements of color and texture that can be sold for *background* usage: soldiers, not generals.

Versatility, Graphic Power, Simplicity: Important Elements of Saleable Scenics

Some photographers seem to be born with an innate ability to spot good scenics; others must work at developing an "eye" through discipline and perseverance. Neither type of photographer is automatically more successful than the other; regardless of which group you belong to, you can improve your sensitivity to scenics and work on your eye. Study magazine ads carefully to help yourself develop an appreciation for and understanding of the wide variety of commercial uses for scenics.

Once you have a feel for how scenic photos might eventually be used, you should find that scenes which never before interested you now catch your attention. But simply knowing that fields of flowers sell well, for instance, doesn't mean that any old picture of a nice field will do. Like other stock photos, the best stock scenics not only have saleable subjects but also have additional characteristics such as versatility, graphic power, and simplicity.

A versatile photo is one that is general enough to have many potential applications.

A photo has graphic power if it can create a mood or make a statement strongly, unambiguously, and immediately. Like all good stock shots of any subject, a scenic should be technically and aesthetically competent at the very least, but in ad-

dition, it must communicate meaning and mood.

A shot has the quality of simplicity if it seeks out and focuses on one specific element—a stream, forest, mountain range, or field of grain. In order to produce a good stock photograph of a scene that incorporates both a mountain and a stream, you must either shoot the mountain or shoot the stream. This doesn't mean that if you take a photograph of the mountain you should not include the stream, or that if you photograph the stream you should not include the mountain. But it does mean that if you produce a photograph where the stream and the mountain have equal weight, the chances are you will end up with a very weak shot.

Suppose for example, that you decide to place your emphasis on the stream because you feel it conveys a sense of purity, of cool cleanliness, of a pristine life-source, of spring. As you shoot, remember that you are primarily photographing the stream. Use the mountain as a compositional element to draw the viewer's eye to the stream. Follow the concept of simplicity and change your angles to prevent random trees from intruding on your shot. In so doing, you will be "working" the situation—experimenting, changing, deciding, remaining all the while fully aware of what your real subject is.

After you photograph the stream, there is no reason not to take a photograph of the mountain. Now, the *stream* is the secondary element. You are focusing on the mountain, and all your creative decisions should be dictated by your new subject.

Do you see what is happening here? You are giving yourself direction, you're forcing yourself to pinpoint the subject and examine the real impact of the scene, and that is the first step toward photographing it simply and effectively.

How do these factors—versatility, graphic power, and simplicity—blend and contribute to the way you handle a particular scene? First, they dictate that once you have decided the scene might sell, *you must next determine what, in fact, you're photographing.* If you conclude that "I'm taking a photo of the scene in front of me," your shot will be ambiguous, unfocused, and weak. You've got to *analyze* the scene you're looking at. Pick it apart. What are the elements: trees? streams? mountains? Which do you find most visually interesting? How can you best focus on that single element? How can you use the other elements to enhance the effect of the one you're focusing on? How does that affect your choice of

lens? Of angle? Of depth of field? What are you *saying* with the photograph? What mood are you trying to convey? Are you conveying it *clearly?* Strongly? Is there anything present that will unnecessarily restrict the uses to which the photo can be put?

All these questions, and probably many more, depending on the nature of the scene you are confronted with, should be running through your head as you prepare the shot. At first, you will need to make a conscious effort to consider all these questions, but with practice the effort will become almost second nature.

The interesting part—the part that makes photography generally so fascinating—is that what *you* see in the scene, the moods you feel are generated by the scene, may be very different from those someone else would feel. The whole process is very subjective, and your success as a photographer will depend very much upon your ability to use your camera to capture the feelings, ideas, and moods that, while generated by an objective scene, are uniquely yours.

For instance, there are innumerable ways to say "dawn" or "dusk" or "spring" or "autumn." You must find the way that is uniquely yours but that makes the statement dramatically and effectively. Clients who need to say "Fall" are not necessarily looking for the traditional golden-hued woodsy lane. A tight shot of a single leaf or an ax recently embedded in a freshly cut log might work better. Be creative; *work* with your camera. Remember that you're not just taking pretty pictures, you're trying to make a statement. The more effectively you explore each subject you choose, the more dramatic—and ultimately profitable—that statement will be.

Knowing When to Shoot

If you are going to be a successful scenic photographer, there is yet another ability you must cultivate: the ability to see a scene not only as it is but also *as it will be when the light changes.* A scene that seems flat and mundane at one time of day might leap to life at another time. It is your job to anticipate the effect of those lighting changes even before they occur. That is, as you travel, you must look not only for scenes to shoot at the moment but also for scenes that are worth waiting for or returning to—scenes that might be truly memorable under different light conditions.

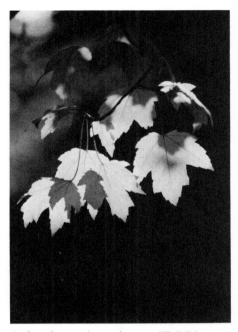

A photo buyer who needs to say "Fall," does not necessarily look for a traditional woodsy lane. This shot has been used on a record album, the cover of a real-estate brochure, by a national TV network during its weather report, and on billboards for an Ohio radio station.
Photo: James Baum

Keep in mind that, in the main, the best light for shooting scenics occurs in the early morning and late afternoon. Light at other times is harsh and contrasty. In morning and afternoon light, however, your subjects cast pleasing shadows that give definition to the landscape, and your photos pick up that golden hue that can be so appealing.

Ultimately, of course, the choice of when to shoot is a creative decision that only you can make. It is essential, however, that you make an active effort to anticipate the changes in light conditions that will contribute to successful scenics and not leave them to random chance. Remember that whereas amateurs are left to the mercy of the prevailing conditions, professionals *make* those conditions work *for them.*

How to Give Yourself a Scenic Photography Assignment

The first step to this assignment is to evaluate your already existing photography. Go to your files and pick out the ten scenics you consider your best. Study each one carefully and ask yourself what is the subject of the photograph. Answer as specifically as possible. Simply saying it's a photograph of a "scene" won't do. Is it a mountain? A stream? A leaf? A blade of grass? Analyze the photo. What is its mood? Does it carry any sense of feeling? Can you think of any product to which the photo might have an application? How? Why?

Now look at all ten photos as a group. Is there anything common to all ten? Are they all, for example, panoramas, or are there some macro-shots or detail shots? Do you favor any specific subjects? angles? lenses? Why?

The object of this exercise is to make you aware of your own sensibilities, of your own unique way of perceiving the world. Too many photographers rely solely on the opinions of others to give definition to their vision, instead of defining their vision for themselves. But if you have a keen understanding of your own preferences and areas of expertise, then you can use your knowledge to sharpen and expand your capabilities. Ask yourself what it is about these scenics that made you want to photograph them. What did they make you feel? And do your photographs succeed in conveying those feelings to others?

If you have analyzed your existing photography honestly, you should have a firm idea of where your interests lie and what directions you want your scenic photography to take.

Now you've got to give yourself a disciplined exercise in the use of the camera to illustrate ideas, make statements, and create moods.

This exercise is divided into two parts, which can be combined in the execution of your photographs. The first part consists of defining the subject, the second with making a creative statement.

1. *Defining the subject.* Your first task is to find a scene with at least three elements (a stream, a mountain, and a forest; or a field, a fence, and a barn, etc.). Now, bearing in mind the importance of simplicity and focus, take three photographs, one of each of the three elements. In other words, take three different photos of the same scene, but change the main element in each of the photographs. First concentrate on the field, then change to the barn, then to the fence. You'll find that this is not easy. You'll probably have to change angles, lenses, maybe even the time of day that you shoot. But in each case, there should be no ambiguity about which is the main element and which elements play a supporting role.

2. *Making a creative statement.* Pick any one of the words listed below and illustrate it with your scenic. If these words don't work for you, pick your own. But be disciplined. Assume you've got a job to do, and demand of yourself that you do it well.

The words are:

strength (power)
permanence
beginning (life)
ending (death)
fertility
peace (tranquillity)
change
mystery
hope
decay
summer
spring
fall
winter

Once your film has been processed, assess the results. Analyze your new shots with the same rigorous attention you gave

to the old ones. Is there improvement? More definition? Is the mood clearly and unambiguously presented? Are there any extraneous elements that dissipate the impact of the intended statement?

Show them to a friend whose judgment you respect. Ask him or her to match your shots with one of the above ten words. Was your friend right? If not, try to see what your friend saw in the photographs. This exercise will help you understand your own abilities to communicate, and you will have begun to sharpen and develop your photographic skills.

SPORTS PHOTOGRAPHY

Say "sports photographers" and people who don't know photography or photographers and their special problems envision overequipped technicians whose photographic ordnance (film packs, cameras, lenses, bags) causes them to look like Bolivian revolutionaries, and whose presence becomes most apparent when a 350-pound football behemoth steamrolls into one of them, causing camera, lenses, and assorted hardware to fly helter-skelter. Meanwhile, the photographer is deposited pancakelike on the turf, the subject of much amusement and ridicule.

Although it is possible, by a judicious selection of the sport in which one specializes, to minimize the threat of physical injury and even eliminate it altogether, the problems facing most sports photographers do not by any means end once personal safety is achieved. In fact, if you decide to shoot sports—almost any sport—as a *stock* photographer, the complexion of the problems you can expect to encounter, as well as the potential rewards you may reap, alter dramatically.

Stock Sports Photography vs. Traditional Sports Photography

There is an important difference between photographing a sport in order to *illustrate* a specific aspect of it, and *using* sports photography to communicate an idea or make a statement. Illustration is what traditional sports photographers do so well—the Neil Leifers, the *Sports Illustrated* staffers, etc. Their assignment is usually either to cover a specific event—

Photo: R. Michael Stuckey

the Super Bowl, the Millrose track games, the Stanley Cup—or an aspect of a sport, such as violence in hockey, finesse in horseracing, stamina in tennis, and so on. And the best sports photographers are truly masters at what they do. When they cover an event like the Super Bowl, they take shots that skillfully capture the essence of that particular game or sport. If one individual excelled in the game, the photographers will have it on film. Then the editors and art directors can use this material to tell a visual story about the game, race, match, or whatever.

The primary market for the traditional sports photographer is editorial: magazines and newspapers. When a publication runs a story on the Super Bowl, the editors need photos to illustrate the story, so they hire a pro. The traditional pro might also produce public-relations shots for the teams themselves or take photos for the local chamber of commerce to use in attracting visitors to the team's city or for illustrations for travel brochures advertising the various attractions of the city, including the local team. In each case, however, the photographs are intended *to represent either the team or the sport itself.*

This is also true of those "stock" sports photographers who either by choice or necessity shoot their film on a nonassignment, speculative basis. These photographers take pictures of famous sports figures and *then* try to peddle them to a *Sports Illustrated* or a *Tennis* magazine. Alternatively, these photographers might have shots left over from an assignment to which they have retained second-sale or "stock" rights, which leaves them free to sell the photos anywhere they can.

Technically, these are "stock" photographers, but since their clientele resides primarily in the editorial market, they intend their work to be a journalistic representation of a specific team, sport, competition, or event. In that sense, their basic aims and intentions are fundamentally the same as those of any traditional assignment sports photographer, and in the following discussions I will be considering them as such.

In contrast, true stock sports photographers have a vastly different clientele and consequently photographic aims that are entirely different from those of their more traditional counterparts. In general, the potential outlets of stock sports photographers, whether commercial or editorial, are much broader and more lucrative than those of the assignment pho-

tographer, because they sell their shots not to people wishing to illustrate a sport but to people wishing to illustrate an *idea.* Stock sports photographers sell to ad agencies, design studios, companies—to all those lucrative clients who buy the other types of stock photos we've already discussed. They may also find some buyers in the editorial market, but in different areas than traditional sports photographers. Thus, though the stock photographer and the traditional sports photographer might be shooting side by side, the two might just as well be in different worlds.

The following hypothetical situation illustrates the difference between stock and assignment photographers. You and I are at a track meet. You're there to cover the event for *Track and Field* magazine. I'm there to shoot stock for my files with the intention of selling them wherever I can.

Stock photographers shooting sports are after images that do more than simply illustrate the sport they're covering. This photograph, for example, can be used to convey anything from "freedom" to "flight" to "danger."
Photo: Judy Yoshioka

The one-hundred-yard dash is coming up, so we get into position. You decide to go the finish line to be ready for a shot of the winner crossing the line; I position myself at the starting blocks.

Shortly before the gun, you take a wide shot of all the contestants as they prepare for the initial sprint. You choose your angles to lend the favored runner prominence, and you take some telephoto close-ups emphasizing that runner. You then set up to capture the finish.

Meanwhile, I've been shooting close-ups of one of the runners—it really doesn't matter which one—poised for the start. I've come in with a tight shot showing only the legs, coiled and ready to spring from the starting block.

I then set my camera at a very slow shutter speed and wait for the start.

The gun sounds. I snap the shutter and, due to the slow shutter speed, I get a streaking, blurred-action effect as the runners burst from the blocks. I snap off two more quick general running shots, also blurred.

As the race ends, you grab a shot of the finish. The favorite has won. The crowd is going crazy, and while you're frantically chasing after the winner to make sure you get some victory shots in case your editor wants them, I'm very unobtrusively taking generic shots of the cheering crowd.

Now, let's compare your photos with mine.

Your shots portray a particular runner in a particular race at a particular meet. And, you have the potential to sell your shots to anyone wishing to depict that racer or that race or that meet. In other words, depending on the importance and status of the meet, your potential clients probably number somewhere between zero and five. Also, since interest in all but the most significant sporting events tends to be fleeting, if you don't sell your photos quickly, their value diminishes, until they are soon of interest only to the occasional sports historian.

Now, let's look at my shots. Remember when you went to the finish line and I went to the starting gate? There was a reason for my choice. Whereas it's true that the climactic moment of most races is usually the finish, the fact is that as a stock photographer I'm not interested in *this particular race*. Rather, I'm concerned with how I can *use* the race to make general photographic statements.

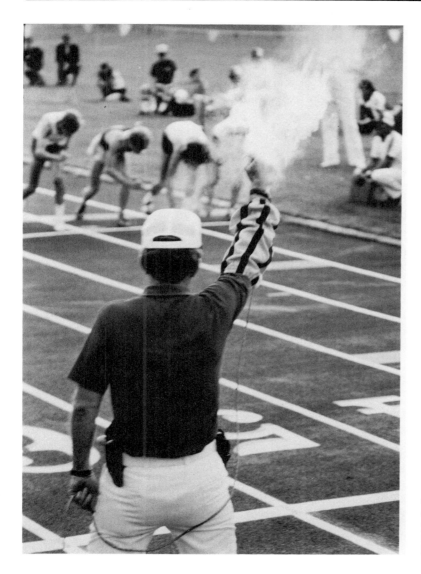

Many buyers who have no connection to the world of sports have a need to visually communicate such ideas as "get off to a fast start" or "get a jump on the competition." A shot like this can be used in any of a thousand ways.
Photo: R. Michael Stuckey

For example, I know that many advertisers who have no connection with the world of sports have a frequent need to visually communicate such ideas as "get off to a fast start" and "get a jump on the competition." What sorts of clients need to say these kinds of things? Here are a few actual examples from my own experience:

- A car-battery manufacturer.
- A manufacturing company with a profit-sharing plan that

was producing an in-plant poster to impress on its personnel the importance of getting off to a fast and efficient start each day.

A magazine making a pitch to potential advertisers. The magazine was promoting the idea that this year, in its race against its competitors for increased circulation, it was off to the fastest start and by year's end intended to be number one.

None of these uses was directly related to sports, yet the track-racing theme lent itself well to each. And in each sale, the photographer received much more for the photo than he or she could possibly have expected for a strictly editorial usage. Most important, these clients are representative of the virtually limitless market that exists for good stock photos of sports subjects—a market you too can tap, once you stop taking only those photographs that make statements about sports itself, and begin taking sports photographs that make statements about life.

To be a successful stock sports photographer, it is essential that you learn to view the world of sports and athletic competition in a larger context than you have in the past—for instance, that you see more in a football game than a struggle for yardage waged by twenty-two men tossing a ball around. Once you begin to think of the game in wider contexts, you will begin to *see* the game differently and therefore *photograph* it differently.

To help yourself develop a broader outlook on sports, try to think about the essential qualities of different events. Competitive swimming, for example, plays a visual melody quite different from, say, wrestling. What are the differences between the sports, and how can you use your camera to capture the essential elements of each sport and to make statements that go beyond the individual sports themselves? What are the similarities between such seemingly diverse sports as swimming and wrestling? Similarities do exist, and if you discover them you'll learn what the sports you're photographing have to say about even such lofty topics as the nature of the human condition.

One of the reasons sports have been such an important and popular element in almost every culture throughout history has to do with the nature of athletic competition and the fact that it relates to one of the most fundamental human charac-

teristics and impulses. As a result, the world of sports is an incredibly fertile arena for creative photographic expression. Discipline yourself to look beneath the surface; cultivate an ability to identify the essential elements, and then photograph them and use them as visual building blocks that relate to and depend on one another. Whether you're photographing a track meet, a baseball game, or a rodeo, try to use the event to make a statement that has nothing at all to do with the event itself but with a broader concept like "truth" or "humanity." If you can succeed at this task, you're already well on the road to becoming a successful stock photographer.

Before you go to photograph your next sporting event, take a look at the section "How to Give Yourself a Sports Photography Assignment." It will help you define your objectives and guide you toward better sports photography—of any kind.

But before you attempt to *sell* any of your work, be sure to read the following section. Ignorance of some of the legal ramifications mentioned below can spell disaster.

Special Problems in Shooting Sports

The section later in this chapter on shooting with models deals with model releases—what they are and when you need them. Photographers should never even *think* about selling their shots for *anything* until they have a basic understanding of the right-of-privacy laws involved and the possible consequences of ignoring those laws.

Nowhere is the danger greater or the water murkier than in the area of sports photography. Here are some guidelines:

Generally, photographs of sports figures and sporting events which are used for editorial purposes, that is, to illustrate an article or news story, where sports figures are in a public arena fully aware that they are open to public scrutiny, may be published without fear of a lawsuit for invasion of privacy or for unauthorized use of a person's image for commercial purposes. This means that if you take photographs of a local high school football game and then sell them to the town paper doing a story on the game, that's okay. Then, if *Sports Illustrated* wants to do an article on your local star quarterback, that's okay, too.

But photographs of sports figures may *not* be used *for com-*

mercial purposes, that is, to promote, sell, or endorse a product or service—at least not without the individual's permission. And in the case of professional athletes, that permission usually costs money—lots of it. That's one of the main reasons the law exists in the first place. These people don't want anyone profiting from their carefully cultivated, valuable images unless they have received money for the privilege. In other words, the photo you took of the local high school star quarterback that was okay to sell to the local paper and to *Sports Illustrated* would *not* be okay to sell to the local tire dealer for an ad to attract new customers. In this case, you would be unfairly using the local star to promote a product the quarterback might well not want to promote, at least not without being paid for doing so. In the first instance the use was *editorial*, in the latter instance it was *commercial.*

All this means that to protect yourself you must do one of three things: (1) Arrange to get a model release. (2) Compose the photo in such a way that while you use the sport to make visual statements you avoid focusing on any individual or team. (3) Use technical tricks to make sure no team or individual is recognizable. Let's take a look at some examples:

1. With a little ingenuity it is often possible to find sports figures who are willing to give you a release. This is rarely the case with established professionals, but since as a photographer you'll be more interested in making generic statements than in depicting a specific individual, it really doesn't matter if your subject is one or two rungs down the ladder. For example, let's suppose you've decided to use the sport of weight lifting to make some visual statements about strength or power or discipline or determination or whatever. If you go to the U.S. national champion and request permission to shoot photos and then sell them, you'll probably be told to get lost, unless you're willing to pay a substantial amount of money.

However, if you're creative, chances are you can locate a local weight-lifting enthusiast, or perhaps a college competitor, who will serve your purpose just as well. And, if you approach such persons and propose giving them photographs of themselves in exchange for model releases, they will often be eager to accept. Naturally, in this case (just as in all cases requiring a model release) you have both an ethical and a legal obligation to let the person know exactly what you're doing—that you're attempting to produce photographs that you will then

sell and that he or she will receive no compensation other than the photographs.

Another arrangement might be for you to offer to let your model share in the revenues you receive for the sale of the photos. The most common arrangement in such cases is a percentage split, the amount going to the model being determined by such considerations as the availability of similar models and how much the model is in demand.

Once again, it is important to be straightforward and honest and above all to *get the release in writing.* (See pages 122–123 for a sample model release.)

2. You can solve model-release problems by composing your shots so that they do not include recognizable individuals. The best way to do this is to focus on small details that illustrate the idea you're trying to convey rather than try to create the whole picture with a broad brush—for example, a shot that focuses in on the hands of a football center tensed to hike the ball. The photo shows nothing but the center's hands and the ball, but the tattered, blood-speckled bandages on the hands tell a much larger story and carry the kind of graphic impact that a photo buyer will look for. At the same time, since the hands are not identifiable and no faces or uniforms appear, you will not be in danger of infringing on anyone's right of privacy and are free to sell the shot. (If, however, the center is wearing a one-of-a-kind family heirloom ring that is clearly identifiable in the shot, it's conceivable that the player could sue you if you didn't first obtain a release. When in doubt, get the release.)

Other examples of using small details to tell a larger story: a shot of a soccer player from knee to toe at the moment of impact with the ball; an extremely tight shot of a thoroughbred's flank, glistening with sweat, with just a hint of a rich leather saddle and the jockey's bright silks; a tennis ball leaving the server's fingertips on the service toss with the racquet head poised to strike. Every sport has such small details that can be used—free of model-release problems—to tell a story. It's your job as a photographer to find those details and capture them in interesting and exciting ways.

3. Finally, you can use technical "tricks"—such as blurred action and selective focus—to make sure no team or individual is recognizable. Both these techniques, when used properly, will not only avoid model-release problems but can also help you to take exceptionally exciting sports photographs.

Focusing on the smaller details of a sport can often result in graphically powerful images that avoid model-release problems.
Photo: R. Michael Stuckey

Blurred action and zoom techniques are also extremely effective methods of creating powerful sports shots. By using these techniques, you can sometimes avoid the need for model releases.
Photos: H. Scanlon

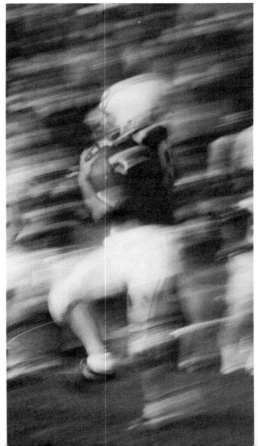

Blurred action requires a great deal of experimentation to perfect but is extremely effective when mastered. Simply stated, it is a technique whereby, through the use of a purposefully long shutter speed, the subject seems to blur and streak across the frame. Used in conjunction with panning or zooming, any number of startling effects can occur. And as mentioned, an additional benefit to sports photographers is that often the subjects become unrecognizable and the photographs can therefore be sold to the commercial market. But be careful. The subject must be totally unrecognizable or you must get a release. Not sure? Get a release.

The other method, *selective focus,* is a technique that you're probably familiar with. By limiting the depth of field to throw the subjects far enough out of focus to be unrecogniz-

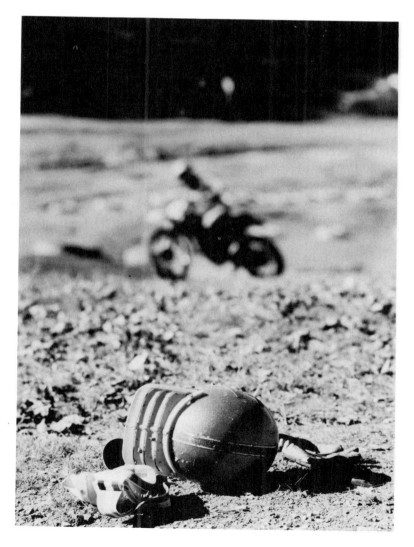

Learn how to apply selective focus to your sports photography. It can be a valuable tool in your repertoire.
Photo: H. Scanlon

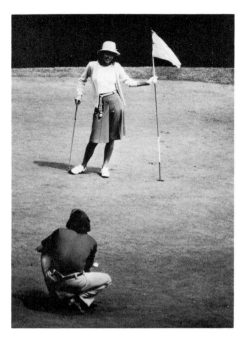

Don't overlook the recreational sports that hobbyists take advantage of. There is a large market for these lifestyle oriented subjects. Photo: F. Willems

able, and then placing a small detail of some related subject into the area of critical focus, a general view of the sport can be given without incurring model-release problems. Examples of this technique include a pool player, shot from table level looking across the felt as the player lines up the shot, focused on the tip of the cue with an extremely shallow depth of field, throwing the shooter unrecognizably out of focus; or a shot of motocross equipment which captures the essentials of the sport while the out-of-focus rider speeds by in the rear.

Remember, you cannot sell photographs of identifiable people for commercial purposes without a release, so your choices are to either obtain a release or use a photographic technique that makes a release unnecessary.

Noncompetitive, Recreational Sports

One area of sports photography that, while often overlooked, is nevertheless a fertile territory for stock photographers is recreational sports: skiing, boating, golf, tennis, swimming, hiking, backpacking, mountain climbing, etc. Often, you can photograph these sports using friends as models. And, if marketed properly, your photographs can open up substantial new areas of profitability.

Clients usually seek shots of recreational sports for one of three purposes:

- To use the subject to make a broad statement. A mountain climber, for example, can be used to convey the concept of "danger."
- To illustrate aspects of a *life-style*. For example, they may want to promote a product for the rugged, outdoorsy type so they'll look for a series of shots that exemplifies the kinds of activities their man or woman customer will respond to.
- To show the attractions a specific location has to offer. Condominium builders in New England or Colorado, for example, may want photographs to illustrate skiing in the winter and hiking in the summer for their selling brochures, ads, etc. Or travel agents might be promoting special low-fare trips to an area with sailing, swimming, golf, horseback riding, etc. They'll need photos of all those activities.

For greatest success in shooting recreational sports, it's important to keep these three different types of usages in mind

and, when shooting, to get shots that will satisfy the needs of all three.

How to Give Yourself a Sports Photography Assignment

This is an easy task. All you must do is use your photograph of the sport—any sport—to convey something beyond just that sport. Below is a list of ten words. The next time you go out to shoot the sport of your choice, try to illustrate as many of the ten words as you can.

strength
pain
fear
energy
speed
grace
stamina
determination
joy
brotherhood

One of the challenges of sports photography is that so much can happen so fast that speed and an ability to spot immediately a rewarding development are the key ingredients for success. Make yourself work hard. If you have to, say the words over and over as you scan the action for situations or details that will illustrate them. After a while, you'll find you will automatically start seeing things differently—more analytically and with more insight. If any of the ten words don't work for you, substitute others of your choice. But be disciplined; your assignment is to illustrate the ideas. Make yourself do it.

When your film is developed, take each photograph and decide which of the ten words it illustrates. If it illustrates none of the ten or several of the ten, it probably doesn't "work." A successful photo, on the other hand, will clearly and immediately illustrate the concept you are trying to convey. Some shots may effectively illustrate two ideas, or even three—but certainly no more than that. If you think the shot illustrates more than two or three of the concepts, your analysis is probably wrong—the photograph is very likely confused, and in-

stead of capturing several ideas at once, chances are it captures none.

Once you have your shots separated into piles, take a look at the size of the stacks; you'll learn something about the sport and something about yourself. Carry that information in your head the next time you shoot.

ANIMAL PHOTOGRAPHY

With a little creativity and determination, photographing animals can be both aesthetically and financially rewarding. But it's important at the outset to make a distinction between photographing domestic animals and photographing wildlife. Although there is a certain amount of overlap between the two, there are also significant differences in approach that you should be aware of.

The Market for Animal Photography

Let's take a look at the area of pets and domestic animals. Can you actually make money taking shots of Rover? The answer is, yes . . . depending—depending on Rover (let's face it, some animals, like some people, are more photogenic than others) and depending on how much effort you're willing to expend.

There are really two primary markets for photographs of domestic animals: manufacturers who use the photo as part of a consumer product (greeting cards, calendars, posters, jigsaw puzzles, etc.) and firms that use the photographs for promotion purposes in ads, displays, and the like.

The greeting card, calendar, jigsaw puzzle, and similar companies have a truly voracious appetite for animal photos, especially—but not exclusively—for what I call the "cutesy-pie" type of shot. The easiest way for you to develop a feel for what these companies look for is simply to scout the retail stores to see what they are producing. You will quickly recognize some patterns.

Suppose you were to study the greeting card industry, for example. You would realize right away that there are a number of logical animal tie-ins to various holidays—bunnies and baby chicks at Easter time, deer at Christmas, etc. And you would notice that, unlike jigsaw puzzles, on greeting cards

Photo: A. J. Hartman

room must be left in the photo for the addition of type ("Happy Easter," "Best Wishes," "To Dad on Father's Day"). So, in anticipation of these usages, as you are shooting you must compose so as to produce some shots suitable for adding type, as well as shots that can stand on their own without type. (See above for a discussion of how to compose your photos to leave room for type.) A myriad of such observations can be made on each industry, and since market tastes and styles are constantly changing, you need to continue your research indefinitely if you decide to pursue this market.

If you like animals, have incredible patience, and can handle situations where your subject's disposition can range from hostile to comatose, you may find that greeting card, calendar, and jigsaw puzzle companies are a ready market for your work.
Photo: R. Michael Stuckey

Once you have thoroughly studied the existing market, you will no doubt realize that no matter what you or I happen to think about it, "cute" definitely sells. Nonetheless, keep in mind that "cute" isn't necessarily "best." For some reason, people who shoot photos of animals are in at least one respect identical to those who shoot pictures of children. They adhere unflaggingly to the concept of "cute," to the seeming exclusion of all else.

Don't get me wrong. I like droopy-eyed beagles and fluffy ducklings as well as the next person. It's just that many people think the *only* purpose photographs of animals and children serve is to make people, well, coo . . . Certainly there are photographers who have made successful careers from shooting cutesy-pie animals for the above-mentioned clientele. And certainly the market is very large. But before you rush out to compete for a spot in that market, be sure to consider some of the following drawbacks.

"Cute" definitely sells, but the market for cute animals tends to be fickle. One day every company is looking for photos of hamsters or koala bears or pandas, and the next day you can't give photos of these subjects away.
Photo: A. J. Hartman

Drawbacks to Commercial Animal Photography

First of all, the market is very competitive and fickle. As a result, to make any real money in this market you're going to have to shoot a lot of film. For one thing, those good shots you already have in your files will be snapped up quickly. Moreover, in order to sell a particular shot, you have to give the buyer exclusivity for that photograph—that is, you have to agree not to sell it or any similar shot to a competitor. So by selling to a greeting card company, for example, you eliminate all potential sales of that photo to other card companies, as well as to poster, calendar, and puzzle companies. Therefore, since these are virtually the *only* markets that use this sort of shot in any quantity, your files can become exhausted quickly. And to complicate matters further, the calendar/poster business is extremely unpredictable. One day every company in the country will be looking for photos of hamsters (or koala bears or pandas), and the next day you can't give photos of those subjects away.

In addition, since there are so many photographers out there shooting animals and actively vying for the sales, the companies are usually able to negotiate relatively low rates for the use of the material worldwide. In the final analysis, if you decide to tackle this market you've got to expect to shoot

a lot of film, much of which will never sell to this market and for which no other substantial market exists. Nonetheless, as mentioned, some photographers do very well, and if your bent is toward animals, you too might find your niche.

A second drawback is that once you've exhausted all possibilities with Rover, Tabby, your parakeet, goldfish, and gerbils, you're going to need to find other subjects outside your own immediate family. The next logical step is to turn to neighbors and friends. Often they will be flattered that you're interested in photographing their pets and will be more than happy to let you do so. (As always, you will have to be very straightforward with them as to what you're doing, so as to make sure they understand that you will be attempting to sell the shots you take. And to be safe, obtain model releases from the pets' owners.)

Eventually, you will exhaust even these resources, and you'll then need to begin to cultivate a continuing supply from strangers. To accomplish this, you will need to employ one or more of the following techniques used by most successful animal photographers:

1. Get to know the people at the local pound and humane society, and make periodic visits to scout out promising subjects. (You will find that the personnel are likely to be friendly and helpful and will make an effort to get in touch with you if a particularly photogenic specimen arrives.) Since photographs of their candidates for adoption help them find homes, the humane societies are often eager to have their animals used as models in exchange for photographs.

2. In rural areas, get to know local farmers who will give you access to their livestock and alert you to new births. Often even urban areas have "animal farms" for young people, and these places can be a source of subjects. In both these cases, you can often have complete access for a small fee or in exchange for pictures.

3. Scan the newspapers for classified ads placed by people selling new pups, kittens, or anything else. Contact these people and arrange to take pictures, once again for either a small fee or for prints.

In short, animal photographers, like photographers in most other specialized areas, need to cultivate a thorough knowledge of the resources available to them, and then to remain constantly alert for new sources. As in so many other areas of

photography, the actual taking of the picture can be the least demanding part of it all.

A third drawback (but one that is becoming less of a handicap) is that photo buyers in this market still prefer large-format (4 inches x 5 inches or 8 inches x 10 inches) film. As mentioned in chapter 2, although the number of photo buyers who will accept *nothing* but 4″ x 5″ transparencies and larger is rapidly dwindling, the fact remains that the poster and card industries have special demands that cause them to *prefer* the larger format. On the other hand, I sell photos in 35mm to these people all the time, as do many other stock photo agencies. Still, I know that if a card company is trying to choose between my photographer's shot and someone else's, and if mine is on 35mm and the other's is on 8″ x 10″ and all else is equal—they'll buy the large-format photo. Does this mean that you should run out and buy large-format gear if you want to photograph pets? Not necessarily, since it is true that while the other photographer is spending two hours producing one 8″ x 10″ shot, you can be spending the same time producing hundreds of shots on 35mm. So while that photographer may get that one sale, you can be ahead in the long run with volume. Nonetheless, the fact remains that you will be losing some sales if you are not shooting large-format.

Getting a Start

There is no question that there are photographers who earn a handsome living from shooting cutesy-pie animals for the above-mentioned clientele. If you like animals, have a great deal of patience, can handle situations where your subject's disposition can range from hyperkinetic to hostile to comatose, and if the drawbacks don't bother you, then you may well find that this is the area for you.

Suppose you do decide to take a shot at this market. How do you begin? First, as mentioned, you must do your homework and develop a real feel for what the current retail market is producing.

Bear in mind that it's tough to break into the animal market if Rover is the only thing you shoot, but shooting Rover isn't a bad place to start, and once you understand the principles you can move on to subjects from other sources. Use your shots of Rover to compile a small "portfolio" to take with

you—it will help establish your credentials with the owners of pets you would like to photograph. Merely stating that you're a photographer and that you will take high-quality pictures of the people's pets can often be greeted with a large dose of skepticism. But if you show them impressive samples of your work, they're much more likely to be willing to let you shoot for no cost. To this end, take care not only to have a portfolio to show them but to make sure it's a good one.

This is not the place to go into all the little tricks the masters of the trade use to get pets to come across with all those goofy grins and heart-rending expressions so popular among the buyers. Suffice it to say that if you're interested in photographing pets you'll have to search the libraries for whatever information exists in books and back issues of magazines. For the most part, skill in this area really boils down to your own personality, plenty of patience, and the experience that comes only with shooting as much and as often as you can.

Using Animals to Explore Ideas

What alternative is there to "cutesy-pie" animal photos? Is it possible to open up the markets of design, ads, and brochures—that sprawling market of general commercial photography? The answer is yes. And if you broaden your objectives and set goals that are a little more demanding than putting a straw hat on a burro and shooting away, you may find that animal photography can be a challenging means of photographic expression and a truly rewarding aspect of your work. Like the other subjects we're discussing—sports, children, scenics, etc.—the world of domestic animals can offer an endless source of opportunities for you to exercise your creative sensibilities, in addition, of course, to providing you with another avenue of earning your living through photography.

As always, the key to commercial success in animal photography is to use your subject to make statements that are not *limited* to that subject. Consider horses, for example. With its grace, fluidity, power, and speed, the horse can be used to embody any number of concepts and emotions, such as strength, speed, freedom, etc. and throughout the ages the horse has been a subject for artists of every type. Your job as a photographer is to capture some of these concepts and emotions with your camera, to get beyond the mere physical aspects of your

subject and use your subject to express a more universal idea or feeling.

Take a look, for example, at the shot above of the mare and her foal. Like most good stock photos, it is basically simple, but upon examination it reveals a powerful ability to convey a mood. What might have been an unremarkable scene of an equine idyll becomes, instead, much more. Notice the way the foal seems to be looking off into the distance, curious, eager, but still too timid to stray very far from its mother who is routinely going about the business of the day's foraging. We know something about the way the foal *feels*, and that in turn is a message that goes far beyond this particular scene or even horses in general. No, this photograph is not one that is likely to be enshrined as one of the all-time masterpieces of the photo world. But it is a good stock photograph, it does convey meaning and mood. It stands as an example of a photographer doing a job professionally and with style.

Of course, what can be done easily with a horse becomes considerably more difficult with a gerbil. But even with house pets there are areas you can explore. Instead of snapping Rover looking at the camera with his tongue hanging out, try to

peer inside his head. Rover has feelings, and he probably has some very primal instincts that will manifest themselves in both behavior and expression. What are they? How can you capture them? If you've ever seen the eyes of a well-bred retriever sensing an impending hunt, as in the photo at left, you know that even dogs have a fundamental, instinctive passion that is not too different from the corresponding human emotion. A discerning photographer will recognize such passion and capture it. And if you do so effectively and often, in addition to personal satisfaction you will have produced material with market value.

The Trick to Shooting Wildlife

Many books and articles have been written on this subject, and if you've read any of them you know that shooting wildlife demands extreme patience, cleverness, and dedication. If you possess those qualities and hope to shoot wildlife, I wish you good hunting.

Even though I don't know much about the technical aspects of shooting wildlife photographs, I do know something about selling them, and I have found there is one pitfall that almost all amateurs and many professionals fall into. It is a mistake that is understandably easy to make and one that reduces what might have been truly exceptional photographs to mediocre or even worthless ones.

Here's a typical scenario: You know that a certain stream deep in the woods occasionally serves as a drinking spot for wild deer. So you hike ten miles through the forest, camp overnight, get up before dawn to set up your cameras in a blind that you make from fallen timber. You shiver in the cold for hour after hour until . . . finally, . . . there he is, a magnificent buck. You grab your camera with the 500mm telephoto lens, aim, focus, snap. You've got one shot, maybe two—and the buck is gone.

But you're happy. Two shots is all you can reasonably expect—and you got them.

Which is true. When you have your film developed, there they are, two fine shots of a splendid buck, from shoulder to antler tips. The 500mm lens brought you practically on top of him, and there he is, sharp, clear, big as life.

The problem is that you could have gotten almost exactly

the same shot at just about any zoo or wildlife preserve in America.

The biggest mistake you can make in shooting wildlife is *always to reach for your extreme telephoto*. The 500mm lens in these shots brought you *too* close; the photograph has no sense of place. The background is out of focus, there's no foreground, all there is is the deer—albeit a magnificent one—but nothing else.

If you want to take a truly marketable photograph, the subject must be *integrated with the environment*. If the buck had been seen in the midst of a pristine forest with his image reflected in the morning light on the rushing stream, if you had captured a real feeling for the locale—you would have produced a unique photograph whose rarity would have catapulted it far in front of all those telephoto shots the other photog-

When shooting wildlife, it is very important to integrate the animal with its environment. Otherwise, the shot might just as well have been taken at a zoo.
Photo: A. J. Hartman

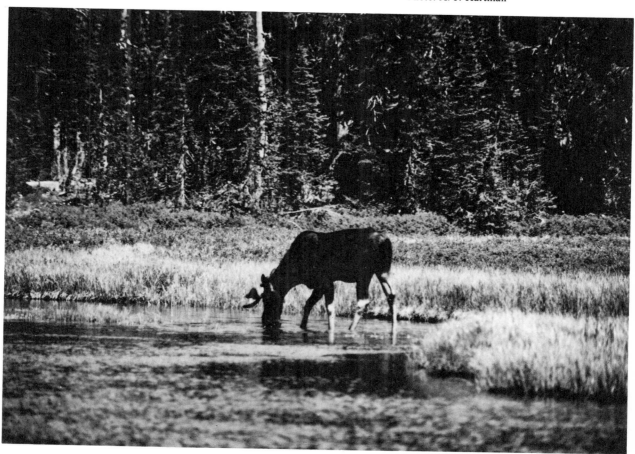

raphers have that show the subject but which could have been taken anywhere. A tight telephoto shot of an animal can rarely be used to convey anything more than the physical image of that animal. An encyclopedia, for example, might use the shot if all it wanted to do was show its readers what a buck looked like. They wouldn't care if the photograph had been taken in the Canadian wilds or at the Bronx Zoo. A shot with the animal integrated in its environment, on the other hand, such as the one on p. 91, goes beyond presenting just the animal and addresses itself to a much wider realm of abstract concepts: serenity, grace, nature, environment, and so on. Illustrate these concepts, and suddenly you've transformed the commonplace into a very marketable photograph. And don't forget, even gerbils have environments!

How to Give Yourself an Assignment Shooting Animals

We've discussed two different types of animal photography: domestic cutesy-pie and serious wildlife. I'm not going to tell you how to give yourself an assignment shooting the former type of photograph for two reasons: First, the area is so specialized that there's not much I can tell you, and, second, if that's what you're interested in you've already discovered that you've got to be part animal trainer and part masochist, so all I can say is you're on your own in a very tough market.

As for serious domestic animal shots and wildlife, since they're really quite different, I've broken the assignment into two sections.

1. *Domestic animals.* Once again, I'll list ten words. Pick one or perhaps two, and try to illustrate them with your subject. Show your film to a friend, and ask him or her to determine which of the ten words you were trying to illustrate with the shot. Whether the guesses are right or wrong, if you listen carefully to what is said and study your film, you'll begin to discover your own special eye. If none of these words stirs your interest, think up some of your own.

The ten words are:

loyalty
innocence
grace

primeval
industriousness
instinct
speed
aggression
fear
joy

2. *Wildlife.* Since, as described above, a good wildlife shot will often be a good scenic, this assignment combines both. And since a good wildlife photographer needs a good deal of patience, it's likely that this exercise might take you some time.

The first step is to take a trip to the woods and look for scenics. Bear in mind that a good scenic isn't necessarily a sweeping panorama or a swirling stream. It can be a small nook where there is an interesting play of fallen trees, or a tiny opening in an otherwise dense forest. Photograph a scene in two ways. First, photograph it simply as the scene itself. Try to make it an interesting photograph. Second, imagine there is a deer or a raccoon or a chipmunk—whatever you decide. Let your imagination run, and rephotograph the same scene. Decide where the animal might be and compose accordingly. Yes, it's true that if there really were an animal in the scene you would probably only have a fraction of a second to shoot, but give yourself some time; practicing now will give you speed when you need it.

Now look at the film you shot. How does the scenic work? Are you satisfied that it is composed well, that it has a mood? What about when you imagined an animal in the shot—would that have worked?

The next step is, of course, to go out and try to capture some shots of wild animals. Obviously, it is a rare animal that will be so cooperative as to step directly into a scene you have prechosen, so a certain amount of luck and patience are necessary. But once you have your subject, *remember the scene.* Even as you're walking or waiting you should constantly be examining your surroundings, almost like a driver checking the rearview mirror. Like the driver, you need to be constantly aware of what's going on around you, so that in the instant you have to react you will react in the best way.

When you have your film, again, examine it not just for how well it depicts the animal but also for its overall quality

as a photograph, one element of which is an animal. What is the mood of the animal? What is the mood of the scene? If either one is not clearly evident, the shot is not as good as it could have been.

PHOTOGRAPHING CHILDREN

The next time you take your child out to the backyard to snap a few photos for the family album, bear in mind that there are photographers who make a very handsome living by taking shots exclusively of children. What sets these photographers apart from the crowd? The difference is that they don't limit themselves to "Junior," they don't limit themselves to album snaps, and they don't limit themselves to the backyard.

Making a Statement, Not Just a Likeness

As discussed in chapter 2, if you're going to be successful as a professional you've got to use your subject—in this case a child—to make not just a record of what is in front of the camera but also a visual *statement*. A typical amateur's photograph ends up saying "Here's what Johnny looks like." As a professional, you must aspire to more than that—a lot more. In short, the most important idea to keep in mind when you photograph a child is to show not what the child *looks* like but rather what he or she is *thinking* and *feeling*.

Unlike shooting scenics or animals, in photographing children this task is made easier by the very nature of childhood, since children—all children—are the repositories of unbridled, constantly changing imaginings and fantasies. And from the resulting kaleidoscope of emotions springs an almost limitless array of potential photo statements for you to draw on.

Take, for example, the shot at right of the little boy watering a young sapling. The boy's name is Christopher, and I happen to know that this is one of his mother's favorite shots. If you ask her why, she'll say that even though she has hundreds of photos of Christopher, this one seems to capture what he's really like: curious, inventive, vivacious.

The reasons Christopher's mother finds this photo so appealing are precisely the same reasons an art director or photo buyer would—it's not simply showing Christopher, it's con-

Photo: Tom Grill

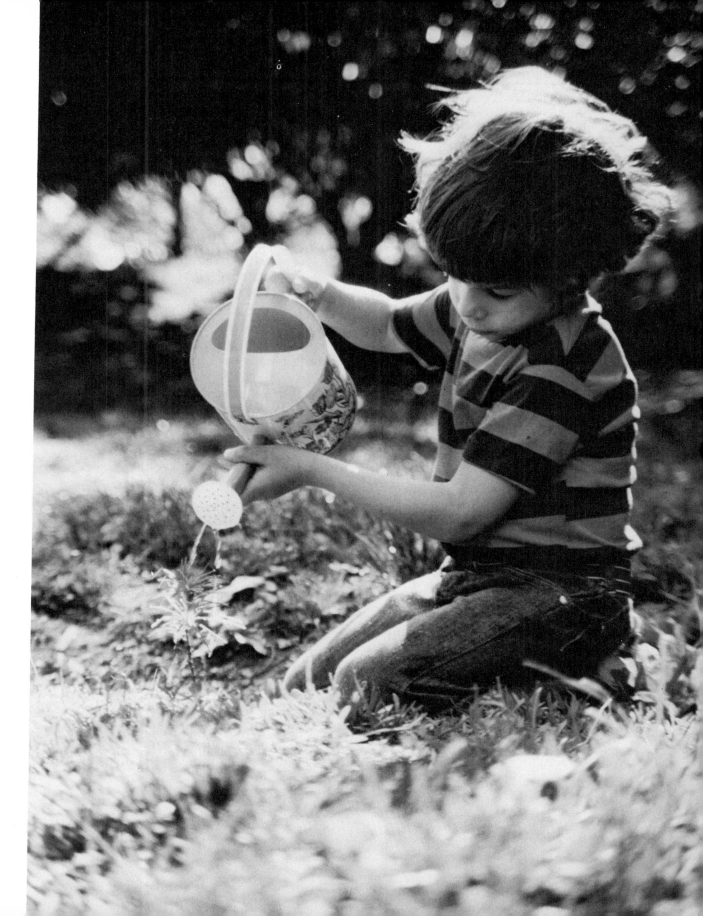

veying *what Christopher is like.* And more, it's graphically telling a story.

Suppose, for example, you were the art director in charge of designing an annual report for a paper manufacturer. Along with all the facts about profits and growth, you want to convey the idea that your company is also concerned with the long-term effects of expansion and investments. You want to say, "Look, we're making a profit by cutting down trees and making paper, but we're also taking steps to ensure that twenty years from now we will still have trees to harvest and forests for recreation—so we're planting new trees every day." If you visualize the photo of Christopher in that annual report, you'll see how quickly and effectively the photo gets this point across. It's a pleasing image—and an effective one.

On the other hand, suppose you're an art director for a magazine devoted to child care. Let's further suppose that a leading child psychologist has written an article contending that many parents expect their children to be too grown-up, too soon. Your magazine is going to publish the article, and you need a photo illustration to go along with it. You want to say visually that a child needs to be nourished and tended to if he or she is to flourish and grow strong. Again, the photo of Christopher does the job nicely.

Or suppose you manufacture water purifiers and are designing a magazine ad to sell your product. Think of all the headlines you could use with this photo . . .

The principle is clear: The saleability of your photograph is directly proportional to the number of different ideas it can convey, the power and impact with which those ideas are conveyed and the demand in the marketplace for those ideas.

What are the potential sales for a well-executed photo of a child? Let's take another example—the shot on the cover of this book of the little girl with the balloon running across the field. The little girl is not unlike a million others, in a park not unlike a thousand others, wearing a simple dress, with a single unremarkable balloon trailing behind her as she runs. It appears to be a fairly standard snapshot that could have been taken by any loving parent watching a daughter at play.

Now, let's look at some of the ways this shot has actually been used. As of this writing it has been purchased by *eighteen* different photo buyers. Some of the uses:

This photograph has been sold eighteen times. The reason? It successfully captures the carefree innocence of childhood, and many buyers can make good use of its mood and message.
Photo: Tom Grill

- In a catalog of audiovisual aids
- On the cover of the Tournament of Roses brochure
- On a paint can label
- In a building contractor's self-promotional brochure
- On a credit union information brochure
- In a toy display
- On an air conditioner manufacturer's sales sheet
- For wall decor in a condominium sales office
- In a store display for back-to-school supplies
- In a hospital brochure
- On the cover of a Savings and Loan Association's quarterly magazine
- As part of an ad for the March of Dimes

Total revenues so far on this one shot: $3,710.

Some of these commercial applications might at first seem odd to you, so let's examine the reasons this photo was selected by so many clients.

Take the hospital brochure, for example. The creators of

the brochure were making the point to family breadwinners that, should illness strike, one of their most pressing and immediate concerns would be for the welfare of their children. This photo was used to bring emotional impact to that point.

Consider the air conditioner manufacturer's brochure. In that case the art director took advantage of the cool, breezy feel of the shot to exemplify the capabilities of his product.

Or the Tournament of Roses brochure. There's not a single rose to be found anywhere in this photo. Nonetheless, the Tournament Committee wanted to illustrate the more fundamental and long-lasting aspects of the Tournament philosophy and felt that the youthful exuberance and vitality of the little girl articulated the ideals they sought to express.

Or the condominium sales office. The sales agent knew that a primary concern of prospective buyers would be whether or not the environment of the condominium complex was conducive to the happiness and contentment of their children. This photo clarifies that concern in an instant, saving a salesperson endless hours of verbal convincing.

Or the Savings and Loan Association brochure. The bank wanted to remind its depositors that the time to start saving for their children's education is when their children are young. This photo effectively contrasted the carefree aspect of being young with the reality of the rigorous financial demands of providing a college education.

And what about the paint can labels? The company had a lower-priced "everyday" exterior paint and wanted a green label that would present an easygoing outdoor scene. They liked the overall flavor of the photo, and the color was right, so they bought it.

In short, here we have what appears to be a wholly undistinguished snapshot; the subject matter is commonplace and the composition is conventional. Visually, it can best be described as "uncluttered." And yet this simple photograph has earned nearly $4,000. Why?

The answer, of course, is that although the photo *appears* simple, it is so not by accident but by design. Like many successful stock photos, despite its seeming simplicity it is the result of careful planning and imaginative execution by the photographer who took it. This photographer felt certain that he would have in his hands a good, marketable photograph if he could produce a shot that would convey the carefree innocence of a little girl. Nothing more than that—but nothing

less, either. He also felt that if the shot was to be successful he should not rely on extraneous props or gimmicks. If possible, he wanted to get his idea across with nothing more than the child herself and a complementary location.

He decided on a woodsy scene, to augment the feeling of pristine innocence, and he had the little girl wear a typical playdress, one that would not distract the observer from the personality of the child herself.

The photographer shot from various distances as he had the child try a number of poses standing and sitting. All these variations had some appeal, but none seemed to project instantly the feeling the photographer was after. They were either too demure, too forced, too stagey, or the child was too self-consciously aware of the camera.

Finally, in an effort to get the little girl to loosen up, the photographer asked her to skip away from the camera and then back. Indeed, the little girl began to become much more relaxed, but again, with the little girl running directly at or away from the camera, the shot—while greatly improved—still seemed a little forced; the camera intruded a little too much.

Then, the photographer noticed that when the little girl was in a certain spot on one of the gentle rises the backlight that fell on her produced a pleasing rim-light that silhouetted her nicely against some darkened trees in the distance. So he asked her to run back and forth across the rise. No longer particularly aware of her relationship to the camera, the little girl began to genuinely play. Now, she was simply a little girl having fun in the park. And the shot looked good.

But there was still a slight problem, one obstacle that prevented the shot from conveying to the viewer *only* the idea of total, playful abandon.

To appreciate the problem, imagine the shot *without the balloon.* Without the balloon, the viewer wonders where the little girl is running *to* or *from. With* the balloon, the viewer feels instantly that the child isn't running to or from anything—she's just running, for the sheer joy of it. With the addition of the balloon, the photograph expresses graphically the wonderful qualities we associate with childhood. Moreover, the photograph makes a universal statement uncluttered by even one unnecessary element. *That* is its power, and *that* is its appeal.

In addition, the composition of the photograph, though or-

dinary, is noteworthy in one sense: The photographer composed the shot so that it could be used in a variety of different ways. There are at least four areas in the photo that can accommodate type, and the photo can be cropped a dozen different ways to fit into a layout (see chapter 2). A good marketable stock photograph, as this one surely is, will make its statement cleanly, immediately and with force and will be uncluttered by extraneous, nonessential elements because ambiguity in a stock photograph dilutes impact.

Throughout this section, I've stressed the idea that a successful stock photo of a child is one that makes a broad, universal statement about *all* children (or at least *many* children). However, in all the examples presented, the "universal" statements have been positive and upbeat: youth, innocence, vigor, exuberance, etc. What about statements that are *not* so upbeat, *not* so pleasant? Such topics are not usually in great demand as *stock* photos; however the principle is the same.

Take, for example, hunger. It's difficult to imagine seeing anything more deeply disturbing than a hungry, deprived child; yet, unfortunately, impoverished children exist all over the world. And if you look at any of the hundreds of photo books and photoessays dealing with the subject, you'll find that the most moving photographs, the photographs that most successfully bring the subject home to reality and elicit empathy in the viewer, are those that make a universal statement—that is, the ones that use the image of one child to speak for a whole world of children.

This is not easily done. It is, in fact, this ability that separates the truly great photographers from the competent ones. Remember Eugene Smith's photograph of a Japanese mother tenderly bathing her daughter, a typical scene carried out by people thousands of times all over the world each day—a universal scene. The photo's impact, of course, came from the fact that the daughter being held by her adoring mother was cruelly deformed from mercury poisoning. Had the mother's expression of love for her child and the basic scene itself been anything but universal, the photo could not have been so profoundly moving.

To summarize, if you're going to photograph children for the marketplace you've got to do more than simply show what they look like. You've got to use them to make statements, to illustrate ideas; and the more universal your statements and the more effectively you can make them—the more marketable your shots will be.

Guidelines for Shooting Marketable Photographs of Children

Here are some guidelines to follow that will help you improve your ability to take marketable stock photos of children:

1. Pick a theme for the photo—the more universal, the better.
2. Select a location that complements that theme.
3. Try to visualize the shot you are looking for before you shoot.
4. Keep props to a minimum.
5. Compose with the probable needs of an art director in mind.
6. As you shoot, analyze what is happening; change your plan as necessary to take advantage of the specific combination of conditions confronting you.

The Biggest Mistake Photographers Make When Shooting Photos of Children

If you have a collection of photographs you've taken of children, select any ten of them at random and spread them out on a table in front of you. If you're like most amateur photographers, there will be one characteristic common to all your shots: the subject will be looking directly into the camera. That's because an amateur's sensibility is geared toward showing what things *look like;* the amateur's impulse is to have the child face the camera and look directly into the lens. The direct eye-contact lends intimacy to the shot and brings the viewer into closer contact with the child—which is good so long as the viewers are limited to Grandma, Uncle Ralph, and others who are only interested in seeing what the child looks like. A photo buyer, on the other hand, will not purchase a photograph of Junior simply because it is a good likeness of an adorable child. Quite the contrary. In fact, with the occasional exception of a photo as skillfully executed as the one of the boy watering the tree, the photos Grandma and Uncle Ralph like best are likely to be the ones a photo buyer likes least.

As a professional or aspiring professional photographer, it's important to realize that when you have the child looking directly into the camera the photograph that results is going to say very little other than, "Here I am. I am a child and I am cute." Similarly, if you move the child to a more scenic situation, say to a woods, and shoot straight on the child seems to say, "Here I am. I am a child who has been placed by this

The little boy displays an expression and attitude that can also be found in just about every other little boy. As a result, the shot was selected for use by a film manufacturer on billboards all over the Chicago area.
Photo: Tom Grill

photographer in a woods. I am still cute." The same holds true when the child is on a bicycle. As the child rides by and looks directly into the camera and he or she seems to say, "Isn't it amazing how cute I can look if you put me on a bicycle and snap my picture."

As long as you position your subjects so that they look directly into the camera, you restrict the range of statements you can make with the photograph. No matter how adorable or photogenic the subject, for every photograph I sell in which the child is looking into the camera, I sell *five* in which he or she is not. This is not so much because of a conscious bias against subjects looking into the camera on the part of photo buyers; rather, it is because when you expand your photographic horizons by trying new approaches, the possibilities for creative camera work are so greatly increased that the percentages begin to tip in your favor.

Does this mean you should *never* have the child look into the camera, that he or she must *always* appear to be lost in the act of being a child, oblivious to the presence of the camera? Generally, yes. But there *are* some exceptions.

Take a look at the photo of the little boy. As you can see, not only is he looking at the camera, but his eyes have such animation and sparkle that he seems to be looking right *through* the camera. His expression is half-puzzled, half-mischievous; while we wonder what he might be up to, we sense that he's been caught in the act of being a typical, slightly obstinate, but wholly likeable little boy.

Imagine this shot blown up to billboard size. You're driving along and there he is staring down at you, friendly, appealing—and arresting. Kodak imagined him up there too, because that's exactly how they used this shot—on billboards promoting their films.

What makes this shot so different and saleable? There are millions of similar shots; why is this a good *stock* photo?

Because it accomplishes the one thing that is vital to any truly successful stock photo: It takes a specific subject—in this case a little boy from New Jersey named Braden—and uses it to make a universal statement. In this photo, little Braden displays an expression and attitude that, while specific to him, also represent qualities found in just about *every* little boy. Kodak, which wants to sell film to passing motorists, needs a shot that people can relate to almost instantly. Parents driving by don't see just Braden, they see qualities they

recognize as being present in their own son. They'd like to capture those qualities on film. The photograph on the billboard tells them that to do so they should consider using Kodak's product. Even though the billboard passes by in a matter of seconds, chances are the next time the parents are in the camera store they'll remember the picture and relate it to the film.

In this photograph, the child is indeed looking directly into the camera. But bear in mind that in this specific instance the

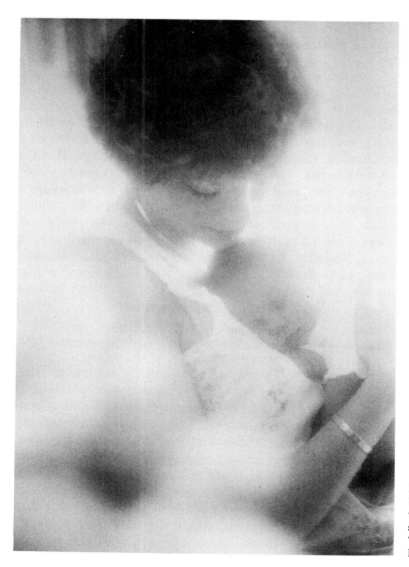

Photographs of babies can be difficult to sell because there are so many available. A more workable area is that of *mothers* and babies, a subject that can be used to illustrate such ideas as "security," "nurturing," "dependence," etc.
Photo: Tom Grill

client was selling *photo products* and the shot was therefore *supposed* to look like a snapshot. And I don't think you will be surprised to learn that this photo, which looks to all the world like a candid snapshot, is the farthest thing from it.

What About Babies?

Surprisingly, the market for baby photographs is almost exactly the same as for cutesy-pie animal shots: poster companies, calendar companies, greeting card companies. Many of them will use a shot of a chipmunk and a shot of a baby almost interchangeably. As a result, the same principles that apply to photographing pets also apply to photographing babies.

There are a couple of exceptions. It's true that many companies have occasion to say "baby"—and nothing more than "baby"—so they use a photograph, any photograph, of a baby. The problem for you as a photographer who wants to earn money from selling your photos is that there are perhaps one hundred million photographs of babies that will do that job, and no one of those photos is particularly more effective than the other. So, if you want to enter the fray of baby photography it's up to you—but know what you're getting into.

The other exception involves photographs of *mothers* and babies. This is a more promising situation for marketing your photos, because you are now in a position to illustrate such ideas as "security," "nurturing," "dependence," and so on. Mother/baby shots fall into the category of "Shooting with Models" which is covered later in this chapter.

How to Give Yourself a Child Photography Assignment

Photographing children can be a subject for creative camera work and can be used to illustrate a myriad of concepts and ideas. That is, if you don't fall into the trap that most people who go out to photograph children do—photographing with the single purpose of showing what the children look like.

So let's go after slightly bigger game here. The next time you photograph a child, try to broaden your goal so that you produce an image that will be pleasing not just to a parent but also to a potential buyer who will look for a photograph that makes a statement, creates a mood, illustrates an idea. If the

child you're photographing is yours, this exercise will, at the least, cause you to see your own child in new and pleasing ways, and you might very well come up with some interesting material for your family album.

The ten words listed below will help you get started. Pick any one of the words and try to illustrate the meaning of that word the next time you photograph a child. Keep trying to capture that one concept throughout the entire session, no matter how much film you shoot or how much time you spend. You'll find that even though you have limited your objective to achieving that one concept, your overall achievement will be heightened by the discipline and intelligence required to properly focus your energies.

The ten words are:

innocence
fragility
trust
dependence
growth
fear
friendship
discovery
curiosity
mischief

If you can think of different words that more effectively stir your creative juices, then by all means use them. But be tough on yourself. View yourself like a professional and demand professional results.

Then test those results. Once your film is developed, show it to another person without comment. Ask the person to tell you—with single-word responses—what the photos make him or her think of. If the words suggested approximate the one you were trying to illustrate, you've succeeded. (If the people whose reactions you're soliciting need help, give them the list of ten words and have them select which one is most descriptive of your shot.)

If the people *don't* see in the photos what you hoped they would, listen carefully to what they have to say. You'll begin to have a better understanding of how effectively your photographs communicate and of the shades and nuances of your own special vision.

SHOOTING WITH MODELS

If you're like most ambitious photographers, there will probably come a time (if it hasn't come already) when you decide to try your hand at shooting with models. Usually, these models will be girlfriends or boyfriends, wives or husbands, sisters or brothers, daughters, sons or friends, but even if you're photographing acquaintances your aim should be no less than to produce shots as good as those you've seen in magazines or on calendars, greeting cards, and the like. If you have already tried it, you know; if you're about to try it, you're going to find out: Shooting with models is one of the most difficult tasks in photography.

Generally speaking, there are three main areas of commercial photography in which models are used: portraiture, fashion, and what is known as photo illustration. Commercial *stock* photography deals with the area of photo illustration, but you should be aware of the distinctions among all three.

Portraiture is exactly what the word implies, namely, the taking of photographs of a specific person to show what that person looks like. All portraits aspire to at least that, but some do much more. Nonetheless, while the works of photographers like Karsh and Walsman are superb because of their ability to reveal character in their subjects, even their portraits remain, in the end, personality set-pieces.

Fashion photography is a selling tool for the garment industry, where an old saying is that first, last, and always the photo must "show the merch." The rule is that neither the photographer nor the model should do anything to distract the viewer from an awareness and appreciation for the merchandise, be it a sports jacket or a dress, a hat, gloves, a necklace, a shirt, stockings, shoes, or lingerie. Since this type of photography is produced for a specific client and usually for a specific season's clothes, it has almost no application to *stock* photography.

When you shoot photographs of models for your stock files, you will be entering the remaining area of commercial photography: *photo illustration*. For this type of photography you will be using models to create a mood or illustrate an idea. Take a look at some of the liquor ads in a consumer magazine. You'll probably see models displaying a certain type of lifestyle. The liquor company is attempting to show the type (income level, age, perhaps even race) of people who enjoy their

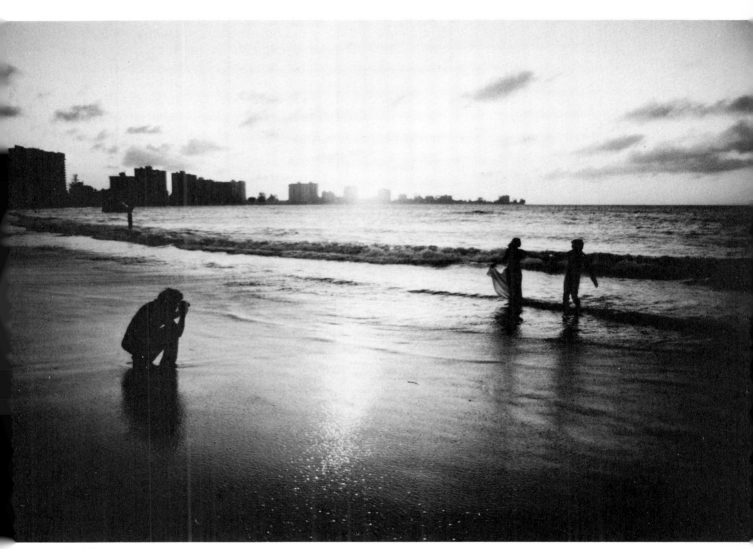

Photo: H. Scanlon

product, and they hope you will identify with that life-style and buy their product. The same is true of many perfume and cosmetics ads, where the concern is not so much with showing the product as with creating a mood. Occasionally even some fashion ads will use photo illustration instead of a traditional fashion shot. A company might, for example, decide that people are more likely to buy its product because of a certain cachet attached to it rather than any specific qualities of the merchandise itself, and in these cases the purpose of the photograph is to suggest that cachet rather than to reproduce an attractive image of the garment itself.

In many circles, photo illustrators are considered the elite of the commercial ranks. Illustrators are the highest paid among photographers, often commanding more than three thousand dollars per assignment. If you are going to be successful shooting models for *stock* photo illustrations, therefore, you are going to be pitting yourself against some of the best in the business, and you're going to have to be as demanding of yourself as the clients of these assignment photographers are of them.

Do the difficulties involved in working with models and the nature of the competition mean you should give up all hope and avoid shooting models altogether? Not at all. Remember that every successful photo illustrator had to begin somewhere, and that was probably at about the level of expertise you have now. While it is true that most people who try to succeed as photo illustrators eventually give up and concentrate in other areas of photography, a few do make it. If you think you might like to be one of those few, you might find it helpful to know that most of the successful photo illustrators who work with models have one characteristic in common: Right from the beginning they set out to shoot photographs of a quality as high as those that appear in the major magazines. They allowed themselves no excuses. If their shots weren't as good as the ones they compared them to, they made it their business to find out why and then tried again. Through this process their own styles eventually emerged, and they were on their way. Like all things that are worthwhile, success as a photo illustrator takes perseverance and determination, but it can be achieved.

Should You Shoot with Models at All?

Not every photographer has the personality and temperament appropriate for working with models. If you're interested in including models in your shots, the only way to know for sure if you can work with them is to actually try, but you can get a good indication of whether or not your personality is suited for this type of photography in advance by knowing the types of personalities that tend to work in the different areas of photo illustration.

Generally speaking, commercial photography can be divided into three broad areas: still life, scenic/travel, and people/models. Whereas almost all successful photographers devote at least some time to each area, just about every photographer tends to emphasize one area more than the others. And, interestingly, each area has a corresponding personality type. Naturally, there are notable exceptions and, as with all generalizations, there is always an exception to the rule; that aside, however, the following descriptions give a thumbnail sketch of the three basic personality types:

Still-life photographers tend to be solitary, intense, and somewhat taciturn. They have unending interest in the technology of photography and can spend hours discussing cameras, strobes, accessories, techniques, etc. When they take a photograph, they want to have absolute control over every element down to the most minute detail. Control is the key to their photography and to their personalities. They have faith in their own ability to "make" a photograph and will brook no outside interference.

Scenic/travel photographers are at the opposite end of the personality spectrum, and they tend to share one remarkable trait that almost defies description: a sense of whimsy. They are easygoing (although extremely professional), and they seem to be privy to God's inside jokes. They tend to be good-natured, convivial, and relaxed, and have the ability to stay calm even when those around them fall prey to nervousness, panic, or depression.

Photographers who shoot models, on the other hand, are the gunslingers of the profession. Unlike still-life photographers, whose attitude toward their equipment frequently borders on the reverential, model-shooters view their cameras much like the cowboy of olden times did his Colt .45—as an extremely important tool of the trade to be taken care of, cleaned, and

respected, but not as indispensable or irreplaceable. It exists to do a job, and as long as it does so, fine; but when it stops, you throw it away and get a new or better or different one. Photo illustrators who specialize in shooting with models think nothing of dunking their cameras in the various oceans of the world, dropping them off cliffs, banging them, abusing them, and getting rid of them. Insofar as their equipment is concerned, they care only that the equipment does the job and doesn't get in the way. Their excitement and joy comes from producing the photographs that "work," capturing fleeting moments, split-second expressions. They are hunters who will at times do just about anything to bag their prey. In contrast to still-life photographers whose enjoyment comes from steady, methodical photography, or the travel/scenic photographers, whose pleasure derives as much from the location where they're shooting as from what they shoot, the model-shooter's photo sessions are like a bullfight that builds and swirls until the final climax; and when it all goes well, these photographers display unmatched elation and enthusiasm.

There is no question about it: Model-shooters are a different breed. They have the inclination and ability to get beneath the surface of people, to explore and reveal them and show their most unique aspects—and at the same time, they relate those unique aspects in such a way that others can identify with their subjects. The best are superb, even exhilarating, to watch, and even *they* are often at a loss to explain exactly why and how they do what they do so well.

So where do you fit in? First, before you consider spending any appreciable amount of time shooting with models, it is important for you to honestly and realistically assess your own temperament and try to get an objective view of your personality. If you have the *right* temperament for it, shooting with models can be intensely rewarding, both artistically and financially, but if you have the *wrong* temperament, you are almost certain of frustration, disappointment, and failure. There are very few photographers whose personalities are suited to working in more than one of the three broad areas. Even some of the most accomplished and renowned professional still-life photographers get amateurish results when they try to shoot with models. By the same token, most photo illustrators who work with models and then attempt still lifes do not have the patience, the sensibility, or the eye to pull it off. They simply aren't suited for the work.

What specific traits should you look for in your own personality if you want to shoot with models? For one thing, you need to like working with people. This may sound obvious, but I know photographers who have tried to make a career of shooting with models and failed, only to discover later that the reason they failed is simply because they preferred working alone. If you have the talent, get along well with others, and like working with people, photo illustration may be a good choice for you.

Another requisite for working successfully with models is that you have an eye for serendipity. Most of the best model shots simply appear, unexpected and fleetingly; they're gone almost as soon as they arrive. You've got to have the type of personality that relishes these happy chance occurrences—and that knows how to encourage their appearance. For this reason, the more your bent is toward a controlled, precisely planned and executed photograph, the more likelihood there is that you will be unhappy shooting with models.

Professional Models

Many people are surprised to learn that there is a great deal more to modeling than simply being pretty or handsome. To make it as a professional, a model must know how to move, how to "project," how to relate to the camera, and most important of all, how to respond to the directions of the photographer. In order to develop these necessary skills, models with high potential usually come to large cities, especially New York, and sign on with a model agency.

Likewise, aspiring photographers gravitate to major cities, where they serve an apprenticeship, working as assistants to established photographers, in an effort to hone their skills. Then, to gain the experience and skill they need in conveying to a model what they want, and then coaxing it out of her, these young photographers arm themselves with recommendations from the professional photographers they have worked for and make arrangements with the modeling agencies to take photographs of their models on a "test" basis. No money changes hands at this point; rather, both the photographer and the model agree to a shooting session for the sole purpose of gaining experience and to produce photographs for their respective portfolios. This process, whereby photographers learn how to take good photographs with models and models learn

how to model, is often a slow and tedious one, but, when the talent and dedication are there, the end result is two capable professionals.

Unfortunately, if you're shooting photos of your girlfriend, boyfriend, or whomever, you don't have the advantage of working with a highly trained professional model. And, most likely, you're working with someone who is hesitant, self-conscious, and nervous before the camera. So it becomes your job to extract poses, attitudes, and expressions from that person that will be the equivalent of those of a professional model. Needless to say, the task is not easy.

In sum, photographing with models involves much more than simply locating a willing subject and shooting away. The following sections discuss aspects of model photography with which you will have to become familiar, and offer suggestions for improving your chances of success. Remember, however, that the skills you seek to gain come only with experience and practice.

Defining Your Objective: What Are You Trying to "Say"?

What is true with scenics, travel, animals, and children is especially true when photographing models: Nothing will contribute more to your success than having a clear idea in mind of the statement you want your photo to make. Many photographers, when confronted with a beautiful face or a lithe, attractive figure, make the mistake of forgetting everything they have learned and attempt merely to show that face or figure with no well-defined statement in mind. You *must* have an objective, something you're trying to convey, at the very least a mood you want to create. This is not to suggest that your model's personality or appearance will have no effect on the statement you choose, but rather that as soon as you can you need to clarify in your mind what the actual objective of the photograph is—that is, the statement you want to make that is likely to appeal to the commercial market. Unless you, the photographer, know exactly what that statement is, you are not going to be able to select an appropriate setting or convey your ideas to the model in a manner she can understand and respond to.

What kinds of statements should you concentrate on? Photography buyers usually want to convey either a particular mood or a particular life-style. An insurance company, for ex-

People who buy model shots are often looking to create a mood or suggest a life-style. This photograph was used in a shoe ad in *The New York Times Magazine.*
Photo: H. Scanlon

ample, might want to convey a mood of security and so will look for a photograph that effectively projects such a mood upon which it can build its sales message. (A father and son, perhaps, where the father is obviously protective of the son.) A shoe manufacturer, on the other hand, might be more interested in having a photograph of a woman who represents one of their typical customers. If they cater to a sophisticated clientele, for example, they might well use a shot of a well-heeled woman sipping wine in an outdoor café. The photo on the preceding page, which incidentally is of the photographer's sister, sold for exactly that usage and appeared in an ad in the *New York Times Magazine*. A glance through a selection of contemporary magazines will provide you with countless examples of "mood" and "life-style" shots.

Again, if you have a clear idea of what you intend to shoot before you begin, you will be able to communicate your ideas to the model who can then become a willing, active participant in the shooting instead of a bewildered prop.

Matching Model and Statement

If you're like most photographers just starting out, you probably won't have the luxury of a great range of choice in whom you select as a model; most likely you'll be photographing your sister or another female relative or a friend or girlfriend. Don't be discouraged, though. The technical problems and challenges you face shooting your girlfriend are the same ones you will face time and again with any model, and the mistakes you make at the beginning are part of a process you must go through before you can expect to produce successful model photography with consistency.

The important thing is to make sure the model you select is appropriate for the photograph you intend to take. Thus, if your choice of models is limited you may have to let the characteristics of the model affect the statement you are trying to make. For example, suppose you have two potential models. One, your girlfriend, is slim, pretty, with long blonde hair and a sinewy body. The other, your mother, is sturdy, handsome, dignified, with a face that exudes great character. If you decide to shoot your girlfriend, you can envision her in a long, flowing gown idly strolling through a quiet meadow while a soft summer breeze gently wafts her hair. Placing your mother in the same situation would be, at best, discordant.

She may, however, be completely suited for another type of shot, say one in which you have decided to convey the concept of rugged Americanism. In such a shot, you might make good use of those strong qualities in your mother's face and use the photograph to explore the nuances of her character. Placing your girlfriend in that situation and attempting to elicit from her the same qualities your mother has would be a resounding failure. Obvious as it may seem, beginning photographers often miss this crucial point: Make sure your model is appropriate to the situation, and vice versa.

Finding a Location

If you are just starting to shoot with models, it's an excellent idea to find your location and know what kind of photo you want to shoot *before* you even begin to think about picking up your camera. By the time you are ready to shoot, you should have already scouted locations and determined where you want to place your model and how you want the model to relate to the environment in which you have placed him or her. The worst thing that can happen is for your model to look alien or uncomfortable in the surroundings. Before you're on location, you should have already determined how you intend to use the location to enhance the impact of the image you want to create. And remember, there must be a *reason* for the model to be in the location you select. That reason need be only subtly implied, but if it is not present, the photograph you take will very likely appear incongruous, confused, and perhaps even ridiculous.

Here's an example: Let's go back to your mother and girlfriend again. Suppose you decide to photograph your mother knitting peacefully in her favorite wooden rocking chair. You want the photograph to convey certain traditional values and customs. Behind your house is a field with a small stream running by. You place your mother and the chair in the field and click away. The problem with your photo will be that there is no ostensible reason for your mother to be doing her knitting in that field, or, in other words, the location is basically unrelated to the action of the model. In the absence of a reason to join the two, the photograph's overall impact is muddled and disjointed. Place your girlfriend in the same situation and you need imply no more direct a motivation than the desires of a young girl to pass time idly in beautiful surroundings as she

Whatever location you choose, give your model an appropriate reason for being there, even if that reason is as subtly stated as a young woman idly picking flowers.
Photo: Tom Grill

dreams, perhaps, of an absent lover. All we need to know to accept her presence in the location is that the girl is lost in her own thoughts and memories.

Now, look at the photograph at left. As you can see, this photo is notable both for its simplicity and for its ability to create a mood instantly. The location is nothing more elaborate than a common woods (in fact, this "woods" was a small pocket of trees in an otherwise desolate and unattractive urban park). The model is simply dressed, and she carried a small basket of freshly picked flowers (actually, flowers freshly *bought* by the photographer). But the important thing is that what she is doing seems completely appropriate for where she is. It appears that she is passing the time by herself, wandering through the woods picking flowers on a warm summer day and letting her thoughts drift wherever they might go. In viewing this photo, you sense that there is a *reason*, however subtle, for her being there. You get the sense not that a calculating photographer placed her there (which is, of course, the case), but that a young girl had been caught unawares as she did what she would naturally be doing.

The key to selecting the appropriate location for your photograph is to discipline yourself to plan clearly the ideas, moods, and concepts you want to convey with your model in advance, so that the location you select will be a logical extension of your plan.

Simplifying the Shot

As a general rule, simple, uncomplicated, and uncluttered locations and settings are best, especially in the beginning. Chances are, as you begin to shoot, you'll find you'll have more than enough to occupy your attention just directing the model without compounding your problems by adding an elaborate setting. If you want your photograph to suggest a woods, find a simple one. Likewise, indoor locations need be only a corner of a room or perhaps one chair by a window; you don't need ornate sets. If possible, simulate the outdoors inside, if that makes it easier to shoot. Remember the photo of the woman sipping wine at what appears to be an outside café? Look again. The shot was actually taken in the photographer's living room—a technique that vastly simplifed the shot.

Don't be afraid to use props, but keep them to a minimum. Although this photograph looks as though it were taken at an elegant restaurant, it was actually shot in a photographer's studio. With just a few judiciously placed elements, the photographer was able to suggest an entire scene. Photo: Tom Grill

Look at the photograph above of the couple dining. Obviously they are enjoying themselves in an elegant restaurant. And there's probably soft music playing in the background and a wine steward just off-camera is ready to cater to their every whim. Right? Wrong. This photograph was taken in a studio. The table is a round piece of plywood with a sheet draped over it. The chairs are old, worn "director's" chairs. The plants are all plastic. The background consists of reflective Mylar (an aluminum-foil-like substance many profession-

al photographers keep on hand). As you can see, there are very few props on the table: some flowers, a couple of glasses, cream and sugar—that's about all. And yet, with just a few judiciously placed elements, the photographer was able to suggest an entire scene. Everything is designed to add emphasis to the couple and to create a mood. Nothing was left to chance; the photographer knew what he wanted to create and set about doing it with economy and graphic effectiveness. (Incidentally, this photograph has sold over twenty-three times.)

Remember, reduce the number of elements, props, etc. to the bare minimum necessary to convey what you need. More shots are ruined by too much propping than by too little.

Posing the Model

One of the most widespread misconceptions about shooting with models is that a model is essentially no different from any other subject you might choose to photograph, such as a tree or a car or a flower. Nothing could be further from the truth, and because most budding professional photographers do in fact treat their models the same way they treat inanimate props, their efforts are usually doomed: Their shots come out embarrassingly stilted, self-conscious and amateurish.

One of the main stumbling blocks you'll encounter in working with models is how to pose them. Professional models are trained to fall into poses that look natural (even if they're not). Amateur models almost invariably assume poses that look awkward and unnatural (even if they're not). One of the best and easiest ways for you to overcome this problem is to study magazines and clip out shots with models in poses that you find appealing and convincing. Then, during your next shooting session with a model, pull out one of the poses and ask the model to try to duplicate it. Given this starting point, your model will begin to adapt the pose to his or her own body style and may even develop some other just as interesting and effective poses. The model will need help at first, and your job is to provide that help in an encouraging way. But in every case, *you* must be the director in command of the situation, the one with a clear understanding of what you want the pose to "say," and who explains it to the model.

One of the best ways to learn how to pose a model is to study the magazines and clip out shots where models are in poses you find appealing. Have your model try to duplicate the pose. Given this starting point, the model will begin to adapt the pose to his or her own style and body-type. Photo: Tom Grill

Being encouraging and helpful to your model does not mean saying, "Go stand over there and look pretty" or "Okay, smile." Tell the model *why* you want him or her to smile, or what the model is supposed to be thinking about. If you want to convey sadness, *tell* the model so. Let the model know what you're thinking, what you *want*. Usually, your model will be eager to help you, and even the most inexperienced amateur can be surprisingly effective if given a good starting point and the proper instructions.

The best models are to all intents and purposes *actors and actresses*, and they often need to be given some kind of motivation for what they're doing. This is especially true for amateur models, who are inclined to be self-conscious and awkward. Often, the best way to help models relax and act naturally is to provide a fantasy of some sort they can involve themselves in mentally. Eventually, if you're lucky and skillful, their own sensibilities will take over and add dimension to what you've initiated. It is on those felicitous occasions when the dual sensibilities of photographer and model come into harmony that the best photos are born. But you're the one who's going to have to plant the seed, nurture it, and make it bear fruit.

Complicating matters somewhat is the fact that (fortunately) models are not objects that can be manipulated the same way you might an inanimate prop. They are people and, as such, have complex personalities and a variety of subtle characteristics. When you are working with a model, your job as a photographer is to take the time to determine, within the context of the statement you want your photograph to make, what it is about a model that you want to explore. As you develop skill in working with models and as your pool of potential models expands, your ability to identify the unique aspects of the model as an individual will improve, as will your ability to combine them with your own special sensibilities to create a powerful, evocative image.

Model Releases: What Are They? When Do You Need Them? How Do You Get Them?

Legally, you may not use a photograph of a person for commercial purposes without that person's permission to do so. It's as simple as that. If you sell a photograph of a person for a commercial use, you had better have a model release. If you don't, the person can sue you, and he or she will win. The U.S. courts take an extremely hard line on cases that involve invasion of privacy, and that is exactly what you will be committing if you sell someone's likeness to promote a product without his or her permission. How much can you be sued for? Just about everything you own.

What then, exactly, are "commercial purposes?" A photograph used commercially is a photograph that is used to pro-

mote the sales of a product or service. This includes product brochures, ads, displays, billboards, annual reports, even book covers. However, a photograph used *editorially* to illustrate an article rather than to sell a product or service often does *not* require a release. For example, if you take a photo during the Easter parade that is used by a newspaper to show what the parade was like, you do not need to obtain a release. But, if that same photograph were used to promote, say, deodorant soap, theoretically you would need to obtain a model release from every person who is recognizable in the shot *before* you are free to sell it.

There is some confusion about when you need a model release and when you don't. For instance, suppose you are in San Francisco and you take a photograph of a street vendor on Fisherman's Wharf. Then a tour company buys the photograph from you to use in a brochure promoting travel to San Francisco. A travel brochure is a commercial item, used to promote a product (the tour). However, the photograph was taken in a *public place* and is being used to illustrate *only what it is*—a San Francisco street vendor. The tour company is simply showing its potential customers what they are likely to see if they travel to San Francisco. As such, even though it is a commercial usage, no model release is required. However, if the same photograph were sold to a liquor company to promote its bourbon or to a frozen fish company that wanted to imply its frozen dinners tasted just like "fresh fish from Fisherman's Wharf," a model release would definitely be required.

Obtaining model releases is especially important when taking photographs of sports figures and entertainers. These professionals make their living with their images and their bodies, and they have no intention of giving away for free something they should be paid for. Under no circumstances can a sports figure or entertainer be used to promote or endorse a product without that person's permission.

What exactly *is* a model release? A model release is a document signed by the person which grants you permission to use his or her image in ways that are outlined in the release. Some releases are very broad, granting the photographer virtually unlimited permission to use the photographs; other releases, most notably those used by the four or five top modeling agencies, are very limited, granting the photographer and his client a very narrow range of uses or perhaps only one specific use.

In the latter case, the releases are worded in such a way as to prevent photographers and their clients from using the photographs more extensively than they pay the model for. Because New York models get at least $75 an hour, as well as additional "bonuses" for pictures used for ads, packages, etc., that can run into thousands of extra dollars, the model agencies are very careful to make sure that photographs of their models are used only for the purposes originally described by the photographer and are duly paid for. As a result, since a stock photograph should by its very nature be versatile and lend itself to as many uses as possible, the large modeling agencies rarely, if ever, allow their models to sit for stock shootings.

For the purpose of shooting stock photographs that you may or may not sell eventually, you will need to secure from your models an "across-the-board" release granting you permission to sell your photos wherever and whenever you can. How much you pay your model is subject to negotiation; many people are quite willing to give you a release in exchange for some prints. Some photographers I know arrange to give their models a percentage of the profits of any photos they might sell. What you do is up to you, based on your judgment as to how valuable the model is to your work.

Here is a typical model release:

SAMPLE MODEL RELEASE

For valuable consideration, receipt of which I acknowledge as payment in full for my services as a model and for the permission herein granted, I hereby irrevocably consent to and authorize the reproduction, publication, and/or sale by (PHOTOGRAPHER), and his/her licensees and assigns, of the photographs identified below, in whole or part or in conjunction with other photographs, in any medium and for any lawful purpose, including illustration, promotion, or advertising, without any further compensation to me.

I understand that (PHOTOGRAPHER) is a stock photographer and that these photographs will be included in his/her stock files. I agree that the photographs, the transparencies thereof, and the right to copyright the same, shall be the sole property of (PHOTOGRAPHER) with full right of lawful disposition in any manner.

I waive any right to notice or approval of any use of the photographs which (PHOTOGRAPHER) may make or authorize, and I release, discharge, and agree to save (PHOTOGRAPHER), and his/her licensees and assigns, harmless from any claim or liability in connection with the use of the photographs as aforesaid or by virtue of any alteration, processing, or use thereof in composite form, whether intentional or otherwise.

PHOTOGRAPHS:

Description: _____

Date Taken: _____

MODEL: I am over twenty-one years of age.

Signature: _____

Print name and address: _____

FOR MINOR: I am the father/mother/guardian of _____

_____. For value received, I consent to the fore-
going on his/her behalf:

Signature: _____

Print name and address: _____

WITNESS: Dated: _____

Signature: _____

The important thing to remember is that you must be abso-
lutely straightforward and honest with your models about
what you intend to do with the photographs. Always explain
what a stock photo is and that you intend to sell the photos. If
people do not want their image used in this manner, then they
have every right to decline your offer; under no circumstances
should you ever attempt to deceive these people or try to take
advantage of them. Not only can you get into severe legal
trouble, but the ethical ramifications are quite obvious.

To summarize: When in doubt, get a model release. Don't
ever sell a photograph for commercial purposes unless you
have releases from all the models used in it. Even if you're not
sure whether the usage is commercial or not, it's best to get a
release. You've got too much to lose and, believe me, you'll
lose it if you play fast and loose with the model release situa-
tion. DON'T TAKE THE CHANCE.

How to Give Yourself an Assignment Shooting with Models

Shooting with models can be difficult and fraught with unexpected problems. One of the best ways to avoid such problems is to try to duplicate a photograph from a magazine, newspaper, package, or display. By choosing a photograph that you like and trying to duplicate it, you will be forced to analyze the photograph—its mood and the statement it makes—and to examine the details of the photograph in ways that you would not otherwise have done. For the first time, you might begin asking yourself *why* the photographer included that vase or that lamp, and *why* the photographer placed it there. Such questions will help you establish a starting point of poses for your model.

This assignment is not quite as simple as it may seem, for as you begin to shoot you will probably find that what might have appeared to be a simple photograph is not so easy to duplicate. All the difficulties of any model shooting will very likely present themselves, and your job will be to handle them as a professional would. And in all likelihood, despite your efforts to duplicate another photograph, chances are you will produce a photograph that is uniquely your own. Try it. You'll see what I mean.

Once you've tried to duplicate the photograph, sit down and analyze what you've learned about that particular photograph. *Now* what do you think its mood is, and what is it trying to convey? Pick three abstract words, such as innocence, serenity, anger, sophistication, wealth, poverty, joy, etc., that you think are inherent in the photograph. Now try to take a photograph of your own design that conveys the same moods and ideas, using your creative imagination and your own special sensibilities to make a photographic statement. If you can begin to use your camera and your models to produce photos that "speak," where the model is relaxed and the setting natural and harmonious, you're well on your way to producing saleable stock photos of models.

PART II
Selling Your Photographs

4

How to Market (Sell) Your Photographs

"Marketing." That's a word that's used a lot.

"Marketing Managers." You've heard of them. "Executive Vice-President in Charge of Marketing." Corporate titles conjuring images of gray suits and wing-tip shoes. BIG BUSINESS. Mysterious. Overwhelming.

"The Market." The stock market? Fruits and vegetables? Bartering chickens for potatoes?

Marketing. What is it? How do you do it? Is it necessary?

Ninety-nine percent of the photographers with whom I come in contact have no knowledge of marketing. If they've heard the term at all, it was by accident in a conversation they were probably bored with. Much more interesting to talk about "aesthetic realism" or "decisive moments."

If only the remaining 1 percent of the photographers know anything about marketing, why should *you*? Simply because *that 1 percent includes virtually every photographer who makes a living at his or her trade.* In fact, it can be argued that a photographer's financial success depends more on marketing ability than on talent!

WHERE DOES TALENT FIT IN?

It may sound crass, but many photographers with only minimal skills are *thriving* simply because they know and understand the needs of the market—*not* because they possess a great deal of creative talent. Other tremendously talented photographers are starving *because they don't know how to introduce their work into the marketplace.*

More often than not, these unsuccessful photographers cling to the belief that "talent will out." They naively suppose that if they produce photographs of exceptional quality someone with "influence" will eventually notice their work and they will then receive the recognition they deserve. In other

words, they feel they should concentrate solely on their art and let the rest—fame, financial reward, etc.—take care of itself.

Unfortunately, "artistic" photographs are seldom bought for commercial use. Although they are given much play in photography magazines, these rare occurrences really represent nothing more than a false hope for those talented photographers who wait impatiently to earn enough from their art to support themselves (which is as unlikely as a movie star being discovered in a Schwab's delicatessen).

It's a sad fact of life, but in the world of commercial photography—which is the main source of income for the vast majority of professional photographers—talent will *not* "out." Yes, you need to have talent, but talent is no more rare a commodity in photography than it is in, say, acting. Those of us who've spent time in New York City are fortunate beneficiaries of the sprawling reservoir of acting talent there. For a few dollars (or even for free) we can go to off-off-Broadway plays and watch some of the most talented actors in the world practice their trade. They do it for the joy of performing the work they love, but also because they hope that someday their acting potential will be more widely recognized and exploited.

Exploited. That's the operative word here. Talent *demands* exploitation. But exploitation does not necessarily mean that people or their talent have to be abused. On the contrary, it can imply that every ounce of that talent is used to its fullest, to the ultimate benefit of *everyone* concerned.

Certainly the meeting between the art world and the commercial world is a "push and shove" point of conflict and exploitation. And each party has its own interests. Ideally, though, the common goal of both photographer and client is a harmonious and productive relationship between talent for its own sake and the *use* of that talent for whatever other purposes are decided upon.

Consider this: Do photographers who shoot for art's sake and succeed in the marketplace "make it" because the irresistible force of their talent has garnered its rightful place in the public eye? Experience shows that photographers who lack marketing skills and still climb to the top of their profession do so only because *someone with strong marketing skills* has taken them under his wing and exploited their talents for them.

Simply stated, in order to succeed as a professional photog-

rapher your talent *needs* to be exploited by someone, and there is no reason why that someone shouldn't be *you*. If you wait around for someone else to do it for you, most likely you'll wait in vain. Or your "patron" will turn out to be a pretender, a disappointment, or worse, a thief.

It's up to *you* to take the steps that will bring financial rewards for your creative efforts, and the next chapters will show you how.

PEOPLE WHO NEED YOUR PHOTOGRAPHS AND ARE WILLING TO PAY FOR THEM

Although the market for photography continues to grow by leaps and bounds, the number of people who are in a position to actually buy your photos is relatively restricted. And it's important for you to know as much as you possibly can about this small group of buyers. Any good salesperson will tell you that in order to be successful you must "target" your audience, that is, you must know who you are trying to sell to and must thoroughly understand that person's job. Otherwise, you will not be able to tailor your presentation in a way that effectively addresses the potential buyer's specific needs.

Much of the rest of this book is devoted to helping you understand and deal with these various buyers, but by way of an overview, what follows are brief descriptions of the people most likely to need—and be willing to pay money for—your photos.

Magazine Art Directors. Pick up any magazine from your local newsstand and turn to the masthead page (the page that lists the publisher, the editors, etc.). In every case you will see a listing for the art director. He or she is responsible for the visual "look" of the publication, including the basic layout, type selection, paper selection, format, size, and photography. If you are an assignment photographer, this is the person most likely to hire you. If you are selling your stock photographs, this is the person most likely to buy them. Magazine art directors are frequently trend-setters. Unlike their counterparts at the ad agencies, who are often subject to tremendous pressure from clients, magazine art directors are often inclined to take some risks and to give a photographer a great deal of latitude. At any consumer magazine, the art director is *the* person you should get to know.

Trade Journal Art Directors. The trade journal art director performs a function similar to that of the consumer magazine art director. He or she is responsible for the overall design of the magazine and the purchase of photography. Interestingly, trade journal art directors will frequently have a background in the trade their magazines cater to. For example, if you have a large number of shots that are agriculture-related, you might very well want to get to know the art directors of the various agriculture trade magazines. You'll find that these art directors are knowledgeable not only about the design of their publications but also about the business of agriculture and can therefore converse with you intelligently on the more arcane agricultural aspects of your photography. The same holds true for any of the trades: pharmaceutical, medical, chemical, engineering, construction, travel, real estate—the list is endless.

If your photographs have particular application to a specific area that is covered by a trade journal, the art director will be especially important to you.

Ad Agency Art Directors. Ad agencies are divided into two parts, one that handles the "accounts" (that is, the people who operate the financial side of the company) and the other that handles the "creative" side. The creative side is then roughly divided into writers who write the "copy" and artists who are responsible for the visual content of the advertisements. Those artists are called "art directors," and they can be the single most lucrative contacts you can make. They buy more photography and pay more for it than any other single group of people. (For a detailed discussion of how ad agencies work, see chapter 6.)

In-House Corporate Art Directors. In addition to or sometimes *instead* of hiring advertising agencies, many companies have their own department that performs essentially the same function as an ad agency. Ads that emerge from within the company are known as "in-house" ads, and the departments are often referred to as in-house advertising departments. Like the commercial ad agencies, these departments employ in-house art directors, who are responsible for purchasing photography. Also like their ad agency counterparts, in-house art directors are often in a position to pay handsomely for your work.

The duties of an in-house corporate art director are by no means limited to creating ads; in fact, the in-house staff is of-

ten more involved with designing "collateral material" such as brochures, flyers, sales sheets, displays, posters, and the like. They often use tremendous amounts of photography over the course of a year and are well worth seeking out.

Graphic Designers. The difference between graphic designers and art directors is more semantic than real. Both are involved with designing ads, packages, brochures, etc., and both have backgrounds in the art world, often having attended design schools, such as Parsons School of Design or Pratt Institute. The primary difference between the two seems to be one of position and authority. Art directors tend to be employees. An individual might be one of thirty art directors at, say, J. Walter Thompson in New York, or the only art director in a small rural ad agency. Graphic designers, on the other hand, have more autonomy in their jobs and tend to be the head people in relatively small graphic design studios. Sometimes a graphic designer is a former ad agency art director who decided to go off on his or her own. Rather than become the "creative director" (that is, the boss of the art directors and copywriters) for a "full-service" ad agency, this person hangs out a shingle stating that he or she is a "graphic designer" who is offering specialized services in that more limited area. A graphic designer's work is often weighted towards "collateral" material rather than ads. Collateral material includes everything from brochures to (especially) annual reports. (For an in-depth discussion of just what Graphic Designers do and how to approach them with your work, see chapter 4.)

Book Publishers. Many people mistakenly believe that the world of publishing consists of a handful of gargantuan firms like Random House or Harper & Row and that to sell these companies photographs for use in books one must have an "in" or some special entrée to what is viewed as an elite corps. In fact, however, such large publishing firms are only a part of the total publishing picture. There are smaller, more accessible publishers all over this country, many of whom publish only a few titles each year but almost all of whom need photographs at one time or another. In these smaller companies the person who publishes the books is often the same person who designs the book and selects the photographs. Chapter 7 will show you how to reach this lucrative market.

Greeting Card, Calendar, and Poster Companies. An area of photography usage where the photograph in essence

becomes the product itself includes greeting cards, calendars, and posters. This market is traditionally somewhat trendy and fickle, and it is fraught with pitfalls. However, it is a market that has tremendous potential for any photographer. (See chapter 7, Greeting Card and Calendar Companies.)

PINPOINTING THE MARKETS

If you are to develop a systematic, effective strategy to sell your photographs, you must have a firm understanding of how markets are defined and categorized. Basically, markets are defined in two ways: by geography and subject.

Markets Defined by Geography

There is no mystery here. Geographical markets are determined by two characteristics: (1) the physical location of the buyer (the magazine, the ad agency, the greeting card company, etc.) and (2) the size of the audience that will see your photograph. For example, an ad agency may seem "local" to you if it is in your hometown, but it may also be "national" if its clients include companies with national marketing plans. However, with the exception of New York, Chicago, Los Angeles, and to a lesser extent Minneapolis and Atlanta, most local ad agencies service only local clients. An agency in Des Moines, for example, probably represents local banks, local retailers, local construction companies, etc., and it's unlikely that a photograph you sell to them will be seen anywhere but within that local sphere. Local ad agencies also occasionally service *regional* clients—larger companies with more widespread distribution of their product (a regional department store chain with perhaps ten branch stores is an example). These regional clients naturally tend to have larger budgets than their more localized counterparts. In addition, local ad agencies sometimes have nationally based clients, although the great majority of these behemoths bring their business to the large ad agencies in the big cities.

The markets defined by geography fall into roughly three categories: local, regional, and national.

Local Markets. If you are just starting to sell your photographs, this is the market most likely to give you entrée. It includes any potential photo buyer who is located in your town, and believe me, just about every town in America has at least

a few potential clients for a beginning photographer. Possible buyers include the town paper, local retailers who need shots for window displays, the town council, which may want photographs for promotional brochures, and local ad agencies. Almost every town boasts at least a few ad agencies that service the local accounts. These agencies need good photography, and there's no reason why you can't approach them. If you keep a sharp eye out for users of photography in your own hometown, you'll be surprised at how many you'll discover.

Regional Markets. After you've gained confidence by selling photos locally, very likely you'll find you want to spread your wings a bit and go after bigger game. At this point, the next logical market for you to approach is the regional market, including regional magazines whose editorial content addresses itself to *several* towns, a county, several counties, or a whole state. Your local librarian will be able to help you locate all the regional periodicals in your area; peruse thoroughly a number of back copies of each publication to get a feel for their styles and needs. In each case, jot down the name of the art director and/or the photo buyer. Chapter 5 will tell you how to approach them to sell your photographs.

As you go through the publications, make a note of the companies that are taking out ads. If they are companies associated with your particular region, there's a good chance you can approach them directly with your photographs. Chapter 7 will tell you how to contact them directly or how to identify their ad agency.

If you live in a very small town, chances are that a larger town which serves as a regional center is not too far away. Locate it and begin cultivating the buyers there the same way you did with the buyers in your local market.

Once again, as you become more and more attuned to the needs of the photography market and more adept at spotting potential photo buyers in your region, you'll be surprised at how many opportunities to sell your photos are well within your reach.

National Markets. With the exception of a handful of the most successful and well-established photographers, most photographers who market their work on a national level do so through a stock photo agency. This doesn't mean that you can't possibly sell your photos for national use on your own—it simply means that it is much more difficult, because you won't be able, single-handedly, to saturate the market as thoroughly and effectively as the stock photo agencies can. Keep

in mind, though, that some local and regional ad agencies do service national accounts and that as you cultivate these markets there is always the possibility that one or more of your photographs will be tapped for use by one of the big accounts. Chapter 9 deals extensively with stock photo agencies, what they are, where they are, and how to get represented.

Markets Defined by Subject

The second way markets are determined is by the subject matter of the photographs they need. Once you have pinpointed a subject area, you'll find that the potential buyers run the complete spectrum of local, regional, and national markets.

For example, consider the market for photographs of dogs. On the local level, potential clients include kennels, dog training and obedience schools, dog breeders, grooming salons, and so on. Regionally, there might be pet-oriented publications, manufacturers of pet-related products, etc. On a national level the numerous major dog-food companies, dog-oriented trade publications, pet sections of consumer magazines, greeting card companies with animal-oriented lines, calendar companies, jigsaw puzzle manufacturers, etc., comprise a large and lucrative market.

The range of subjects you can exploit in commercial photographs is almost endless—children, sailing, golf, waterfalls, seascapes, pregnant women, families, babies, fish, wildlife—and each subject specialty lends itself to a vertical marketing program from the local level all the way up to the national level.

Or suppose you specialize in underwater or aerial photography. If you compile a substantial body of work, you can let it be known on every level that anyone who needs good underwater photographs can find them with you. If your work is of good quality and geared to possible commercial usage, and you have contacted the right people, the buyers will remember you the next time they need underwater photographs.

All of which goes toward pointing out—

THE ADVANTAGES OF SPECIALIZATION

Most talented photographers have the ability to produce high-quality images in any number of subject areas. Some of them,

however, decide to specialize in one area. Why? Because a photographer who builds a reputation for having an extensive range of photographs in a special area has the ability to drive a substantial wedge into the marketplace. Take, for example, those underwater photographs mentioned above. Many photographers have *some* underwater shots along with their other subjects, as do most stock photo agencies. However, buyers who need a specific underwater photo might have to contact many photographers and agencies before they find what they're looking for. If, on the other hand, they know of a photographer who specializes in underwater photographs, they will contact that photographer first.

One example of a well-known photographer who has been very successful by choosing to specialize is Jill Krementz. Krementz has developed such an extensive file of high-quality photographs of authors that a whole cross section of buyers ranging from book review publications to *People* magazine often think of her first whenever they need shots of writers. She is, of course, a talented photographer in many areas, but because she let it be known that in addition to her other work she intended to compile as thorough a file of authors as possible, she has successfully captured a large market for author photos.

Another advantage of choosing to specialize in one area is that it makes it much easier for you to market your work on a national level without the aid of a stock photo agency.

5

Principles of Selling Your Photography

What do you suppose is the single most formidable obstacle confronting photographers who want to take the plunge into the commercial market? Lack of talent? Lack of experience? Neither. It's lack of confidence. They are intimidated. They view the photo marketplace as a mysterious labyrinth too difficult to penetrate—so they feel, Why try? To many beginning professionals it is inconceivable that their work could have real value and command real attention in the open market.

In this regard, novice photographers are not all that different from beginning writers, artists, actors, and other creative people. It is entirely too easy to overesteem the work of others while denigrating the value of one's own work. Thus, one of the primary tasks of any photographer is to build up enough confidence in his or her ability to overcome the feelings of intimidation that are so often an adjunct to the creative personality.

Just like any photographer who has ever been successful, *you've got to start somewhere.* The first call to a potential buyer sets the stage for the second call, and so on, until eventually you make your first sale. While it is unrealistic to expect that by merely announcing you are open for business the world will immediately beat a path to your door and shower you with riches beyond your wildest dreams, if you are going to take that first step you are going to have to nurture the attitude that your work and your talent have as much right as anyone else's to be represented in the marketplace. Ansel Adams started somewhere. So must you. If you consciously decide to be realistic, objective, and positive, you will be on your way to building the confidence and assurance you need to develop your craft to its utmost potential.

What kinds of results can you reasonably expect? The operative word here is "reasonably," and, frankly, I get fooled all the time. Established professionals have come into my office, and on the basis of the film they put in our files I fully expected that they would make good money quickly. But some of them didn't. Their photos were slightly "off," meaning that, despite the appeal of the subject matter and/or the technical execution of the shots, for some reason they were not being selected for use by the buyers. On the other hand, I've taken a handful of shots as favors to beginners, not thinking there was much chance the shots would sell, and all of a sudden they have "taken off" and the photographers were on their way.

Nothing is certain until you try.

The same principle applies for you as you begin marketing your shots on a local level. It is true that a few photographers have risen rapidly and almost effortlessly to the top of their market. More often, though, a beginning photographer must struggle and gain through hard work the experience and technical ability that characterizes most success stories.

And, too, there is the unknown quantity in the admixture that is your talent. You've got to be open-minded, willing to learn, willing to take some chances, and most of all willing to keep at it. You've got to *learn* from rejection, not simply react to it. You've got to believe that if one person doesn't like your work, someone else will.

Be assured of one thing: The market is there and waiting for the people who are able and willing to explore it. If you've got the determination, you have every reason in the world to believe you can be successful. Perhaps not right away, and certainly not without a lot of effort, but people are out there buying photographs. More and more every day. You have good reason to believe that some of those photographs could be yours.

STEP TWO: HOW TO ASSESS YOUR WORK

The only effective way to assess your work is the same way buyers will: harshly and realistically. Look at each and every one of your photographs with a critical and objective eye. You know the photograph you like so well that you charitably refer to as "acceptably sharp" but which you really know is slightly out of focus? Get rid of it. Or that terrific scenic you have

where the eagle was flying perfectly through the frame and which isn't more than maybe one-half stop overexposed? Get rid of it; it's not so extraordinary if it's overexposed. The shot with the practically unnoticeable scratch, or the one with the processing spots on it that any buyer would know were the lab's fault and not a reflection on your expertise, or that great shot of Milan that is only a little misframed but which any buyer could fix simply by cropping? You know the answer.

Nobody wins all the time. Not the Yankees, not Henri Cartier-Bresson, and not you. Don't be easy on yourself when it comes to assessing the technical or aesthetic quality of your work. Yes, you've got to build up your self-confidence and believe in your work, but the way to do this is not by being too easy on yourself or by making excuses and rationalizing why your photographs aren't better. You will build confidence and begin to have real belief in the worth of your work when you start to view that work and judge it in the most critical, most demanding terms.

Here's a trick you might find helpful as you sit down to assess individual photographs: Imagine the photograph reproduced in a magazine. Really try to visualize yourself turning the pages, feeling the paper, seeing the words, and then coming across the photograph. How would it look? What would you think of it? What would your criticisms be? Don't forget, once a photograph is reproduced—printed in a magazine—it falls under much more demanding scrutiny. Everything will be noticed.

How well does the photo stand up? Does it look professional? Amateurish? If it were not *your* photograph, what would you think of it?

And if it doesn't stand up to close scrutiny or it doesn't have the look of a professional shot, eliminate it from your files before you proceed to the next step, which is *organizing* your work.

STEP THREE: HOW TO ORGANIZE YOUR WORK

Many photographers have an extremely difficult time organizing their material into a coherent and presentable system. While on the one hand these photographers feel—and rightly so—that each and every photograph deserves to be evaluated on its own merit, on the other hand, they feel that the very act

of categorizing individual photographs into groups is some-how insulting to the integrity of the shots as individual works. Unfortunately, this kind of thinking leads to the same result as a supermarket that doesn't organize its groceries. Imagine walking into a store where the baked beans are stocked with the fish and the lettuce and the ice cream. There is one big pile of food in the middle of the store that customers have to pick through in order to find what they're looking for. The store may carry the best baked beans on the face of the earth, and if shoppers have the time and the patience they might fare very well, indeed. But the fact is they won't have the time and the patience, and they'll shop elsewhere.

Another unrealistic attitude some photographers have is that the consumer should be happy to buy whatever happens to be available. This is like the grocer stocking only baked beans on the shelves and expecting the customers to figure out a way to use them. Obviously, such a technique doesn't work for selling food, and it won't work for selling your photographs either.

There are certain basic rules that are necessary for selling anything, and one of them is the need to be organized.

To carry this analogy a step further, it is true that many people will choose to shop in a particular grocery store not because the food and the prices are better, but because the organization is better. That is, they shop in the store where they are able to find what they need with a minimum of effort. If you can understand how that one fact relates to your own photography then you are better prepared to sell your work than the majority of your competitors.

How, then, should you organize your photographs? Unfortunately, there's no simple answer to this question, because the method you choose very much depends upon the shape and form of your body of work itself. Photographers who specialize have one set of problems; those who shoot more general subjects have another. However, one principle holds true for both: You will not be able to organize your work effectively unless you, the photographer, have a clear understanding of what your work "says." We've discussed at length the importance of communicating thoughts, ideas, and moods with your photographs. Likewise, your success in organizing your photos depends entirely upon your own understanding of exactly what it is your photography will communicate to a potential buyer.

This shot could be filed under anything from "Washington state" to "backpacking" to "mountain climbing," and the category you select will be determined by your work and the needs of your special clientele. Organizing your work properly is crucial to successful marketing.
Photo: Curtis Solonik

Suppose, for example, you have recently taken the photograph of the mountaineer above which was shot in Washington state. If you are oriented toward travel photographs, that is, toward selling your photographs to travel agencies, tourist bureaus, and the like, you would probably have your files organized in such a way that you could file that photograph under "Washington state." If, however, your clientele is geared toward the "sports" or "adventure" market, you might very well file that same photograph under "mountaineering" or "backpacking" or another appropriate heading, so that you would be able to retrieve the photograph quickly when the need arises.

Retrieval is one of the keys. In a large agency, such as ours, where there are hundreds of thousands of photographs, the or-

ganizational problems will, of course, be more complicated than yours as an individual photographer, but the *nature* of the problems is the same. If a photograph we accept is misfiled, it might just as well never have been accepted at all. It will never sell, because it will never be found to be sent to a client. On a lesser scale, the same is true of your own files. If you have that shot of a mountain climber filed under "Washington state" and you get a call for mountaineering and don't remember where you have filed it, the shot will never be shown and never be sold.

But, you're saying to yourself, you have such an intimate knowledge of your own photography that you could never forget where you filed that shot. Don't believe it. What about the clients who tell you they are looking for a shot that says "open spaces" or "freedom" or "escape"? Will that shot automatically come to mind? And if it does, will you know where to find it?

Sometimes, cross-referencing can help. But cross-referencing cannot solve this problem entirely simply because a photograph is a message, a visual statement, and as such, it is subjective and can never be categorized completely.

The truth of the matter is that no matter how much you try, the perfect system for organizing photographs does not exist and never will. In our agency we are constantly reorganizing the files, amending them as we grow and taking into account new trends as the body of work we accept from photographers expands. We are constantly refining our retrieval systems as well, and so must you. Being able to locate photographs quickly and easily is an absolute necessity for any professional photographer, no matter how much work it takes.

Bear in mind that it is important to reorganize your files not simply because they are expanding as you take more photographs. In fact, this isn't even the most important reason. The real reason you need up-to-date organization in your files is so that you will be able to accommodate the changing needs and demands of your *clientele*. In other words, you must anticipate what *they* want and make sure that your files are organized in such a way as to meet their needs. It works in exactly the same way at our stock photo agency.

Let me give you an example.

A few years ago it seemed that everybody was looking for shots of sunfishes, those little sailboats that resemble a surfboard with a sail on it. Hotel people needed them to show one

of the activities a guest at their resort could enjoy; condominium builders who had lakes on their property also wanted photographs to attract buyers. And, of course, boat manufacturers, also enjoying the boom, had endless need for effective mood shots of their product. So we devoted a file exclusively to sunfish shots. If a call came in, the file researchers knew exactly where to go and could almost immediately send to the client a wide selection of photos from which to choose.

Soon, however, the boom in popularity of sunfishes began to wane and clients were no longer calling specifically for shots of sunfish. So, not wanting to lose income from our good supply of stock sunfish shots, we began sending out the same sunfish shots to fill requests for more general travel photos. For example, if we had a call for Puerto Rican travel scenics, we included some sunfish shots from that island. Gradually, it became not only unnecessary but actually counterproductive to maintain a separate file devoted only to sunfish—after all, a sunfish shot taken in Puerto Rico that might very well have sold to a travel company requesting general Puerto Rican illustrative scenics will not sell if the shot has been overlooked in another file. In short, at one time the market dictated that it was most prudent to file a shot under one category—"sunfish." But as that market changed, it became prudent to refile the same shot under "Puerto Rico" in order to maximize its potential for sales.

As you organize your own files you will have to make similar decisions. Organizing files is not unlike arranging a poker hand. You assess each card (photograph) and arrange your hand into the combinations with the most promise. The exact same cards could be arranged into a flush or a straight. It's your decision as to which to go for. So you play the odds and, if your cards (photographs) are good, you have an excellent chance of winning.

In addition to enabling you to retrieve photographs when you need them, your system should also be set up so that it can reaccept those photographs easily when it comes time to refile them. How you accomplish this will, again, depend upon the specific complexion of your body of photographs and the relationship between your photographs and your personality. I know one photographer, for example, who specializes in travel photography and has keyed each of his photographs by number to the Michelin Guide. When he wants to find photographs of any particular region, he need only consult the

guide and relate their numbering system to his own. The same is true when he refiles. If you're starting out, it's unlikely that you will need so elaborate a system, but you *will* need a system of some sort.

Here's another tip that might help as you begin to create a filing system: Never underestimate the value of purely mechanical aids. Filing cabinets, manila folders, accordion files, vinyl sheaths, special boxes you can build yourself, different-colored labels, gold stars, indelible markers, and other such items of a mechanical nature that you can use to key, separate, group, or distinguish your photographs are invaluable. Become familiar with your local stationery store; explain what you're doing to a competent salesperson and ask for suggestions. Take the time to go through their catalogs carefully—you might very well happen across an item you would never have thought of but which could solve your organizational problems.

The same is true of photo supplies, holders, mounts—whatever. Read the photo magazines carefully to be aware of new products or refinements of old ones.

In sum, as you tackle the job of organizing your files, bear in mind these two most important considerations:

1. Your filing system should address itself not just to the subject matter of your photographs but also to how those photographs can be applied to the *market*.
2. The process *never* ends. Your files will always be expanding and the market needs will always be changing. To be effective, your filing system must always be up-to-date, changing and adapting as the needs of marketplace dictate.

STEP FOUR: HOW TO PREPARE YOUR PHOTOGRAPHS FOR PRESENTATION — THE PORTFOLIO

Just about the worst attitude a photographer who wants to sell his or her photos can have goes something like this: "Any photo buyer worth his or her salt will be savvy enough, experienced enough, and perceptive enough to discern the good qualities of my work no matter how I present them. That's what they're hired for and that's what they do well. After all, aren't they like the Hollywood agents who can pick out the stars from all the starlets and would-be actors who cross their paths?"

The truth is, average photographers with well-thought-out and carefully executed portfolios often fare better in the marketplace than more talented photographers with poorly organized, poorly planned portfolios.

Your portfolio is your calling card, your sales force, your public relations department, and your advertising tool all rolled into one—it is the single most crucial selling instrument you have at your disposal. Never make the mistake of underestimating its importance.

There are just about as many types of portfolios as there are photographers, and there is no one type that is best for everyone. Again, how you prepare your presentation is very much determined by your own personality and the nature of your photographs. There are, however, certain guidelines that will be helpful to keep in mind as you prepare your portfolio.

1. *Your portfolio should accurately reflect the style and thrust of your work.* This may sound obvious, but many photographers create portfolios that have much more to do with how they would like to *think* of themselves as photographers than with what their work is really *like*. Thus, the first step toward producing an effective portfolio is to thoroughly analyze, organize, and understand your own work.

2. *Simplify. Simplify. Simplify.* Uncomplicated themes and unified presentations leave an impression. Random presentations leave either no impression or a disorganized one. If you have truly come to understand the body of your work, you will recognize one or two strong themes that run throughout. Discover those themes and present them in your portfolio. Simply.

3. *Don't try to show too much.* Most photographers err on the side of showing too much rather than too little. Showing a portfolio shouldn't take more than five minutes, tops. Never include five photographs on a subject when one will do.

4. *Never include a photograph you have any doubts about.* Your portfolio is only as strong as the weakest photograph it contains. A weak photograph in a portfolio will leap out at the buyer; it may be the only one the buyer remembers after you're gone. Furthermore, if you include even one poor photograph, buyers may assume your portfolio contains every good photo you have ever taken. If, on the other hand, your portfolio contains only great shots, they're likely to assume you have others of similar quality in your files.

5. *Use mounts, frames, etc., tastefully.* Your presentation should show your respect for your own work, not reverence.

There is a fine line between sophisticated, effective presentation and gilding the lily. That line varies; find it.

6. *If you have a specialty, make sure your portfolio demonstrates it to buyers so that they will be more likely to call you when they have those particular photographic needs.* Nothing more than that and nothing less. You are not trying to convince buyers that you are an artist, rather, that there is a good possibility that you have something they need. If your portfolio has done its job, buyers will remember your work, they'll call you, and you'll be on your way.

STEP FIVE: HOW TO SELECT THE MARKET THAT'S RIGHT FOR YOU

If you have accurately assessed your work, developed an effective organizational system, and carefully assembled your portfolio, you should now be able to stake out a market where you have a good likelihood of succeeding.

First, you should become fully acquainted with the guidelines for finding photo buyers that are discussed in chapter 7. These guidelines will help you begin to understand the various markets that exist for photography (some of which even many professional photographers are unaware) and at the same time aid you in developing a sense of how to "stalk your quarry," that is, how to determine the best method of tracing back a photograph that you see in a magazine or other publication to the person who was actually responsible for purchasing it— and who might be in a position to purchase yours.

Suppose you have discovered as you organized your work that your strengths are in three areas:

- General scenics of your home state (say, Virginia)
- Horses, stables, and related subjects
- Thorough coverage of Washington, D.C., in all seasons

Each of these areas has commercial possibilities. Some photo buyers will have potential use for all three areas, some for only one. Most, however, will have use for a combination of all three with varying emphases.

As discussed earlier, markets can be defined either by geography or by subject; you can and should cultivate both markets.

As for the geographically defined market, the best system is to start locally and expand from there. *Now that you've defined your photographic strengths, you've got to start letting*

people know what you have. Prepare a portfolio, making sure it includes your name and the areas of your strength (a business card can serve this purpose nicely). Then contact your local newspaper to show your portfolio. Do the same with any local magazines, ad agencies, advertising consultants, graphic designers, publishers—anyone you can think of in your area who might have need of your material.

Remember, you're a local person with local photographs catering, at this point, to a local market; for these very reasons buyers will often want to help you out, remember you, and encourage you. Take advantage of that.

After a while, if you feel your body of work is strong enough, you can expand into wider markets, to anyone you feel would have potential need for photographs of Virginia, of horses, or of Washington, D.C. But don't forget, the more you extend yourself the greater the competition and the more important it is for you to back up your efforts with photographs of sufficient caliber and variety.

Eventually, if all goes well and you have built up a substantial library of high-quality photographs of marketable subjects, you can begin to think about marketing your work on a national level, probably through a stock photo agency. (See chapter 9.)

However, if you are a relative newcomer still working at creating an extensive library of good stock photographs, your best chance for success often lies in catering to the markets defined by their subject area. Take, for example, your shots of horses. Let's say you have done enough work in this area to have a solid, workable body of photographs of the horses, stables, and farms in your vicinity. Now is the time to let special-interest publications and organizations that address themselves to these subjects know what you have and how to get in touch with you if they need it. Also, contact any local, regional, or national publications that are devoted to horse-back riding and the horse breeding industry. And, if you're in your local stationery store and notice a line of greeting cards specializing in mood shots of horses romping in fields, look on the back of one of the cards to see who manufactured it, and then follow the suggestions in chapter 7 for tracking down the address of the company and submitting some of *your* work for consideration. Don't let yourself be intimidated. These companies are always looking for new material and will be willing to talk to you even though you are not well-known or represented by a huge photo agency with a vast collection of photo-

graphs. First, be sure that your photos are of good quality. Then be persistent.

Even if you have only one subject area of photographic strength, you can still market your work effectively to the specialized markets. Always be on the lookout for advertisers, poster companies, book publishers—anyone who seems to have an interest in photographs of horses. There is no reason you cannot and should not get in touch with them.

So, too, with your Virginia scenics. The state Department of Tourism, for example, is likely to need photographs, as would any advertising agency catering to a client with a specific interest in the state of Virginia. Keep your eyes open. Watch what's going on in the magazines both editorially and in the ad pages. Be on the alert for any possible application of your shots, and then follow up. If you don't, someone else will.

STEP SIX: HOW TO FIND THE RIGHT PERSON WITHIN A COMPANY TO PRESENT YOUR WORK TO

Let's say you have noticed that a local advertising agency has a client that seems to need certain types of photographs you feel you can supply. How can you find out the name of the person who actually purchases the photography?

By picking up the phone and calling the agency.

A receptionist will answer, and you should then identify yourself: "My name is Joe Smith. I'm a free-lance photographer." You state your business: "I would like to speak to the person in charge of purchasing photography for the X account."

The receptionist will tell you who that person is, or say something like, "I really don't know who's in charge of photography for that account, but let me turn you over to so-and-so who is in charge of the X account."

She will transfer the call, and you will then be talking to either the head account person or his or her secretary. Ask your question again. You may be asked again who you are and why you are calling, but once you explain your business you will usually be given the information you want (don't forget that it is the photo buyer's *job* to deal with you).

It's really just as simple as that. There is no reason to be intimidated. Even if you call the largest company in this country, if you're honest, straightforward, and a little persistent you can find out exactly the right person to approach with

your work. Sometimes you may be led to the wrong person, say, the art director of another account. Usually he or she will know who the right art director is and steer you in that direction, but frequently you can also begin to establish a working relationship with the first art director. Who knows, maybe he or she can use your photography too.

Remember to be friendly, helpful, and open to all possibilities. You are a professional photographer and are in a position to supply a company with a product they need. It's in their interest to help you. There's nothing magical or mysterious about it. Even the photo buyers for General Motors and General Mills are just people who sit at a desk and do a job. They are approachable and willing to listen. If you're not selling them *your* photographs, then others are selling them theirs.

STEP SEVEN: HOW TO CONDUCT YOURSELF WITH PHOTO BUYERS

The most important thing to remember when dealing with photo buyers is: Don't waste their time. If you do, they'll resent you and quickly forget you. Or, if they do remember you they'll probably avoid you, making it even more difficult for you to approach them and establish a working relationship with them in the future.

How do you make sure you won't be wasting a buyer's time? By thoroughly understanding what it is you have to offer and approaching only those buyers who can use your photographs.

In New York, for example, there are thousands of art directors who buy photography on a regular basis. However, due to the specialized nature of the market, most art directors concentrate on only one or at most two areas. One art director might work on nothing but fashion accounts, and another might handle automobile accounts exclusively. If you are a photographer who specializes in photographs of automobiles and you make appointments with the fashion-oriented art directors you will be wasting their time. They will expect you to know that because of their area of specialization there is no possibility that they can use your material. By the same token, you are wasting your own time, because you might otherwise have been showing your work to the automobile art director— who perhaps *could* use it.

Do your homework. When you call art directors, know

what you want to say, say it quickly, and be responsive to their questions. If they tell you they have no need for your work, believe them.

Suppose you are calling the art director of a magazine that specializes in articles for parents about their children. You state your name and your business—that you are a photographer specializing in photographs of parents and children in family situations and you would like an opportunity to show your work. The art director will either make an appointment or ask you to call back at a later time. If you do in fact have material art directors should look at, then they *will* see you. It's *their job* to see you.

Understand that you are *their* supplier. They are *your* customers. In that sense, they are your lifeline. Without them you have no job. Likewise, without you and others like you, they won't have the products they need. But be careful not to go to the other extreme and be too sure of yourself or, worse, belligerent. Buyers pick up on these attitudes very quickly in an interview. Don't play the "artiste"; art directors aren't curators, they're employees entrusted to do a job. Sometimes that job involves purchasing photos. When that time comes, you will be expected to conduct yourself as a professional with valuable wares to sell. Maintain an appropriate balance between having a healthy respect for your work and realistically appraising its value to a potential buyer.

Here are some dos and don'ts to keep in mind anytime you are with photo buyers.

- *Do* be open, honest, straightforward, and helpful.
- *Do* have a realistic sense of the commercial value of your photography.
- *Do* respond to any questions completely and willingly.
- *Do* be prepared. Know as much as you can about the buyers—their areas of emphasis, likes, dislikes, etc.—before your appointments.
- *Do* be on time.
- *Do* be positive but not pushy.
- *Do* consider every meeting a learning experience.
- *Do listen* to what the buyers have to say.
- *Do* be alert and on your toes when and if you start talking money.
- *Do* protect your rights and maintain your integrity.

- *Don't* try to bully your way in to see buyers.

- *Don't* adopt an attitude of "artiste."
- *Don't* try to tell art directors how they ought to use your photography.
- *Don't* exaggerate the extensiveness of your files.
- *Don't* exaggerate the extensiveness of your experience.
- *Don't* be *too* eager.
- *Don't* do more talking than listening.
- *Don't* let yourself be intimidated.
- *Don't* be discouraged.

Above all, don't forget that it is *the job* of photo buyers to find good photography and that they therefore *need you*.

STEP EIGHT: CLOSE THE DEAL

In chapter 8 I talk at length about how to price your work and how to negotiate favorable terms. Knowing these principles of pricing and negotiation are crucial to your financial success. As you proceed along and gain experience, these techniques will become second nature and you will automatically adapt them to your own personality and your own set of circumstances.

As you talk with a photo buyer who is interested in purchasing one of your photographs, there will come a time when you will know that you have "come to terms." The money the buyer offers is acceptable, and you are eager to sell the photograph. You are about to close the deal. At this point, it's very important for you to consider not only the immediate sale you are about to make, but also the overall relationship you are establishing with the buyer. It is this relationship that will determine whether you have a *client*—one who will keep coming back to you for more photographs in the future—or merely a customer for a single sale.

What turns a customer into a client? Fairness and a willingness to be helpful.

Part of your job must be to make buyers feel that no matter how much they have paid for a photograph, the price is fair. If they think you have held them over the barrel because they were particularly desperate for your photograph (maybe a project was a rush job and the buyer didn't have time to shop around), they will buy the photograph, but they won't be inclined to contact you in the future. Any time you have the

slightest suspicion that a buyer feels unfairly treated, take it upon yourself to clear the air. There have been many times when I have simply said, "You know, I'm getting the feeling from you that you think I'm a little out of line on this. Maybe we should discuss it, because I really don't want you to feel that I'm being unfair—my interest is in providing you with good photography on a regular basis at a fair price." When buyers hear this kind of sincere response, often they will tell me exactly what they're thinking so that I can respond to it. Usually, with explanation, the buyers will see the reasoning behind the price and will accept it. Sometimes, of course, the discussion yields information that alters the situation, and I will actually reduce the price of the photograph. But had I not taken the initiative and gotten more information from the buyer, I would have kept the price at what was considered an unreasonable level, the buyer's resentment would have smoldered, and very probably I would never again have the opportunity to sell that buyer another photograph.

Thus, when closing any deal, don't be too anxious to take the money and run. Be flexible and willing to negotiate. Remember that anything you say and do now, while it may not affect this sale, can have major impact on *future* sales (to say nothing of your word-of-mouth reputation among other photo buyers).

Everything you do as you close a deal sets a precedent for future sales with that buyer. This includes not only the price you charge but also the conditions you set. As explained in chapter 8, these conditions include such things as the length of time the buyer will be allowed to use the photograph, how many times the buyer can use it, in what territories, as well as the conditions under which the buyer can have an option to extend those original usages.

Be as helpful as you can to buyers; they'll appreciate your efforts and remember you. Let's say a buyer wants to use one of your scenic shots and would like to know the exact location of the shot. He or she might want to know out of idle curiosity *or* out of an obligation to a client. (I recall one instance, for example, where certain legal requirements made it essential for the client that some fairly nondescript pine trees in a photograph be a specific type indigenous to only a small section of the Southeast.) Do everything possible to provide buyers with the information they request as quickly as possible. Certainly you should not challenge their reasons for asking. Suppose a

buyer wants to use one of your shots and mentions that ideally he or she would like a little more room at the top to place type. Be accommodating. If you have other photographs taken at the same time but with just the extra space required, offer to show them.

Don't forget: The key to closing a deal properly is to remember that you are *establishing a relationship,* not just making a sale. Be fair, be willing to help, but at the same time protect your own rights, as any professional would. Strive to find that balance.

STEP NINE: FOLLOW UP — HOW TO AVOID BEING PUSHY

Photo buyers want your help and your enthusiasm. They *don't* want your advice on how they should do their job. Any time you contact photo buyers it should be in the spirit of offering your services if they are wanted; sometimes they will be, sometimes they won't. If you can distinguish between those two times you will be able to avoid being "pushy."

For example, suppose you have sold one of your photographs to an art director for use in a brochure. It is in your interest to get a copy of that brochure. If the brochure is done well and your photograph plays a prominent part, it will be useful to you as a display item in your portfolio. In addition, once you see how the art director has used your shot, and once you see the other shots and how they were used, you will have a valuable understanding of that particular art director's methodology, an understanding that will improve your ability to sell him or her photographs in the future.

When you sell the buyer your photograph, ask for a sample of the brochure when it becomes available. Remember that there is often a considerable delay between the time that you sell your photograph and the actual production of the piece it will appear in. So be patient. If you ask for samples too soon, art directors will very likely tell you that they'll be sure and send you a copy when they get one, then they'll forget about it until you call them again. If you keep calling and keep pestering, they *will* remember—they'll remember not to buy your photographs in the future because you're such a nuisance.

How do you avoid being pushy? Anticipate the needs and problems of buyers, make any requests as easy for them to comply with as possible, and, whenever possible, try to convince them that to do what *you* want is in *their* best interest.

In the case of securing a sample of the brochure with your photo in it, you should consider the following:

Anticipate when you call the art director that there's a good chance that copies aren't out yet and try to make the job easy: "Listen, if you don't mind, I'd like to send you a self-addressed, stamped envelope so that when the brochure comes in you won't have to go to a lot of trouble to send me one." (Nobody throws out envelopes with uncanceled stamps on them, so your envelope will probably sit on a desk as a daily reminder to send you a sample.) Finally, let the art director know that he or she might have a vested interest in sending you a sample. "You know, it really helps me to see how you work so that when I'm out there shooting I can keep in mind your special requirements."

Here are some sure signs that you're pushing your luck with photo buyers:

- When you call, they're never in.
- If they talk to you they seem impatient, overly curt, irritable.
- They make a point of never remembering who you are.

Trust your senses. If you get the feeling you're doing something wrong, you probably are. Back off and try a new approach, or go after other buyers. And be on the alert for those few buyers who seem to get some kind of perverse pleasure out of keeping you on a string. I once tried to make an appointment with a very well-known Madison Avenue art director whose secretary kept telling me that the guy definitely wanted to see me and to call back in two days. This happened three times. Eventually, I found out that the guy was simply playing a power game. He never saw anyone, and whenever possible, he shot all the photographs he needed himself.

Listen to your instincts. They are often a lot sharper and more accurate than you might give them credit for.

Of course, a problem with any "how-to" book is that despite all the theory and explanation and description and examples, the ultimate goal—the end result—fails to reveal itself through the forest of detail. I once read a book on electrical wiring, for example, and when I put it down, I felt as if I knew just about everything a person could know about the subject. I soon realized, however, that it was still magic to me. I didn't honestly believe that it all worked—more importantly, I didn't believe that it *could* work. Eventually, through trial

and error, I found that, yes, it works—not always well, not always the way I would like it to, but, in the end, it wasn't magic.

In order to reduce some of this magical aura, let me present a typical scenario about a hypothetical photograph, a photograph that shares the essential qualities of the thousands I have sold. As the scenario unfolds you'll begin to understand the nuts-and-bolts aspects of the business of photography and start to accept that the process of generating money from your photography really involves no mystery. Luck, yes. Perseverance, yes. But that's all.

Let's say you have been taking pictures for a few years and have pretty well mastered the technical aspects of 35mm photography. Lately, you have been comparing your work to the photographs you see in magazines, brochures, on billboards, etc. You begin to wonder if you might actually be able to sell some of your photos—maybe even make a living at it. Since you have limited funds to spend on photography, you think about potential photographs you could take in your own vicinity that might have value to a photo buyer. Since you live near a lake that is a central recreational gathering place for the community, you begin to concentrate your efforts in that area.

One day you are experimenting with various lenses and exposure times and lighting situations and you take a particularly effective shot of a sailboat, like the one at left. The long exposure time and the backlighting on the waves results in an ethereal, almost impressionistic effect. The photograph says "sailing," but is completely nonspecific to any boat, waterway, or place.

You take that shot, as well as all the others you have on hand, and begin to organize them. Your photographs from the lake fall into several categories: people having fun at the beach, people having fun on the water, general scenics of the area, sailboats, and motor boats. You set up your files according to those categories, but can't decide where to put that one photograph. Certainly, it's a sailing shot, but it's different from the other, sharp-focus, more reportorial shots that you have taken of specific boats. You decide to file it under General Scenics because it seems in its overall mood to represent the flavor of the whole area rather than a single part of it.

You know that the local paper uses photographs, and after looking in your local Yellow Pages, you find that there are several advertising agencies in your town that might need

good photographs. After a great deal of deliberation, you gather your courage, look up the phone number of the newspaper, and call. You ask to speak to the person in charge of purchasing photography and are transferred to a person who says,

"Mr. Platt's office."

"Hello," you say. "I'm a freelance photographer and I'd like to talk with Mr. Platt about showing him some of my recent work."

"I'm afraid we have several photographers on staff and most of our work is done by them" responds Mr. Platt's secretary.

"I understand. However, I've been making something of a study of the lake area and, although I know your staffers are fully qualified, I think I might have some shots that they wouldn't have had the time to cover fully. I thought perhaps he might be interested in looking at them at his convenience."

"Would you please hold on one second?"

After a short pause, Jack Platt comes on the line. After introducing yourself, you repeat what you told the secretary. "Well," he says. "As it turns out, we're doing a special Sunday feature on the lake in a few weeks and we might be able to use some fresh material. Why don't you come in and show me what you have."

When you arrive for your appointment, you are organized, your presentation is professional, and you have a helpful, friendly attitude. Platt seems interested. He tells you that as far as the more reportorial aspects of the lake are concerned, he feels his staff photographers have provided him with all the photos he needs. But, since the special feature will be a whole section in the Sunday paper, he needs a more general "mood" shot to lead it off.

You pull out your "general" file, he sees your sailboat shot—and likes it. He wants to buy it, so you negotiate a price and finalize the sale. You've done it; you've sold a photo.

Encouraged by your first success, you decide to approach some of the ad agencies in your area. You call up an agency and tell them your story. You talk to the art director, who sets up an appointment to see you because he can always use good photography and it's his job to be aware of what's available.

Each time you meet with an art director, you are helpful, communicative, and accessible. You begin to develop a reputation as a commercial stock photographer.

Eventually, an agency contacts you. One of its clients, a bank, wants to do a promotion for loans to potential boat buyers, and the art director needs a generic boat photograph. He remembers you and calls you in. You show him your shots of boats.

He buys your shot. Second sale.

You continue to sell photographs to the newspaper and to the ad agencies. The photo buyer at the newspaper recommends you to his friend, who is the art director of a regional magazine. He, also, puts you on his list of photographers to call when he needs material.

You keep in touch with them. You begin to anticipate their needs. You are constantly shooting more and better material. You have become a valuable supplier to them, and they have become your clients.

As your files expand, as you become more knowledgeable, you begin to think that perhaps you can compete in a larger market. So, you begin to think about a stock photo agency to handle your photographs. (But you keep your wits about you. You bear in mind all the principles and warnings described in chapter 9.) After a careful search, you and an agency find each other.

One day, after your photos have been on file for a while, the advertising agency for a nationally-advertised shoe company contacts your agency. They have a new sneaker they want to market to boating enthusiasts and they need a photograph for background. Your sailboat shot is sent out along with other boating shots, and yours is selected. It sells for two thousand dollars.

Is this scenario far-fetched? Not at all. Similar success often accrues to those with talent who go about selling themselves and their photography systematically and with confidence. But remember, it won't happen unless you *make* it happen. Others have done it; so can *you*.

Let me say it again. Selling your photography is nothing more than a combination of taking photographs for which there is a need and then getting those photographs in front of people who indeed have that need.

Don't hide your light under a bushel. Get your work out where it can be seen. If your work is good, and if you aren't afraid to go after the market—sure enough, people will pay you for it.

6

What Every Photographer Should Know About Advertising Agencies

YOUR BIGGEST CLIENT MAY BE IN YOUR OWN HOMETOWN

New York City's "Madison Avenue" has become synonymous with "advertising," because for years many of the largest and most successful advertising agencies have maintained their offices on Madison Avenue. This has led to the widespread but erroneous belief that the only agencies of importance are located in New York City, specifically on those renowned few blocks of midtown real estate.

Actually, there are thousands of advertising agencies all across America, and almost every town can boast of at least one. For example, in my old hometown, Norwalk, Connecticut, there are no fewer than seventy-three advertising agencies and advertising consultants listed in the Yellow Pages. What's more, any agency, regardless of its size or location, has the potential for becoming a regular purchaser of your photography. And of all your sources of income, from magazines to greeting cards to art galleries, none pays more—consistently—than the advertising agency.

In short, it is not unrealistic to assume that you can earn a confortable, even a luxurious, livelihood as a photographer simply by cultivating a good working relationship with only a few of the ad agencies that probably exist right in your area.

However, you are not going to accomplish this simply by hanging out a shingle emblazoned "Photographer." Rather, your success will depend in large part upon acquiring a thorough understanding of why ad agencies exist and how they operate—and upon your using this knowledge to your best advantage.

THE BIRTH OF AN ADVERTISING AGENCY (AND THE 15 PERCENT DISCOUNT)

Let's trace the inception and development of a fictitious advertising agency, pausing where appropriate to emphasize and elaborate on important points. Along the way, you'll learn about the need ad agencies satisfy, how they go about their business, and why they need you as much as you need them. By the end of this chapter you should have a clear idea of the people who comprise the ad agencies and how to work with them to maximize both the likelihood of your selling them your photographs and the money you can expect to receive.

Some years ago, in a little town we'll call Willoughby, Vermont, a representative of the local newspaper, the *Willoughby Chronicle,* approached the owner of the women's apparel store and told her that if she paid the newspaper one hundred dollars, the *Chronicle* would advertise the items she was selling. The newspaper representative pointed out that for a mere one hundred dollars the store owner might increase her business substantially.

The owner thought about it and decided that, yes, advertising was probably a pretty good idea, but she had no idea how to prepare an ad. "Don't worry," said the newspaper representative. "You just tell us what you want to get across, and we'll do the rest."

So the owner described the merchandise she carried and explained that she was going to put everything on sale for a three-day period.

The newspaper's representative then went back and told his people to make up an announcement for the store and print it in the next edition. Then he sent the store owner a bill for one hundred dollars.

Sure enough, the store's sales volume increased so much that the owner decided to take out another ad. And then another one. Eventually she was advertising on a regular basis.

Then one day the store owner called the paper's representative and explained that she was getting tired of the same old ads, that she was facing new competition from a store across the street, and she wondered if maybe there wasn't a way to add a little more pizzazz to her ads.

The representative said he knew a couple of free-lancers, E. Fitzgerald Appleby and Phyllis Rosencrantz, who specialized in pizzazz and that he'd talk it over with them and get back to her.

The representative contacted the two specialists and presented them with an idea: "Listen," he said, "I have this woman who wants to add some sparkle to her ads. I happen to know that you two are very creative, and I think you could come up with some good ideas

for her. What I want you to do is talk it over with her and use all your creative juices to produce ads for her that I'll run in the *Chronicle*."

"Fine," they said. "What's in it for us?"

"Okay, here's the deal. Right now she's paying us one hundred dollars for a full page ad. If *you* create the ads and place them in my paper, I'll give you a fifteen percent discount. That way she can give the one hundred dollars *to you* and you have to pay me only eighty-five dollars. You get to keep fifteen bucks. And she should be perfectly happy to go along with it because it's not costing her one cent more to have you do the work."

"Sounds pretty good," they said, "but when she hears you're giving us a fifteen-percent discount, won't she want the same thing?"

"Okay, I'll make you a deal. I'll only give the fifteen-percent discount to recognized advertising agencies—that's you—and if she tries to go directly to me, I promise to charge her one hundred dollars."

"Why don't you just let her pay you the one hundred dollars and then *you* can give us the fifteen dollars for our trouble."

"Because it's better for me in the long run to disassociate myself from the preparation of her ads. She's got a competitor across the street that I'd like also to sell ad space to, but if they think I'm playing favorites, they won't buy space. You're completely independent from me. If you create the ads, I can take them from all comers."

"But you're still out the fifteen bucks."

"Sure, but I figure it this way. If you're making money placing ads in my paper, you're going to be out there drumming up new clients. In the long run, I'll make out fine."

Thus did Appleby and Rosencrantz join to form "A&R Advertising."

This is still the way advertising agencies make their money. They work for the client but are paid, in essence, by the publication—newspaper or magazine. The arrangement works for the clients because they are getting a service they do not have to pay for, and the publications like it because it brings them new business and relieves them of the chore of having to create ads for their customers. And it's all based on a 15 percent discount given to recognized advertising agencies.

How much does that 15 percent mean to the agency? Look at it this way. Let's say the agency creates an ad that is to be placed in one publication whose page rate is $1,000. The agency nets $150 for its efforts. But suppose that same ad will be run three times in that same magazine. The *insertion costs* (the fees payable to the magazines before the 15 percent dis-

count is applied) are now $3,000, so the agency nets $450 for the same amount of work. Let's further suppose that the ad was to run twice in each of five national magazines. That's ten insertions—not uncommon. Some prestige magazines have page rates for one insertion of upwards of $50,000. That means the total insertion costs to the magazines could be as much as $500,000. All of a sudden the agency's 15 percent of the action becomes a cool $75,000—all for the same ad that in the first example yielded only $150! With returns like these, it is not surprising that advertising is big business, and that "A&R Advertising" prospered.

WHAT THE 15 PERCENT DISCOUNT MEANS TO YOU

The amount that an advertiser pays to the magazine for an ad can directly affect what the advertiser is willing to pay you for your work, so *determine as early as possible how your photography will ultimately be used.* For example, if your photo is to be in an ad placed in a small magazine that is charging only a few hundred dollars for the space, the advertiser may be unwilling to spend a great deal for photography. If, however, the ad will appear in magazines charging many thousands of dollars for their space, the cost of photography pales by comparison, and you can usually negotiate a higher fee (see chapter 8). Common sense tells you that if an agency is making $75,000 for an ad, they're much more inclined to pay big money for photography than if they're making $150.

THE 17.6 PERCENT MARKUP

As their business started to expand, Appleby and Rosencrantz found that they were providing a variety of extra services to their clients, such as market research and media planning (more about these later), all of which were being billed directly to the client, since A&R's profit was limited to the difference between what it cost them to insert an ad and what they billed the client. Analyzing the situation, it seemed only logical and fair that some of these extra expenses and services should be billed to the client. But wasn't it also logical and fair to make a profit on the items too? Certainly it was, but how much should the markup be?

Seventeen-point-six percent. If you spend much time around people in the "ad game" you'll hear that number a lot. What is it? What does it mean? For the answer, let's return to that 15 percent discount publications give to ad agencies.

Fifteen percent of one hundred dollars is fifteen dollars—which leaves eighty-five dollars (15% × $100 = $15; $100 − $15 = $85). The publication sends a bill to the ad agency for $85. The agency then sends a bill to the client for the original $100. *From the agency's point of view,* in order to bill the client $100 the agency has had to mark up the $85 bill sent to them by the newspaper or magazine by $15, which is 17.6 percent of $85. (Mathematically, a 15 percent *discount* is the exact equivalent of a 17.6 percent *markup.*) Thus, if an agency placed an ad for a client in a number of magazines with varying rates, they would take all the bills from the magazines (all of which reflect a 15 percent *discount*), add on a 17.6 percent *markup,* and bill the client. The agency's profit is that 17.6 percent markup.

Gradually, as the standard relationships between ad agencies and clients evolved over the years, often (but not always) the agency would be able to bill for reimbursement of expenditures for supplies and services required in order to produce the ad—costs such as typeface and artist's materials and paper and even, sure enough, photographer's fees.

Therefore, it is important for you to *determine if the ad is being prepared with a standard markup or on a contract basis.* From the photographer's point of view, the 17.6 percent markup is very advantageous. Let's say the agency hires a photographer at a fee of $100 to take a photo to be used in an ad that will be placed in a magazine at an insertion cost to the agency of $500. The agency would add the $500 and the $100 together for a total of $600, and then mark up the whole thing by 17.6 percent and bill the client a total of $705.60. In other words, the agency is also making a 17.6 percent profit *on the photographer's fee.*

You can see what's happening here. If the agency's profit is a markup on your services as a photographer, it is in the best interest of the agency *to pay you as much as possible* (while still maintaining its basic responsibility to its client). The larger your fee, the larger the actual dollars in their 17.6 percent markup. Thus, if the agency has budgeted, say, $200 for photography and obtained the client's approval to spend that amount, you are not doing the agency any favors by shooting

for less. They, the agency, are not paying your fee, the client is—plus the markup for the agency.

What does this mean to you? It means that if you determine that the agency that wants to buy your photography is working on a straight markup basis, you can assume that in general they will have no objection to paying you as much as the client will allow, and you are in a strong position to be paid that entire amount, *assuming you ask for it*. An ad agency that has integrity—and most do—would never commit more of its client's money to a job than it had to in order to complete that job successfully. But the fact remains that neither you nor they have anything to gain if you set your fee too low.

OTHER WAYS AD AGENCIES MAKE MONEY

There are other ways agencies set up their fee structures with their clients that aren't quite so favorable to the photographer.

Many ad agencies—particularly the smaller ones—frequently *contract* their jobs on a "package deal" basis. The agency will agree to do the job, whatever that job is—from creating and placing ads to designing and producing "collateral material"—for a specific set fee with everything included.

Let's say, for example, a shoe company needs a catalog showing its line of shoes to prospective retailers. The company will need five thousand copies of the catalog to distribute to stores around the country. The ad agency will put together an estimate of the costs to produce the catalog, including everything—photography, printing, paper, design, etc. It will add on a reasonable profit for itself and then tell the client it will do the entire job for, say, $10,000. If the client agrees, the agency will set about producing the job in the most cost-effective way possible, because every dollar the agency can save in production expenses is a dollar in its pocket. If it turns out the agency's cost estimate was too low and it actually spends $11,500 to produce the catalog, the additional $1,500 might very well come out of its own pocket. Therefore, those who run the agency have a very real interest in getting their materials—and that includes your work as a photographer—as inexpensively as possible while still delivering the quality the client expects. Thus, when they are negotiating how much they

will pay you for your work, keep in mind that they will plead a tight budget, abject poverty, starving children—whatever they can think of to get you to lower your price. *You still have a right to earn what your photography is worth, it's just that you'll have a harder time getting it.*

WHO CAN HELP YOU AT THE AD AGENCY

As A&R Advertising continued to thrive, it soon became apparent that the business had two somewhat distinct aspects. On the one hand, it was necessary to attract new clients and keep them happy. On the other hand, it was necessary to create the ads themselves. E. Fitzgerald Appleby's refinement and schooling made him a natural choice to take charge of the "account" side of the firm, and Phyllis Rosencrantz's artistic flair led her to concentrate on the "creative" side of the business.

As their business boomed, not surprisingly the partners found that they had more work than two people could handle alone. So Appleby employed some people he felt would be skilled in handling accounts and called these people "account executives."

At the same time, Rosencrantz hired the most creative people she could find to help her. She placed herself in charge of the creative division and dubbed herself "creative director." The people she employed became "art directors" (who create the visuals on an ad) and "copywriters" (responsible for coming up with the words). From humble beginnings, the agency had grown to include thirty employees.

From the huge New York City agency with billings of millions of dollars, to the small local firm whose clients are the town bank and the neighborhood car wash, all agencies are comprised of the same two divisions: the "account" side and the "creative" side, each with its own "personality."

The account side is responsible for soliciting new business, and, once the account is secured, for making sure the client is kept happy at all times.

A stereotypical (and somewhat unfair) description of account people would be that they wear three-piece suits and are the type of people you think of as being in the "ad game" and who like to take an idea and run it up the flagpole to see if anyone salutes. They are notable for their ability to speak the same language as their clients. Tongue in cheek, some say the success of account executives is directly proportional to their

ability at all times to tell clients exactly what they want to hear.

The "creative" side, on the other hand, is responsible for actually producing the ads, brochures, displays, packages— whatever work has been solicited for the agency by the account side.

People in "creative" often shun suits and ties, and they also seem to possess an antipathy toward the account side's preoccupation with deadlines and "bottom lines." Why? The creative side frequently feels the account executives don't understand them and don't appreciate that the creative process often requires a good deal of time. To be sure, being "creative" is frequently accompanied by certain behavior patterns that to the outsider might seem bizarre and which the account executives sometimes characterize as "strange," "offbeat," and occasionally even "psychotic."

Popular mythology has it that art directors and copywriters tend to be "frustrated." Supposedly, all art directors want to be painters and all copywriters hope to become novelists. This cliché, like most, contains a certain amount of truth.

Nonetheless, although the account side and the creative side often appear to be adversaries, in the most successful agencies a genuine harmony exists between the sensibilities of the more stolid, businesslike account people, on the one hand, and the more flamboyant, impassioned, creative people on the other.

Your concern as a photographer will be primarily with the creative people in an ad agency, because it is they who are in a position to buy and use your photography. (Don't, however, make the mistake of neglecting the account side altogether, because whereas the creative people decide *if* your work will be used, the account people often determine *how much* you will be paid for it.)

The Art Director. Specifically, the person for you to see in an ad agency is usually an *art director* since he or she, more than anyone else, is likely to be the one who will make the decision to use your photos.

Despite the somewhat imposing title, I've found that regardless of the size of the agency, art directors and copywriters as a group tend to be extremely likeable, hardworking, and, at times, even brilliant. Some of the most enjoyable and inventive conversations I've ever had have been with groups of

these people. Many art directors are quite approachable and often more than willing to help out beginning photographers if they show promise.

The Art Buyer. Many ad agencies buy so much photography that rather than have each art director maintain separate files of photographers, illustrators, artists, stock photo agencies, etc., they centralize those files with an art buyer. It is the job of the art buyer to run a sort of command center for the purchasing of photographic services. If, for example, an art director is working on a project and needs a stock photograph, rather than calling the potential sources of that photo directly, the art director will tell the art buyer exactly what's needed. The art buyer will then draw upon his or her up-to-date familiarity with photography sources to choose those photographers and agencies most likely to be able to fulfill the request. In some agencies the art buyer has almost complete control over which photographers and photography the art directors ever get to see. As a result, they can be extremely important to photographers who hope to sell their work to that agency.

The Production Manager. A production manager is responsible for the nuts-and-bolts operation of carrying the art director's conception from idea to reality. If the agency is producing a brochure and the art director has specified a certain type of paper, the production manager will know how and where to get it. The production manager might also select the most appropriate printer to produce that particular piece. And at times, usually on jobs of lesser importance to the agency, the production manager can be responsible for purchasing photography. Even though the job might be a minor one from the agency's point of view, it can mean good income for you as a photographer. You should get to know production managers, where there is one. Even if they can't purchase your work themselves, they can often tip you off to what's going on in the agency and possibly give you a lead that will result in a sale to an art director.

The Receptionist. That's right, the person who sits at the front desk and answers the phone. At most agencies, the receptionist is probably accustomed to being treated like a functionary, but if you make an effort to be friendly to the receptionist you may be surprised to discover what a wellspring of information he or she can turn out to be. It is utterly astonishing how much a receptionist often knows about the innermost

workings of an agency. A receptionist who likes you can be of inestimable help in getting you in to see the right person at the right time.

WHERE YOU AS A PHOTOGRAPHER FIT IN

So far we've discussed why ad agencies exist, how they make a profit, and how they are structured, but you still need to know about the actual physical production of an ad so you can understand where you fit into the picture. So let's once again peer into the workings of our now tremendously successful ad agency and follow an ad from original idea to finished product.

Mr. Appleby, as chief of the account side, has persuaded one of his agency's clients, Intergalactic Airlines, of the wisdom of increasing its advertising. Mr. Appleby is extremely interested in having Intergalactic do this, because every time Intergalactic increases its advertising, A&R Advertising, Inc., increases its profit.

It seems that Intergalactic has scheduled daily flights to a small island in the Caribbean. Unfortunately, the few people who have even heard of the island did so in connection with the fact that for the last twenty years the U.S. Navy has been using it for target practice. Thus, the advertising manager of Intergalactic presents the challenge to Mr. Appleby: "We have a twofold objective. One, we want to make the public aware of this island as an appealing place to vacation. Naturally, toward that end we want to emphasize the positive aspects of the island (deserted beaches, beautiful weather, etc.) while underplaying the negative aspects (unexploded bombs). Second, but equally important, we want potential visitors to use Intergalactic as the airline of choice to get them there."

"Not to worry," Mr. Appleby says to the Intergalactic advertising manager. "I'll turn it over to Creative, let them noodle it around a bit, and see what they come up with."

Whereupon he dumps the problem in Phyllis Rosencrantz's lap. As creative director, Ms. Rosencrantz selects one of her art directors and one of her copywriters to work on the project. Meanwhile, other members of the staff (the *market researchers*) set out to determine which segment of the population is most likely to want to take advantage of the flight Intergalactic is offering and what the best magazines are in which to place ads that will reach that segment (the task of *media planners*).

The art director and the copywriter, after innumerable discussions with other members of the agency as well as representatives of the client, eventually hammer out a "concept." For visual impact,

the art director wants to use a photograph of a vast expanse of deserted beach bathed in the pastel glow of a Caribbean sunset and complemented by the use of a subtle, understated typeface that suggests the quiet solitude of the island.

The copywriter has come up with the following headline: "Intergalactic—The Only Airline to Places You've Never Heard Of." In addition, somewhere in the ad (the exact placement is up to the art director) the copywriter wants to list some of the island's attractions:

- A pervasive stillness
- Tropical sunshine by day and cool Caribbean breezes in the evening
- An island rich in military history
- Merely three and a half hours from New York

The art director makes a sketch of the photograph of choice and places typeface over it to approximate the eventual look of the ad. This "dummy" or "comprehensive" is presented through the chain of command from the creative director to the account people and eventually to the client. At any step along the way, the client can reject the ad concept, at which point the art director and copywriter must either make changes or start all over again. Eventually, a "dummy" gets client approval and the ad is ready to be produced.

This is the all-important moment when the art director starts looking around to purchase a photograph. There are two choices: The art director can hire a photographer to go down to the island and shoot the photograph, or the art director can purchase the use of a photograph that already exists—a stock photograph.

In this case, the art director decides to look for a stock photograph. There are a few reasons for this decision. First, despite the fact that the art director's primary responsibility is to produce the best ad, he or she is also aware that the advertising agency and the client it works for are both businesses—run by business people with their traditional interest in keeping costs down, or at least reasonable. It would cost a great deal to fly a photographer to the island, pay the photographer's fee, and, in addition, pay expenses for however many days it took to get the shot.

Also, if the art director hires a photographer on an assignment basis, the art director is committing the ad agency to the expenditure without any real idea what the photographer will come up with. If, for example, the photographer is confronted with torrential rains while on the assignment, the agency is nonetheless liable for the fees, even if there are no useable photographs.

In addition, the project for Intergalactic does not require a very complicated photograph that includes elaborate setups or products. The art director needs only an outstanding "generic" shot of a deserted beach, so an appropriate stock photo will do the job. Even if

there is the equivalent of an assignment photographer's fee for the use of the photo, the art director will at least be saving the cost of transportation and accommodations. And, most important, the art director will be able to *see* the photograph before buying it.

Having decided to look for a stock photograph, the art director will then do one of two things: (1) contact a number of photographers and ask them to send whatever photos they have of deserted beaches, or, more likely, (2) call a stock photo agency. The agency will take the order, drawing on its experience to ask the art director the right questions to discern exactly what kind of photo is desired. Then the stock agency will have a trained researcher go into their files to make a selection from the work of the various photographers it represents. The stock agency will often charge a "research fee" for its efforts, which the art director is usually more than willing to pay in exchange for the convenience of having the stock photo agency do the legwork.

Once the art director has received and reviewed the photos sent by the stock agency, he or she (either alone or in concert with other members of the agency and representatives of the client) will select one of the photos for use in the ad. The art director will then have a print made of the photo to the exact size that the ad will appear, lay type over the print, and make a finished "comprehensive" to send again through the chain of command for final approval.

At this stage, someone, usually the account executive, will want to have some kind of cost estimate—specifically, how much the ad agency will have to pay to use the photograph.

If the art director has obtained the photo from an individual photographer rather than a stock photo agency, the photographer will often base the price on how much the fee would have been had he or she been commissioned to shoot the photograph on an assignment basis (although frequently that price will be reduced, especially if the only reason the art director initially decided to use a stock photo was a tight budget).

A stock photo agency usually determines the fee it charges by the amount of exposure the photograph will receive. For any given usage, there is a range within which it hopes to get the ad agency to pay, with the ultimate price being determined by negotiation.

Once a price for the photograph has been established and the ad has received final approval from the client, it is ready for production and ready to be placed in the newspapers and magazines that the media planners have selected as being the most appropriate.

If the ad works—that is, if it increases the sales of Intergalactic tickets sufficiently to please the client—then everyone is happy, and the role of the ad agency has been successfully filled. And if it doesn't work, Intergalactic might very will start looking around for another agency, and the art director could be looking for another job.

So there you have it. Perhaps this chapter provided you with more than you *want* to know about ads and ad agencies, but let me assure you that it contains nothing you don't *need* to know. In fact, a few points could bear emphasizing.

For one thing, the production of an ad is a logical, orderly process that has as one of its main features the use of photographs.

For another, there are so many reasons for an art director to use a stock photo instead of an assignment photo that it is no wonder the field of stock photography is growing by leaps and bounds—as is the money to be earned.

Finally, though ad agencies can be imposing, remember that they are staffed by human beings, employees who, in most cases, will welcome you because you have that very thing they search for constantly: good photography.

7

A Complete Strategy for Locating Buyers

No one photographer can expect to sell his or her work in every market to every buyer. And it is not likely that any two photographers will have styles so similar that their efforts are best directed toward identical markets. The overall market is so vast and its needs so varied that your tactic must be to pinpoint those potential buyers best suited for the kind of photographs that you, personally, have to offer.

Several publications exist that purport to be exhaustive guides to the photography marketplace. These books contain lists of consumer magazines, trade publications, ad agencies, greeting card companies, calendar companies, and the like. The fact is that no *one* source book can possibly list all the best outlets for *your* photography. The market for photography is too broad, the needs of photo buyers are too diverse, and, most important, *those needs are constantly changing.* Moreover, the guidebooks are no more than summaries, often edited by people who really have very little practical experience in selling photographs. These source books have a use, but that use is limited, and you would be doing yourself a disservice were you to rely on only such source books to obtain leads to potential clients.

Unfortunately, even if I were able to draw up the perfect list of potential buyers for you, it would probably be outdated by the time this book goes to press (yes, the market changes that rapidly). Instead, I am going to present you with something far more valuable than a list: a strategy for finding the relatively unknown sources that will provide you with a personalized list of buyers *tailored to your own photography.*

Of course, what I am going to suggest involves a little more effort than relying solely on the general-audience source books, but the difference in results can be dramatic.

The remainder of this chapter is divided into two sections: (1) an overview of some resources we'll be referring to later and (2) ways to combine those resources with some basic legwork into a strategy for finding the specific clients most likely to buy your photographs.

The most marketable scenics are basically simple and uncluttered and they powerfully evoke a sense of mood. *(Bob Grant; H. Scanlon; Ed Pieratt; Jack Elness)*

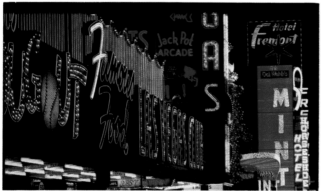

Unusual angles and compositions can often add interest to otherwise overphotographed locales. Unique treatments can also increase sales to photo buyers. *(A. J. Hartman; Derek Sasaki)*

An effective stock photograph will not only depict a subject, it will also evoke a mood. This shot was selected by an orange-juice company for use in national TV ads. *(Mark Helterline)*

Learn to "say" things with your photographs. Whether you are trying to suggest "moisture," "refreshment," "power," or "longevity," use your subject to convey *ideas*. (*Mark Scanlon*)

Specializing in such specific areas as underwater or aerial photography can give you an edge when it comes time to market your work. (*Christopher Stogo*)

Don't overlook the recreational sports. There is a wide market for shots such as this in the hotel, resort, travel industry. This particular shot has sold ten times. *(Tom Grill)*

A canny photographer can use sports to express any number of ideas with wide application. Note how the boxing shot can convey "power," "punch," "determination," and "fatigue," and the track shot can convey such ideas as "speed," "teamwork," "precision," etc. *(R. Michael Stuckey; H. Scanlon; Judy Yoshioka)*

Keep a sharp eye out for small details that can tell a whole story. Note how the trowel turns a still-life of vegetables into a highly marketable gardening shot. Stock photo agencies look for photographers with this story-telling ability. *(Lynne Waller; R. Michael Stuckey)*

Notice how the photographer has left plenty of room around the subject for an art director to crop in and place type over the photo. This shot has been used in at least ten different ways for airline ads, hotel brochures and resort promotions. *(Tom Grill)*

In any given locale always look for the "key" shot around which an entire travel spread can be built. (*A. J. Hartman; H. Scanlon*)

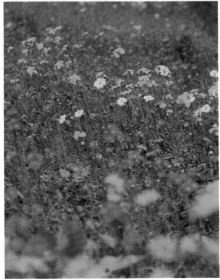

You will increase the sales potential of your flower shots if you remember that these photographs are often bought for *background* usage; that is, the buyer will place another photograph of a product in front of your shot. *(Lynne Waller; Sam McVicker)*

A good stock photograph will be simple but versatile. This shot has been used to denote "autumn," "the passage of time," "eternity," etc. *(Jack Elness)*

An effective travel photograph need not be of a building or a city. This shot, taken in Idaho, successfully suggests the fertility and expansiveness of that region. An advertising agency with an agriculture-oriented clientele might select this shot for an ad. *(Mark Scanlon)*

There is always a ready market for good seascapes and dramatic skies, and you can give yourself an advantage over the crowd if you master the principles of selling your photography. *(Mark Scanlon; H. Scanlon)*

The key to photographing children is spontaneity. Use of familiar props in natural settings can help divert the child's attention away from the camera. Also, remember that photographs with people in them can often command higher prices. *(Tom Grill)*

RESOURCES

Source Books

Here are the most useful source books around. Some are readily available in libraries and bookstores, but some you may need to obtain from an art director you know. (Of course, you can always buy the books directly from the publisher, but some books are quite expensive.) Read through this list quickly so you'll be familiar with the items on it when we refer to them later in the chapter.

> *Literary Market Place (LMP)*
> R. R. Bowker Co.
> 1180 Avenue of the Americas
> New York, New York 10036
> (212) 764-5100

Perhaps surprisingly, two of the best books for photographers are aimed primarily at writers. *Literary Market Place* can be an invaluable source book to photographers who hope to sell their work to book publishers and magazines.

It lists all major U.S. publishers as well as key employees within those companies. In addition, it cross-lists publishers by fields of activity (calendars and posters, games and puzzles, large-print books, paperbound books, etc.) as well as by subject matter (history, cooking, horticulture, etc.).

The *LMP* also has a directory of magazine and newspaper publishing that includes most of the major publications you're likely to run across. These too are cross-classified by subject interest.

You will also find some stock photo agencies listed, although the information is brief and not at all comprehensive.

> *Writer's Market*
> Writer's Digest Books
> 9933 Alliance Road
> Cincinnati, Ohio 45242
> (513) 984-0717

Writer's Market is somewhat similar to *Literary Market Place* but gives a more concise, informative description of the editorial thrust and intentions of each publication. In addition, it gives details of the magazines' policies regarding photography when that information is available. Magazines are conveniently grouped by subject interest.

Writer's Market also has an extensive listing of greeting card companies that includes general descriptions of the types of cards the companies create as well as a list of some of the stock photo agencies.

In general, *Writer's Market* has good, solid information that a budding stock photographer can make excellent use of. It's a good buy.

> *Photography Market Place*
> R. R. Bowker Co.
> 1180 Avenue of the Americas
> New York, New York 10036
> (212) 764-5100

Photography Market Place is a good idea that is still trying to fulfill its promise. Published by the same company that produces *Literary Market Place,* it attempts to do for photographers what the *LMP* does for writers; unfortunately, it falls short. Its listings of photo buyers are far from exhaustive, if not wholly inadequate. It can, however, provide a valuable overview of the marketplace and can serve as a starting point for more in-depth research.

Categories include: picture buyers (ad agencies to consumer magazines to house magazines and filmstrip companies), equipment sources, photographers' representatives (you're much better off going to the Society of Photographers' and Artists' Representatives [SPAR] for this; see chapter 9), stock photo agencies, etc.

> *Photographer's Market*
> Writer's Digest Books
> 9933 Alliance Road
> Cincinnati, Ohio 45242
> (513) 984-0717

Much better is *Photographer's Market,* by the Writer's Digest people. With each listing it gives detailed information about the photo requirements of the publication, including fees and technical restrictions (film size, format, etc.). It also has sections on consumer magazines, ad agencies, book publishers, company publications, trade journals, etc., as well as on stock photo agencies. Once again, these listings are far from complete, but this book provides an excellent overview and is a good starting point for your marketing research.

The Local Library

Your local library can be your best friend and most valuable ally for breaking into the photography business. Get to know all the periodicals (magazines and newspapers) your library subscribes to. If they have any or all of the above-listed directories, study them thoroughly and learn how to use them. If your library doesn't carry one or more of them, see if you can get your librarian to order them.

A good librarian will know how to use all the reference materials the library has on hand. Explain to him or her that you are a photographer seeking new client sources. Often, the librarian will be able to help you turn the library's reference room into your own personal market research department. Once again: *Make friends with your local librarian.*

Advertising Directories

Since the most lucrative photography sales are usually made in connection with advertising usages, you should know where to find leads to and information about advertisers and advertising agencies.

> *Standard Directory of Advertising Agencies*
> National Register Publishing Co., Inc.
> 5201 Old Orchard Road
> Skokie, Illinois 60076
> (312) 966-8500

In the trade, *Standard Directory of Advertising Agencies* is known as "The Agency Red Book" because of its bright red cover. The Red Book is an extremely well-wrought compendium of over 3,500 of the largest advertising agencies in America. It includes the key personnel in each agency, the agency's approximate annual billing, a breakdown of its billing by media (that is, magazine, newspapers, radio, etc.), as well as its list of clients. Used in conjunction with the following book, the Red Book can be invaluable to you as you cultivate the commercial market.

> *Standard Directory of Advertisers*
> National Register Publishing Co. Inc.
> 5201 Old Orchard Road
> Skokie, Illinois 60076
> (312) 966-8500

The *Standard Directory of Advertisers* lists over 17,000 companies that advertise their products either nationally or regionally. The listings are categorized ("airplanes," "household appliances," "wines and liquors," etc.), and for each company the directory provides the name of the ad agency that develops company's ads. This book makes it possible for you to track down those ad agencies likely to need your work.

The Yellow Pages

That's right, the phone book Yellow Pages. There are many more advertising agencies, for example, than those listed in the Red Book. Simply because an agency in your town is too small to qualify for inclusion in the Red Book doesn't mean the agency isn't in a position to buy your photography. Contact the ad agencies listed in your Yellow Pages to let them know you exist. That goes as well for graphic designers, publishers, and anyone whom you can think of in your town who might have use for your work. The Yellow Pages can often be your first step in assessing your local market. Don't be afraid to use them, and don't *forget* to use them. And remember that your library has copies of phone books from all over your state and for major cities throughout the country.

The Local Newsstand

Never underestimate the importance of simply keeping your eyes open and being aware of what's going on around you. Take a good hard look at all the magazines that come into your area—and remember, just because a magazine might not appeal to your own interests doesn't necessarily mean it's not in a position to buy your photography. Scour your newsstand not just for the national publications but also for the magazines whose readership and distribution are pointed more directly at your own locality. Be alert, be thorough, and be canny—pretty soon you'll develop an instinct for finding new sources for selling your photographs.

Insider Sources

Every industry produces publications few outside the particular industry know anything about. If your level of enthusiasm and energy (and/or the degree to which you have decided

to specialize) is such that you feel the need to delve more deeply into certain markets, you should know about certain "insider" publications available (for a price, usually a pretty stiff one) from various organizations. The most notable organizations are:

Standard Rate and Data Service, Inc.
5201 Old Orchard Road
Skokie, Illinois 60076
(312) 966-8500

The National Research Bureau, Inc.
424 North Third Street
Burlington, Iowa 52601
(319) 752-5415

Suppose, for example, you want to know the names and addresses of every single consumer publication in the country (I mean every one, not just the bigger ones or the best-known). Both Standard Rate and Data and the National Research Bureau publish directories that contain that information. The same is true for trade magazines, farm publications, and so on.

One of the volumes in the National Research Bureau's *Working Press of the Nation* series is especially interesting. Volume 5 is called "Internal Publications, Company Magazines, Clubs, and Specially-Sponsored Periodicals." This volume formerly was known as *The Gebbie House Magazine Directory* and is an exhaustive compendium of what are called "in-house" magazines (magazines published by a company for its own employees). The market for photography in these in-house publications is relatively unknown and frequently overlooked but can be enormously valuable to a photographer who is on his or her toes. How many in-house magazines can there be? Volume 5 lists 3,500 of them, by industrial category.

These books are expensive and are sometimes not available in libraries, so if you need one or the other of them, you might have to spend some money or find a company that has a copy on its shelves and is willing to let you look at it. The information contained in these books is aimed primarily at media buyers (the people at ad agencies who decide which magazines their clients should advertise in), so quite a few ad agencies have copies on hand. Once you establish a working relation-

ship with an art director, he or she might be willing to let you use the agency's library.

Both Standard Rate and Data and The National Research Bureau produce brochures describing the directories they produce that you can write away for.

Greetings Magazine
95 Madison Avenue
New York, New York 10016
(212) 679-6677

If you're interested in pursuing the greeting card market you might want to subscribe to a publication called *Greetings Magazine*. This trade magazine for the greeting card industry is designed as a vehicle for greeting card manufacturers to get their message across to retail outlets. Many greeting card manufacturers take out ads in *Greetings Magazine* showing their latest lines. Perusing this magazine on a regular basis can tip you off to new trends and new companies and generally keep you up-to-date. A year's subscription costs $6.00 ($12.00 for three years). If you're serious about the very competitive greeting card market, this is a good buy.

The Creative Black Book
Friendly Publications, Inc.
80 Irving Place
New York, New York,
10003
(212) 228-9750

Although *The Creative Black Book* carries little more than telephone numbers of people in or suppliers to the advertising and graphic arts trades, it may still be useful to you inasmuch as it is a publication intended to be distributed to *photo buyers* (art directors, graphic designers, etc.). There is, therefore, a large section devoted to photographers and photo agencies, and by checking out the ads placed by these photographers and agencies (the ads are often full-color and very lavish) you can get an idea of what the top people in the field are up to, as well as a feel for shifting photo trends. *The Creative Black Book* is available at most art supply stores for around $20.00.

Before we discuss how to take all these resources and use them to develop an effective marketing plan, be sure that you have read the earlier chapters of this book and that you (1) have a firm understanding of your photography (chapter 5),

(2) have tried to shoot marketable photographs (chapters 2 and 3), (3) know how to call a potential buyer and get the name of the person you need to talk to (chapter 5), and (4) know how to conduct yourself with a buyer (chapter 5).

THE TWO APPROACHES TO FINDING PROSPECTIVE BUYERS

Now let's see how to find prospective buyers in specific markets.

Your overall strategy is a simple one: to locate the specific *person* who should be looking at your photographs with an eye to buying them. All your efforts should be devoted toward this end, and you can use either one or both of two somewhat different approaches to reach this goal.

In one approach, you concentrate on an industry and locate the appropriate people at specific companies in that industry to whom you show you work. In the other approach, you watch in the various media for photos similar to yours in style or subject, then track down the art director who used the photo.

The Industry Approach

First we'll consider the industry approach as it relates to consumer magazines, trade journals, in-house publications, ad agencies, graphic design studios, greeting card companies, and religious publications.

Consumer Magazines

Step one: Keeping in mind your personal style and talents, get to know your local newsstand backward and forward. Really look at each consumer publication. If you see one that might have need for some of your photographs—whether it is a large national magazine or a small local newsletter—turn to the page that lists the publisher and the staff and jot down the name of the art director. That's the person you'll want to contact.

Step two: Study all the consumer magazines your library subscribes to. Again, make a note of the name of the art director of any magazines that look promising.

Step three: Study as many of the general source books list-

ed earlier in this chapter as you can. Record appropriate names you obtain from these books, then contact likely publications directly to learn the name of the current art director (see chapter 5). If you can't find a copy of the magazine locally, write a note to the photo editor and request a sample copy. You will improve your chances of getting a reply if you enclose a self-addressed, stamped envelope.

Step four: Follow the principles described in chapter 5, steps six through nine and contact the appropriate art directors. You'll probably want to start with the local publications until you gain some experience, then branch out to larger regional magazines.

Your ability to travel may limit the number of magazines you feel you can contact. Should you feel a particular magazine is an especially good prospect but you know you can't possibly travel to the magazine's headquarters, phone the art director or photo buyer and ask if you can mail some samples. (Be sure to find out in what form you should submit your samples.)

National magazines tend to obtain stock photographs through stock photo agencies, but if you have a truly unique or very timely photograph that you think a magazine might need, by all means call. It can't hurt, and it may result in a sale.

One final note: A large publication might have more than one art director and/or some assistant art directors and/or a photo editor. If you feel the magazine holds promise for you, it's in your best interests to strike up an acquaintance with them all. These are the people who are in a position to buy your work.

Trade Journals

Trade journals are magazines that seek out for their readership the members of a specific industry or trade. Medical journals are trade magazines aimed at doctors; graphic arts magazines are trade journals aimed at art directors; engineering magazines are aimed at engineers, architects, and builders, and so on. For almost every trade you can think of, there is at least one trade magazine aimed at its members.

Step one: Consult the "general" publications described earlier for a list of trade magazines related to your specialty. For example, say you are a pilot and have many aerial views taken

from a light plane. You would check in *Literary Market Place, Photographer's Market, Writer's Market,* and the other sources under aviation trade magazines, photography trade magazines, aerospace engineering magazines, pilots' association magazines, geographical survey trade magazines, etc. Whatever your specialty or the general bent of your photography, make a comprehensive list of possible applications, then look up the names of magazines that serve that trade.

Step two: Ask your librarian to help you find the names of additional trade magazines in your area of interest. *The Readers' Guide to Periodical Literature* may list some you will find appropriate.

Step three: Follow the principles explained in chapter 5, steps six through nine.

In-House Publications

In-house publications are those produced by a company for the enjoyment or use of its own employees.

Step one: The easiest, least intimidating, and most effective way to start out in this market is to seek out the names of any large companies in your local area. Any firm with more than a few hundred employees is likely to produce an in-house magazine or newspaper. Obviously, the larger the firm, the more it is probably willing to pay for photographs. One source of names is the local chamber of commerce. Give it a call and ask for the names of the large companies in the area.

Another tactic is to consult the section of the *Standard Directory of Advertisers,* which classifies advertisers by region. Most firms large enough to be included will have an in-house publication of some sort.

Step two: Contact each company on your list to find out if it has an in-house publication. Usually the switchboard operator won't know, so ask for the public relations department. The PR department secretary may be able to answer your questions and may agree to send you a sample copy, if one exists. An alternative to phoning is to show up in person. Most companies that produce such publications display them in their lobbies.

Step three: Decide which publications are best suited for your work, then contact the editor or art director and follow the procedures in chapter 5, steps six through nine.

Step four: Once you feel confident about your ability to

handle yourself on the phone and in person, try to get a copy of *Working Press of the Nation,* Volume 5, select the names of those publications across the country that seem most promising, then follow the procedures in chapter 5.

Ad Agencies

As discussed, ad agencies have a particularly voracious appetite for photography, so your efforts here can be especially rewarding.

Step one: From the Yellow Pages, compile a list of the ad agencies and advertising consultants in your area.

Step two: Consult the regional listings of the *Standard Directory of Advertisers* for your locale. You will notice that each agency listed has a particular area of emphasis—travel-oriented clients, cosmetic companies, industrial accounts, etc. Compile a second list of advertisers that appear to be good prospects based on their clientele.

Step three: Strike from your first list any names that from your reading of the *Standard Directory* you feel are poor prospects.

Step four: Use the principles outlined in chapter 5, step six, to make contact with the photo buyer.

Step five: After you have gained some experience, try contacting some of the really large advertising agencies located in major cities by using the methods explained in the final section of this chapter.

Graphic Design Studios

Most graphic design studios are small, but they can be insatiable consumers of photographs for "collateral material" such as brochures, catalogs, displays, annual reports, etc.

Step one: Once again, consult your Yellow Pages first. If your town is very small, refer to the Yellow Pages in the phone book of the nearest sizable city.

Step two: Check your library for current and back copies of any of the following magazines: *Art Direction, Communication Arts, Print, Folio, Advertising Age, Graphics USA.* These magazines frequently print profiles of art directors and graphic designers. By studying these magazines on a regular basis, you will become acquainted with many of the leading lights in the field of graphic design. If an article leads you to

believe a designer may be receptive to your material, contact that person.

Step three: Follow the principles outlined in chapter 5, steps six through nine.

Greeting Card Companies

The first inclination of many photographers who begin to think about selling their photographs is to contact the greeting card companies. Greeting cards are quite visible in card stores, drugstores, and department stores, and it is not surprising that photographs on many of the cards budding photographers see are similar to ones they might have taken—after all, many of the greeting card companies obtain much of their photography from amateurs who submit their work either unsolicited or after an initial inquiry. The larger greeting card companies have entire staffs that do nothing but review incoming photographs. And many of these companies are extremely interested in seeing material from talented but unheralded photographers.

But greeting card companies are not necessarily the photographer's best friend and there are certain caveats in dealing with them that you should be aware of. For example, why is it, do you think, that many of the greeting card companies *are* willing to consider the work of beginners? Is it because they altruistically hope to give a budding photographer a leg up in the marketplace? Perhaps. Is it because they like to keep a keen eye out for new and refreshing talent to breathe fresh air into their card lines? Perhaps. Having sold photographs to many photo buyers at various greeting card companies, I can tell you that, in the main, they are very decent people who genuinely like photographers and are quite pleased when they can offer a sale to a newcomer.

But there is another side to the coin, and it is literally a coin. Considering the rights they expect to purchase—generally absolute, exclusive world rights to the photograph—they don't pay very well.

Moreover, some greeting card companies take your photo, to which you have given them world rights, and place it with an overseas stock photo agency. Whenever that agency sells your photo, the greeting card company is paid a royalty, on *your* work. You, in turn, receive a much lesser royalty, if any at all.

In chapter 9 you'll learn that in stock photography the stock agency usually sells one-time rights; that is, it sells a photograph for one specific use (an ad, a brochure, a package) and retains the right to sell that photograph again for other, nonconflicting uses. Any stock photo agency, for example, that sold exclusive world rights to one of its photographs would do so only for an enormous amount of money. That's because the agency hopes to sell the photograph many times and is loath to forgo the additional sales unless the original fee paid is substantial. In fact, the *least* my agency has ever sold exclusive world rights for is $2,000.

Does that mean the greeting card companies never buy from stock agencies? Not at all. But very few stock agencies are willing to give card companies total rights. Rather, an agency will sell the exclusive use of a photograph in the greeting card and calendar industry, and usually with a limitation that the photo may appear only in the United States, unless an additional fee is paid.

The point is, if you are selling your work to card companies you should be aware that (1) they will try to negotiate for all rights throughout the world, (2) they may not be willing to pay you the fee you might like for those rights, and (3) you can sometimes negotiate a higher fee than the company originally offers, even if it claims it never pays more and always gets world rights. Keep your wits about you.

Step one: The easiest and perhaps best way to scout the greeting card market is to frequent your local card shop. If you see a card that reflects a style or subject matter similar to that of your photographs, look on the back of the card for the company's name and jot it down.

Step two: Ask the proprietor of the shop to give you the address of the card's manufacturers, or at least the name of the distributor.

Step three: If you are unable to obtain the addresses of all the companies you are interested in from the store owner, consult *Photographer's Market.* It probably lists the addresses you need. If you have the distributor's name, try calling to find the address of the manufacturer. Remember, too, that *Greetings Magazine* can also be a source of leads or addresses.

Step four: Follow the principles outlined in chapter 5, steps six through nine. Many of the "general" publications listed earlier in this chapter have entries for greeting card compa-

nies, but if you use these listings for a starting point, you'll spend a lot of effort contacting companies for which the style or subject matter of your photography is inappropriate.

Religious Publications

Religious organizations often use great quantities of stock photography for everything from their church bulletins to secular magazines and books. Use the same procedures to contact these organizations that you would to contact trade publications, except, of course, you will be limited to consulting the "general" resource books for leads. *The Yearbook of American and Canadian Churches,* published by Abingdon Press in Nashville, Tennessee, which lists religious periodicals, is another possible source. Ask your librarian for a copy, or contact Abingdon Press directly.

The Media Approach

Now let's turn to the second approach in the strategy of placing your photography on the desk of the person most likely to need it. This approach involves tracing an individual ad back to the person who created it.

Suppose you see a magazine ad that contains a photograph taken in a style or of a subject matter that is close to that of your photography. It stands to reason that if you could put your photographs in front of that very person, you'd have a strong possibility of making a sale. The procedure for doing so is surprisingly easy.

Step one: Make a concerted effort to watch for photographic ads in your style or of your subject matter.

Step two: For any such ad, identify the agency that created it. The method you use depends on the publication's circulation. If the publication is small and local, your easiest course may be simply to call the business office of the publication and ask for the name of the agency that placed the ad. (You may need to specify the issue in which the ad appeared.) Once you know the name of the agency, use the procedures in chapter 5, step six to determine the art director you need to contact.

Larger publications with high circulations may not be willing to check their files for you, but there is an easy solution. Most companies advertising in high-circulation publications

will be listed in the *Standard Directory of Advertisers*. First, look up the name of the firm mentioned in the ad. Included in the entry you will find the name of its ad agency. Next, look up the agency itself in the companion volume, the *Standard Directory of Advertising Agencies*, to obtain the name of the "creative director."

Step three: Contact the agency and follow the principles explained in chapter 5, step six for reaching the person who put the ad together.

Whichever strategy you employ, the results should be the same: your photographs will be seen by the people in the best position to buy them.

8

Pricing and Negotiation

In the first part of this chapter you will find Price Guides that give the prevailing prices photographers and agencies around the country are able to negotiate for the commercial or editorial use of their photographs. You will notice that in each category there is a large spread between the minimum and maximum. The spread exists because there are so many variables involved in pricing a photo—including region of the country and relative sophistication of the buyer, size of the ad in which the photograph is used, print run of mailing pieces, number of insertions in magazines, the circulation of those magazines, etc. These variables make it impossible to list firm, all-encompassing prices. (Following the Price Guides is a full discussion of how to negotiate a fair price by finding out the true scope of the audience for any given project and how the variables can affect your price.)

And it is not true that photographers never accept less than the minimum or receive more than the maximum. If you study the Price Guides carefully, you will have an idea of the approximate fair market value of your work (at current prices) and a better understanding of what these various usages are worth relative to one another.

In fact, perhaps the *most* important information you can get from the Price Guides is not the prices themselves but the *relationship* between the prices. Why? Because some clients will pay you high prices across the board and some will pay you low ones across the board. Thus, if a client at a small agency has paid you $200 for a brochure in the past, that doesn't mean that client won't be willing to pay you more than that for an ad. However, it does indicate that, since $200 was on the low end of the brochure range, the client will probably only be willing to pay you the low amount in the ad range—

which is $500. By looking at the Price Guides and by knowing what a client has paid you on one project, you should be able to determine what that client is likely to pay you on another project.

Does that mean that if a client has been willing to pay only the low price on one project you should never try to get a higher fee on another project? Of course not. (See the next section, on negotiation, to find out how to maneuver the client into doing just that.)

Why can you command more money for some projects than for others? The answer usually has to do with the amount of money the *overall* project is costing the client. Note, for example, that national ads and packaging command the highest prices. This is primarily because the company is already planning on spending an enormous amount of money on magazine-insertion fees (the amount that must be paid to the magazine to run the ad), in the case of ads, and for manufacturing and distribution costs in the case of packages. Therefore, not only is such a company willing to pay top dollar for photography to ensure the success of the overall expenditure, but, in addition, the cost of that photography—as high as it is— seems insignificant in comparison to the other costs involved in completing the project.

On the other hand, it stands to reason that clients producing small brochures, with a total cost of a few hundred dollars for production and mailing, are not likely to be willing to spend a great deal on photography. Nonetheless, don't overlook the fact that whereas photographs used in the large, prestigious national ads command the highest single-sale fees, the small sales, which are easier to get and more frequent, can often yield much more real income in the long run.

PRICE GUIDE: COMMERCIAL USAGE

All prices are for full color unless otherwise indicated. For B&W deduct 25 to 50 percent.

Ads

The price you can negotiate for the use of your photos in ads depends on the number of times the ad will appear and where it will appear (that is, in high- or low-circulation publications or those with local, regional, or national distribution).

Also, if your photograph is the only photograph used and therefore the "major visual," you can negotiate a higher price than if it is one of several photographs or used as part of a montage.

Consumer ads. These are ads in magazines sold to the general public. *People* Magazine is an example of a national consumer magazine; *New York* and *New West* are examples of regional consumer magazines.

Low: $500. An ad that appears one time in a low-circulation consumer magazine.

High: $3,000 or more. An unlimited number of insertions for a period of one year in a high-circulation consumer magazine. (Renewal for a second year would be an additional 50 percent of the original price.)

Trade ads. Trade magazines are aimed at a specific industry or trade or special-interest group. Readership will be more limited than that of a general consumer magazine, but the audience is intensely targeted. *New Engineer, Model Railroader,* and *The Journal of the American Medical Association* are examples of trade magazines.

Low: $350. One insertion in one magazine.

High: $1,500 or more. Several magazines, unlimited insertions for a period of one year.

Newspaper ads. (Black & White)

Low: $175. One insertion in a local paper.

High: $1,500. Several insertions in large city papers like the *New York Times.*

Sunday supplement ads. Sunday supplements are those full-color, magazinelike sections many newspapers insert into their Sunday editions.

Low: $350. One supplement in one paper.

High: $1,500. Several insertions in supplements like *Parade,* to which many papers subscribe.

Packaging

Packaging prices are determined primarily by the distribution of the package and its shelf life (the period of time the package is likely to be seen in the stores).

Low: $500. Local or regional package with a shelf life of one year or less.

High: $3,000. National package with shelf life of two years. Renewal fee of 50 percent after two years.

In-Store Displays

These are similar to packages in that their function is to convince consumers to buy the product while they are in the store (as opposed to convincing them while they're home looking at an ad in a magazine). These are therefore often referred to as "point-of-sale" displays or "point-of-purchase" displays. If you go into a drugstore you'll often see cosmetics products displayed in a colorful rack with a photo on it. This is a point-of-purchase display. Or, in a department store, a battery manufacturer might have wares prominently presented by means of a poster.

Low: $300. Distribution in a few local or regional stores.
High: $1,200. National distribution in high-traffic stores.

Annual Reports

Companies are often willing to spend a lot of money on their annual reports, even though the print run of those reports might be small. After all, this is the report managers make to their bosses—the stock holders—and managers like to make themselves look good.

Cover
Low: $500. Small company, few shareholders.
High: $2,000. Large company, money to burn.
Inside
Low: $200
High: $750

Brochures and Direct-Mail Fliers

Prices for brochures and direct-mail fliers vary widely. The most effective guideline in determining a price will be the number of copies the client intends to print.

Up to 5,000 printed
Cover: $200–$500
Inside: $150–$300
Up to 50,000 printed
Cover: $400–$750
Inside: $200–$400
Up to 500,000 printed
Cover: $600–$1,200
Inside: $300–$600

Over 500,000 printed
 Cover: $750–$1,500
 Inside: $400–$800

Catalogs

Many companies that produce or market a range of products will produce catalogs showing their merchandise. These companies seek stock photographs for background usage or for mood shots or section separators. As with brochures, the price you can negotiate will be affected by the print run and the distribution.
 Cover: $400–$1,500
 Inside: $200–$750

Greeting Cards

Some of the advantages as well as the pitfalls of working with the greeting card companies are discussed in detail in chapter 7. When you're negotiating a price with a greeting card company, pay close attention to the rights they're asking you to give up (usually exclusive world rights). In the main, greeting card companies do not pay very well.
 Low: $150
 High: $500

Calendars

There are many different types of calendars. Some are produced to be sold to the general public. Many are produced by companies to send as Christmas gifts to their clients (or prospective clients). In addition, some companies produce calendars that are then sold on a subscription basis for other companies to use for promotional purposes. Once again, the fee you can get will be largely determined by the circulation of the calendar and its importance as a marketing tool to the client. In addition, the greater the number of photographs the client buys from you, the less the client will expect to pay per photo.
 Low: $200. Local company printing, 5,000 copies or less.
 High: $1,000. Very high quantity being produced by a
 major corporation, or for consumer product to be sold
 across the country.

Posters

Like calendars, posters are often either company marketing or promotion pieces (in which case their pricing is similar to that of brochures) or retail consumer products where the photograph itself becomes the merchandise being sold by the client.

Industrial posters range from incentive programs where the poster will be seen only in certain of the company's plants and seen only by its employees (in which case they probably don't want to spend a lot of money) to large-scale promotional pieces mailed to hundreds of thousands of people.

Low: $300. Small print run, limited distribution.

High: $1,500. High print run, large distribution, or a product to be sold in stores across the country.

Record Albums

Many record companies use stock photos. These companies range from small religiously oriented groups to the large industry giants.

Low: $300

High: $1,500

Wall Decor

Many companies use photographs to decorate their offices. Also, restaurants frequently seek out stock photographs to blow up and mount on walls.

Low: $50. One print in one office.

High: $500. Same photo used in several different stores or locations.

Slide Shows and Audiovisual Presentations

Slide shows and audiovisual presentations usually take place at sales meetings and trade shows and the like. Your fee for such use will very much be influenced by the number of photographs the client is willing to buy from you: the more the client buys, the better the price you should offer per photo. Often, a sliding scale offers the client incentive to buy as much as possible from you.

One shot: $150

Two shots: $140 *each*
Three shots: $130 *each*
Four shots: $120 *each*
Down to $50 minimum per shot

This scale can be adjusted upward or downward, depending on the conclusions you arrive at in the initial stages of negotiation (see next section).

Billboards

Billboards are an important and widely used form of advertising.

> *Low:* $300. One or two billboards, local, appearing three months or less.
> *High:* $2,000. National campaign, appearing for up to six months; 50 percent renewal fee after six months.

PRICE GUIDE: EDITORIAL USAGE

A different fee schedule applies to photographs used for the editorial content of magazines and other publications as opposed to those used for promotional or advertising purposes.

Magazines

Magazine cover and page rates vary widely. Often the most prestigious magazines pay the least, giving the photographer photo credit in lieu of large fees.

Nonetheless, generally speaking, the larger the circulation, the more the magazines are inclined to pay. In addition, many magazines have cover and page rates that are set and sometimes nonnegotiable. Sometimes your best bet is simply to ask what the magazine's standard rates are.

Low circulation (under 200,000)
 Cover: $200–$450
 Inside: $125–$225
Medium circulation (200,000 to 500,000)
 Cover; $350–$750
 Inside: $250–$450
High circulation (over 500,000)
 Cover: $500–$2,000
 Inside: $350–$1,000

Books

Covers
 Hardbound trade books and textbooks $300–$1,000
 Softbound trade books $500–$1,250
 Mass-market paperbacks $750–$2,000
 Special-interest paperbacks (religious, etc.) $300–$750
Inside
 Trade books and textbooks $100–$300
 Encyclopedias (depending on size used and number of
 photos bought) $50–$250

NOTE: Art directors who want to present an idea to a client or potential clients but do not have the photographs they need to do it may ask photographers to send photographs "on approval," which the art directors then use to "pitch" their clients. Whereas some art directors will volunteer the information that they plan to use your photos in this manner, many will not, unless you ask.

NEGOTIATION: HOW TO GET THE MOST MONEY FOR YOUR PHOTOGRAPHS

Any so-called "price guide" is worthless unless you are skilled at negotiation. You are not selling soap, you are not really selling film; in short, you are not selling a product that can be considered to have a wholesale price to which you can simply add a markup as if you were a manufacturer. If you were, you would take the 35mm slide that costs approximately 25 cents to buy and process and you would charge perhaps 50 cents for its purchase. Yet I have sold these 25-cent slides for well over $3,000 each. Such a phenomenal markup is possible only because buyers attach a significant value to the creativity embodied in these small pieces of celluloid pressed between cardboard.

But how much value? How can you make sure you are not undervaluing your work? Equally important, how can you determine if you are asking too much and thereby alienating potential clients? You answer these questions by engaging with a buyer in the process known as negotiation.

To a certain extent, the very word "negotiation" has derogatory connotations. It conjures up images of brawny teamsters in angry dispute with intransigent and exploitative managers. Actually, negotiation is nothing more than two parties

with complementary but competing interests going through a process with the goal of arriving at a "fair" exchange and anyone can learn how to negotiate effectively, even though the very mention of the word causes most photographers to throw up their hands and say, "I could never do it. I'm a creative person, not a business person." You *can* learn to hold your own. Don't be intimidated.

In the best and most successful negotiations, neither party winds up taking advantage of the other. Unfortunately, the people who are in a position to buy your photography will usually be better, more experienced negotiators than you, especially when you are first starting out. Because of this inexperience, many photographers have been raked over the proverbial coals by savvy buyers. Equally disheartening, many photographers needlessly limit their potential earnings by clinging to an inflated view either of the value of their work or of a client's ability to pay for it.

Whether you decide to sell your photos yourself or opt for a personal agent or a stock photo agency to represent you, you must learn the basics of negotiation if you are to be in a position to protect your interests, maximize your returns, and compete successfully in this competitive arena.

The Four Stages of Successful Negotiation

Effective negotiations pass through four stages, each of which you will need to control if you are to successfully advance your interests. The first stage involves *establishing a productive atmosphere* in which the negotiations can take place. The second stage consists of an *exchange of pertinent information.* In the third stage, *initial offers* are made, and in the fourth stage, *final terms* are agreed upon. Let's consider each stage separately.

Stage One: Establishing a Productive Atmosphere

Successful negotiation that ends up with both sides satisfied can take place only in an atmosphere of mutual trust and confidence. Therefore, almost without exception, you should conduct yourself in a manner that genuinely conveys openness and a willingness to be helpful. Too many photographers, intimidated by the whole process of negotiation, adopt a belligerent, haughty, or mistrustful attitude that poisons the atmo-

sphere in which the negotiation takes place. In all likelihood, the buyers with whom you'll be talking will not be out to cheat you, so it's important that you not insult them by assuming they might be, and that you convey by your attitude that *you* have no desire to cheat *them* either. (Oddly enough, many buyers feel just as unsure and intimidated as photographers when it comes to negotiating a price. The most fruitful sessions are the result of two parties getting to know each other's needs through forthright *communication.* And at least 50 percent of the responsibility for establishing that communication rests with *you.*)

One of the biggest mistakes you can make when you sit down with buyers to discuss your photography is to assume that your photo has an automatic worth in terms of money. The reality is that the photo of which you are so proud is worth only as much as you can convince buyers to pay for it. And how much they are willing to pay may very well be affected by your attitude toward them and toward the situation at hand.

The attitude you assume must be tailored to the circumstances, however. For example, when I deal with experienced Manhattan photo buyers, I try to project an image of somewhat aloof sophistication—or the buyer will infer that I'm new to town and probably inexperienced, even if that's not true. On the other hand, when potential clients call me from small towns or rural areas across the country to inquire about their agency's using some of our photographs, they sometimes feel intimidated and as a sort of psychological defense they adopt a somewhat belligerent attitude, as if to say, "I'll be damned if I'll let some New York slickster buffalo *me!*"

I feel my first responsibility is to put such callers at ease, to let them know that they are dealing with someone who is eager to work with them no matter how small their project and that I regard them as being just as important as a buyer in the largest ad agency in the world (which is certainly true). In other words, I want to create an image of friendliness and approachability.

Similarly, one of the most important things you're going to have to do as you deal with your clients is accurately determine just what stance is going to enhance your position the most, and then go about creating that stance in a friendly and conversational manner. If your clients think you're a novice, you'll have to counteract that impression if you're going to ne-

gotiate on an equal footing. If they think you're too high-powered for their blood, you've got to let them know that your're willing, even eager, to work with them, that they should not be afraid to be straightforward and honest with you, and that you certainly don't consider their projects to be beneath your skills—even if you do (remember, this project might not get you too excited, but maybe the *next* one will).

Of course, never be obsequious or ingratiating or appear to be a pushover. Likewise, your demeanor should never imply or even hint that you are desperate for a job or a sale. (There is an old saying among photographers that the best way to *stay* hungry is to *look* hungry.) It is to your advantage to communicate, very subtly but perceptibly, that you are even prepared to give up the job or sale if the price is not right. But through it all, no matter how firmly you may be pressing your position, buyers should feel that you genuinely hope that at the end of the bargaining process *their* interests will have been served as well as yours.

Also, don't underestimate the value of projecting a professional image to a buyer. One of the best ways to do this is to develop a realistic sense of your own worth and that of your photography, and do not allow that basic estimation to be demeaned. As you develop a sense of worth, your carriage will almost instantly establish your professional image, and buyers will sense that they're in the presence of an individual who knows he or she has something of value to offer. While assuming undue airs of superiority or attaching overblown significance to what you're doing can and will be counterproductive in a negotiation, by all means *do* develop a firm belief in your own abilities as a photographer and their expression in the form of your photographs.

Another important benefit to projecting the image of an experienced professional is that if buyers perceive you to be a competent professional who is not likely to have the wool pulled over his or her eyes in the bargaining process, they are likely to (almost unconsciously) raise their estimation of what they're going to have to pay for your work.

For example, let's say you are talking to an art director about using one of your photographs in a pharmaceutical trade ad to be placed in medical journals. It's possible that the buyer thinks you don't know that because of the enormous profits sometimes generated by pharmaceutical ads of this sort, and because of the fiercely competitive nature of the

pharmaceutical industry itself, these companies are often pre-
pared to spend considerably more for their trade ads than
firms in other industries. But suppose you *do* know this (and
after you've been at it for a while, this is the type of thing you
will know). It's going to help you in negotiating a price to let
the buyer know that you know. How can you convey such in-
formation? Conversationally. You might say, almost paren-
thetically, that you have always found it to be a pleasure
working for the pharmaceutical companies because they re-
gard their ads as highly important and therefore don't try to
cut corners in production. This pleasant, seemingly innocent
remark has let the buyer know you are aware that there prob-
ably is a good budget to work with and that you expect to be
paid accordingly. Equally important, you have let the buyer
know that you have experience and that you are a professional
who has dealt with these situations before. Techniques such as
this serve to enhance your image in the eyes of the buyer and
at the same time help to establish a productive negotiating at-
mosphere.

Don't bluff, however. If you *haven't* had experience in this
line, don't pretend you do. Instead, use the opportunity to ask
the questions that will give you the information you need.
Then, use this information in your next negotiating session.

Stage Two: Exchanging Information

Without a firm foundation of accurate, relevant informa-
tion, your likelihood of arriving at a satisfactory financial
agreement with a photo buyer is seriously diminished. None-
theless, all too many photographers start talking money be-
fore they have the information on which fee proposals are in-
variably based.

Understandably, many photographers tend to evaluate their
work mainly in terms of how hard they worked and how ex-
pensive it was for them to produce the shot. (Or, in the case of
assignments, they think only in terms of the effort and ex-
pense they expect to encounter.)

It may come as a surprise to you, but not only do most
photo buyers have no idea what your technical difficulties are
or how much it might have cost you to produce a shot—they
don't care.

Instead, the amount they will pay for the use of your pho-
tography depends almost exclusively on *how they plan to use*

it. As a result, when you sit down with a photo buyer, before you can even *begin* to talk intelligently about money you must first determine as accurately as you can (1) the scope of the project being worked on and (2) how your photo will fit into that project. Everything else is secondary.

Why it is important to determine the scope of the project stems from the economics of business. As you would expect, the larger the project, the more substantial its budget. Likewise, the more limited the project, the more restricted the budget. Naturally, photography will comprise only a *part* of that budget, so if you propose a big-budget fee for a small-budget project, you're not going to get the sale or the job. It won't matter to the buyer that the photo in question is the most difficult photograph you have ever taken or the most inspirational or creative or unique. If the buyer is only using it in a small brochure with a print run of 500, you won't get a lot of money for it. Fortunately, however, the street runs both ways. If the buyer wants the most mundane, ordinary photograph you've got for a national ad, you are likely to be paid handsomely.

How your photo fits into a particular project is nearly as important in determining a reasonable fee as the size of the project. Simply stated, the more important your photo is to the project, the more the buyer will be willing to pay for it. You will be in a much stronger negotiating position if your photo is to be the major visual in an ad than if it is slated to be a minor photo within a collage.

How do you get the information you need about the client's project? Simply ask. You will not be viewed as pushy, because the buyer is probably accustomed to such questions. In fact, by asking what buyers will recognize as the "right" questions, you will be enhancing your professional image in their eyes, an image that cannot help but aid you when it comes down to closing the financial deal.

But remember: *You have to ask.*

What specifically do you need to know? The information you need will vary somewhat with each situation, but at minimum you will always need to know as precisely as possible how the photo will be used. If it's to be used in an ad, ask where the ad will be placed. In how many magazines? How many times will it be run in each magazine? For how long will it run? a month, a year, indefinitely? Will it be a full-page ad? a quarter-page? Will your photography be the major vi-

sual? Will there be any other photographs in the ad? If it's a brochure, will your photography be used on the cover or on the inside? What will the print run be—five thousand, fifty thousand, five *hundred* thousand? If it's a poster, how many will be printed? Who will see them? Will they be sold—or given away? If they're to be sold, find out where—in stores? by mail order? Is the client using the photo to help sell a product directly to customers (which clients do eagerly and therefore lavishly) or simply to convey, for example, a safety message to employees (which the client might be doing begrudgingly and therefore cheaply)?

All these questions have nothing to do with what you think of the photograph, but everything to do with what the *buyer* thinks of it, since as a secondary goal it is in your interest to deduce from the buyer's answers just how vital your photograph is to the "concept" of the project. You need to decide if another photograph would suit the purposes or if yours is the only one that will do. Naturally, if the buyer can substitute another photo for yours, and if you adopt a hard line when you bargain, at some point in the process the client may decide to settle for a less-expensive photo even if he or she actually prefers yours. On the other hand, if the buyer is "locked-in" to your one-of-a-kind shot, you're holding a full house with aces high. But, you won't know how strong your hand is until you've asked the right questions.

Are there any limitations on what kinds of questions you should ask? Or, are there some questions the buyer may reasonably balk at answering? To some extent, there are. While you have a legitimate right to know generally what the buyers' projects are, you are not entitled (at this stage) to be privy to the intimate details of their relationships with their clients or even to know exactly who those clients are. A buyer should not, for example, be reluctant to tell you that a brochure is being done for the "transportation industry," but he or she might be hesitant to tell you that Ford Motors is sponsoring it. Remember, advertising is a highly competitive industry, and at this preliminary stage you cannot expect a photo buyer to give you information that a client would consider confidential. Generally, though, the buyer should be willing to provide information such as that an ad will be run in consumer magazines, but he might be legitimately reluctant to tell you precisely which ones. (You *can* ask him whether the magazines are high circulation or special interest, however.) He should

be willing to tell you that a brochure will have a distribution in the Northeast, but he might not want to tell you in exactly which states. He might be willing to tell you that a display is introducing a new product, but he won't want to tell you too much about it. It is when you come to terms with the buyer and are about to issue an invoice that, in order to protect your rights, you become entitled to more substantial information, such as the name of the buyer's client, the specific magazines or cities involved, and the like. (See the section titled "Protecting Your Rights," later in this chapter for how to send an invoice.)

What if the buyer hesitates to answer and wants to know why you are asking all these questions? Keep in mind that because this first stage of negotiation is an *exchange* of information, you must be willing to explain your purpose. This needn't make you feel uncomfortable, since by giving the buyer a truthful answer you will at the same time be establishing the kind of rapport that is conducive to fruitful negotiations. Simply point out that only by knowing the exact limitations of the project can you determine how *little* to charge, and that the information the buyer gives you can very well be *saving* him or her money. Once buyers understand that you don't want to overcharge them, they should be happy to answer your questions, and you will have created allies, to boot. Fortunately for you, the same information is useful to you in deciding how much you can reasonably ask for.

Be careful, though, of the buyer who continues to refuse to answer questions even after you have explained the reason for your interest. Typically, this type of person acts impatient and annoyed, cuts short your questions, and says such things as, "Just tell me how much this photo is going to cost. I can't be bothered answering all these questions." If such a buyer continues to balk even after you again explain that you need the information in *order* to give the price, your best bet may be to walk away from the sale. If the buyer is deliberately withholding information, chances are there's a reason and that reason is not in your best interest. If the buyer is refusing information because of a mean disposition or because he or she doesn't know the answer, that's not the type of client who is going to be easy or pleasant to deal with—and, you're not doing yourself any favors if you allow yourself to be bullied. Competent, straightforward photo buyers will be happy to give you the information you need; the others—and they are

very few—have nothing to offer you but aggravation and unpaid invoices.

Do photo buyers ever lie? Not as a rule. Believe what they say unless they have given you reason not to. In the main, photo buyers, art directors, editors, etc., are simply not out to cheat you. They, like you, are trying to make a living and are not interested in being less than straightforward and ethical. Yes, there are an unscrupulous few, but once you have honed your negotiating skills and become familiar with the day-to-day workings of the photography marketplace, you will learn to recognize—and avoid—them immediately.

If, after protracted discussion, a buyer suddenly "gives in" and you are tempted to close the sale, remember that once the project is completed you often have no recourse should you discover that the buyer has been less than completely honest with you. If you can't find out the information you need *before* the job goes to press, your best bet, again, may be to turn your back on the sale. You have more to lose than to gain.

Earlier I mentioned that buyers do not care how much trouble you have had (or will have, in the case of assignments) producing a shot, but that doesn't mean that at the end of this second stage of negotiation they should remain unaware that you hold your work in high regard. While your fee may not depend directly on the problems you encountered, the willingness of the buyer to pay the highest possible rate *consistent with the photo's usage* may very well be influenced by pertinent background information. At some point during your discussions it is completely appropriate for you to *mention* that there were (or will be) special problems or expenses involved. This will help the buyer see how highly you value the results of your efforts and will aid you later if you decide to cling to a firm financial line.

In short, one key to success in negotiating lies in establishing a firm foundation for further discussion by a careful, thorough exchange of basic information. Under no circumstances should you allow this first stage to be ended until you have a firm understanding of exactly what the buyer's project amounts to and you know precisely how important your photograph is to the buyer and to the project.

If you have done your job properly, at this stage you will have extracted the information you need, convinced the buyer that you are an experienced professional with honorable intentions, and left the buyer with the impression that you feel your work deserves his highest regard.

Stage Three: Making an Offer

In this third stage, the most important thing to remember is to not back yourself into a corner by discussing specific dollar amounts too quickly. *Don't rush to offer a price.* An initial offer based on only a guess can cost you not only money, but just as important, it can also cost you information, future sales, and damage to your reputation as a competent professional.

If your guess is too high, buyers might thank you for your time, tell you they'll think about it (even though they won't), and say, in essence, "Don't call me, I'll call you."

If your guess is too low, they'll probably buy the photograph and thank you for your help. You'll have made a sale, but you'll never know how much you *could* have gotten.

If your guess is just right, they'll also probably buy the photograph, but you'll never know that the price was just right and you will not have learned anything to help you get a better price on your *next* go-round. The next time you quote a price, thinking you might have been too low this time, you'll come in higher—maybe too high—and blow the sale.

Adding further significance to your negotiations is the fact that the money you may stand to *gain* on one sale can easily cause you to *lose* money on future sales. This is because a stock photo has a fixed value during its effective lifetime. Each time the photo is sold, some of that value is depleted.

Yes, it is true that the most successful stock photos sell over and over again. However, you cannot sell the same photograph for competing usages or to competing media. Two companies cannot use the same shot for national ads, for example, where the same consumer is likely to see both ads. If you sell a shot to a real-estate developer in Tampa, you can't sell the same shot to a competitor, even if the competitor offers you more money. However, you *can* sell that shot to a real-estate developer in Fresno or to a radio station in Chicago. So, while the life and the potential uses of a stock photo may be extensive, they are nonetheless limited and can be depleted. Every time you sell a stock photo, the value of that photo is reduced somewhat.

Also, bear in mind that every time you sell a stock photograph future potential sales are also reduced accordingly. As a rule of thumb, the amount the photograph's value is diminished is directly proportional to the amount of exposure it re-

ceives. A national ad that receives great exposure can literally "retire" a photograph. You can't sell it again. On the other hand, a photograph used in a slide show in your local library has almost no exposure and therefore retains almost all its original value. So, while you run very little risk of harming future sales by selling a photo to your library, you should think twice about giving the buyer a "break" in price for using your photo in a national ad.

Does it ever happen that you've got to turn down sales because of a prior sale? It sure does. I once sold a photograph to one of the major airlines for use in national ads. I had been asking $2,000 but the art director asked me if, as a personal favor, I would reduce the price. I weighed the possibilities and agreed to sell it for the $600 that the art director said was the top figure the company would spend. Within two weeks I had been forced to turn down over $4,000 worth of sales on that photograph.

But it doesn't have to happen that way. As you become familiar with the market and develop a realistic sense of the commercial value of your photography, you will quickly be able to tell which of your photographs have a great potential for repeat sales and which ones don't. Thus, another factor in your pricing determinations should be whether the photograph really does have a bright future or whether the buyer's choice of photograph is so unique and unlikely to be repeated that no one will ever have another use for it.

Adding still further to the importance of the negotiations and your initial offer is the fact that the outcome can directly affect your reputation.

Do not underestimate the value of your reputation—the importance of building a good one and the importance of maintaining it. The professional photographic community is relatively small, even on a national level. Word travels fast. No matter how much you may want or need the sale, don't make the mistake of selling yourself short. If buyers know that you will sell your photos for less than they are worth, they will buy from you as long as they need inexpensive photographs. But beware. As soon as they get jobs with bigger budgets, they will buy elsewhere, if only because they feel a more expensive photograph is a better photograph and if they've got the budget they might as well take advantage of it. Also, if you haven't already, now is the time to read chapter 6 on how advertising agencies make their money. You'll find out why ad

agencies sometimes want to pay you *as much as they can* for your work.

Finally, underselling your photographs can play havoc with your self-esteem. If you're a photographer with a healthy self-esteem, you will get more for your photographs—consistently—than photographers who are afraid to place a reasonable value on their work—even if they're better photographers. It is always in your best interest to negotiate in a way that will maximize both the money you make now and the money you will make in the future. You can best do this by taking your time, understanding your counterpart's probable strategy, and using your own strategy to overcome the other's, as explained below.

Effective negotiators don't jump into a bargaining session with their eyes closed. Buyers with whom you are negotiating will probably already have two figures in mind: (1) the figure they hope to be able to purchase your photograph for and (2) their "ceiling" figure—the highest amount they will pay.

You, on the other hand, need to have *three* figures in mind. Before I explain what those figures are, however, remember that, until you are experienced at negotiating prices, you're going to need a little time at this point to think. No matter what, take whatever time you need *before* you start quoting specific figures to the buyer. If you're negotiating on the phone, excuse yourself, say you'll call back. If you are negotiating in person, ask for a glass of water or to use the bathroom—anything you can think of to gain time to collect your thoughts. Never enter into final negotiations until you have carefully thought out and calculated the three figures I am about to describe. Otherwise, an experienced buyer will negotiate circles around you.

The three figures you need to determine are:

- Your "happy" price—a fair price that is satisfactory for the use of your photo
- Your "jubilant" price—your "happy" price with 25 to 50 percent added onto it
- Your "rock-bottom" price—the price beneath which you will refuse the sale

You might believe it is easy to arrive at these figures, that they can be plucked from the air or read from a chart. If so, you're mistaken and anyone who tells you differently is doing

you a disservice. Behind each figure should be a well thought-out, calculated rationale.

First, establish your "happy" price. What determines this figure? Mainly, it's the information you have about the nature of the buyer's project. Let's say the buyer is producing a condominium brochure and wants to use your photo on the cover. Drawing on your experience and what you have learned from this book, you should be able to arrive at a fee that you feel is appropriate for the job. Let's assume you think $350 is a fair price. (Remember not to divulge this figure to the buyer; it exists only in your mind as an aid to negotiations at this point.)

You could be wrong, though; maybe the buyer's willing to pay more. So you add 25 to 50 percent to your "happy" price to arrive at a figure that would make you "jubilant" were you to receive it. In this case, such a figure might be in the neighborhood of $450.

The third figure can often be the most difficult to determine—and the most important. Decide what the very lowest amount you will accept is. You *must* have this figure in mind as you begin to negotiate. You cannot afford to be shortsighted when determining your rock-bottom fee. If you think only of the immediate return, you might very well end up greatly underselling your photo. Underselling is a big mistake, because as long as you are willing to accept less than your work is worth you will be worth less as a photographer in the buyer's eyes as well as your own. Underselling can also close the door on future, more lucrative sales. Pick a reasonable "rock-bottom" figure—and stick to it. In this example, $200 might be the figure you decide upon.

Okay, you now have the three necessary figures to begin the final stage of negotiation: the fair price, the "jubilant" price, and the absolute minimum price.

At this point you have a crucial decision to make: Do *you* want to name the first figure or do you want to maneuver the *buyer* into giving out the first figure? There are advantages and disadvantages to each course.

You may think that it is up to you to name the first figure, and in many instances you should. The buyer has given you the details of the project and now expects you to say how much you want to be paid for the use of your photograph in that project. Not giving such a figure can lead to a rather awkward silence. Nonetheless, there are situations where you should try to force the buyer to make the first move. For ex-

ample, sometimes, despite your careful estimates, your figure might be in an altogether different ball park from that of the buyer, and if this is the case, nine times out of ten you'll jeopardize the negotiations if you give the first figure. As a rule of thumb, the less sure you are about your three figures, the more you should try to get the buyer to name a figure first.

If, as in the previous example, your "happy" figure is $350, your "jubilant" and "rock-bottom" figures will also be in that general neighborhood. Once again, there are three possibilities: Your figures are either in the same range as the buyer's or they are too high or too low. It is only when both your figures and the buyer's are in the same range (and at this point you have no way of knowing for sure what the buyer's thinking is) that it is to your advantage to establish the first figure yourself. Otherwise, you will be in a better negotiating position if you can get the buyer to name a figure first, thereby tipping you off to his or her thinking.

Let's look at the possibilities. If you name your figure and it is significantly *beneath* what the buyer has in mind, you will be selling your photograph for less money than the buyer is willing to spend, and there is no way at this point for you to then increase your figure. In addition, the *next* time the buyer wants one of your photographs, he or she will make offers that conform to the lower figure you accepted before. You've not only lost money you could have gotten, you've set a bad precedent that you might have to live with for a long time.

If, on the other hand, your opening figure is significantly above the buyer's, you run the risk of scaring the buyer off—and sometimes you won't even know you've done it. Art directors and photo buyers have their pride, too. Suppose an art director has a maximum budget of $200 to purchase a photograph but you quote him your "jubilant" price of $450—even though you would settle for $200 if that's all you could get. Since his maximum figure (which *you* don't know) and your minimum figure (which *he* doesn't know) actually coincide, if you negotiate properly, the two of you should reach an agreement. When you start out abruptly at $450, however, you put him in the position of not wanting to embarrass himself by appearing cheap. So, if your figure is unrealistically high, he's apt to say that he feels your price is reasonable and he'll get back to you—which he never does. He leaves you thinking the price you quoted is fine when in fact he's already dismissed the idea of using your shot.

Had you gotten him to let you know what ballpark he was

in *before* you mentioned a figure you would have immediately known enough to adjust your first figure to put you in the proper range. You would not only have been able to make the sale, you might even have coaxed him into giving you an extra $25 or $50 above his photography budget by borrowing from his typesetting budget.

How do you know when it's most prudent to let the buyer make the first offer, and how do you get the buyer to do it?

As a general rule, as you begin your career as a commercial photographer, more often than not it's better to let the buyer make the first offer. Your "happy," "jubilant," and "rock-bottom" figures will be based on relative inexperience, and unless you've dealt with the buyer before or have already sold photographs for similar usages, the buyer is much more likely to have a realistic idea of what your photographs are worth in the marketplace.

How do you get the buyer to let you know what financial ballpark he's in? Broadly speaking there are two ways: You ask him what he has paid for similar usages in the past, or you tell him prices *you've* gotten for similar usages in the past.

Ask what the buyer generally pays for similar projects, and let the buyer know that you are trying to establish a frame of reference. If the buyer hasn't done similar projects, ask how he or she obtains photos. From a local photographer? From a stock photo agency? Depending on the answer, you will be able to determine how much the buyer is used to spending for photographs. But if he tells you he's been using photos that the client provided—photos that the client took himself because he fancies himself a photographer—you know the buyer is likely to be unwilling to spend a great deal of money. It's even possible that this is the first time the buyer has *ever* bought a stock photograph in which case you've got your work cut out; he will probably be surprised at the fee you request.

Straightforwardly asking buyers what they have spent or what they intend to spend will often yield exactly the information you need to begin your bargaining. Suppose, for example, that you think $350 is a fair price and the "rock-bottom" figure you have in mind is $200. The buyer tells you he or she has been paying $150 for similar photographs. Since your $350 is well above $150, you should realize that you are unlikely to get your "fair" price—but that doesn't mean it isn't a good figure to start negotiating from. Tell the buyer that in your experience a fair price *for the usage he or she has in*

mind for your photo is $350. The buyer may then say that due to the client's temperament and the budget for that project, it is impossible to pay you more than $200 for your shot. As soon as the buyer says this, you should realize that at this point, *you cannot lose*. The buyer has just met your minimum figure, a figure you have already decided to accept if that is the most the buyer will pay.

Now you must decide whether you should push even further. Pushing further can be tricky, and only you can make that decision. What does your intuition tell you about the relationship you have with the buyer? If tone of voice, body language, etc., tell you the buyer will go no further, accept the $200 and *subtly* indicate that by accepting this you consider yourself to be doing him a favor (the buyer might be inclined to remember the favor later). Or, you might tell the buyer that you are unable to accept less than $225. There is a risk involved here, of course, because you are gambling a sure $200 for an additional $25. Use your best judgment. But bear in mind that once you have taken a stand at $225 it is very difficult to go back to the offer of $200. If you do get the $225, you should still let the buyer know—subtly—that it's a bargain (remember, $350 was the price you determined as "fair").

Suppose you can't get buyers to give you an indication of what they're thinking about price. You still have the second technique, which is to tell them what you've been paid for similar jobs. Here, the key to successfully negotiating the price you want is in the "setup" where you prepare the buyer for what you are about to say. Before you mention any specific figures, it is absolutely crucial to let the buyer know that while it's quite possible the figures you have in mind do not relate to what the buyer's doing, you are interested in making the sale and willing to be helpful and reasonable. Now, give the buyer a range of figures—low first, then high. The low figure should be slightly *beneath* your minimum and the high substantially *above* your "jubilant" figure.

If, for example, you feel a fair price is $350 and your minimum is $200, you might say something like, "Well, you know, it's a funny thing with brochures. Oddly enough, I've been paid as little as $150 for a brochure like that . . . and I've also been paid as much as $1500 for almost the same thing."

You might think that you have just told the buyer something, and the buyer will think you just told him something,

but actually, you've told him nothing. He is no closer to knowing what you intend to charge him than he was before you said it. However, you have conveyed two very important ideas to the buyer that are going to help you. When you quoted the $150 figure, the buyer relaxed, knew the fee was not unreasonable, and realized that the two of you would probably be able to come to terms. When you quoted the $1500, you let the buyer know that you are a professional whose work is in demand and that you would probably be able to agree on a fee somewhere in-between. Even though you know that the fee you're willing to accept will be a lot closer to $150 than to $1500, you have let the buyer know that you want to work with him or her but that the buyer's not about to get a "steal." Had you mentioned *only* the $1500, the session would have terminated abruptly. This is why it is important to give him the *low* figure first.

Mentioning the $1500 figure has another advantage: It will get the *buyer* to give *you* the first figure. Bear in mind now that the buyer is encouraged by the $150 figure. If you have conducted your part of the negotiation in a friendly, professional manner, the buyer will now offer a figure, and almost invariably it will be the buyer's *top figure*. After hearing that $1500 figure, the buyer's not going to try to fool or take advantage of you.

Suppose the buyer now tells you that $1500 is *way* out of the project's budget and the *tops* is $225—and will mean borrowing from the typesetting budget to pay that much.

You now know everything you need to know.

Will the buyer be lying to you about the $225? Sometimes, but it won't be by much. Decide for yourself if you want to take a risk and hold out for a few more dollars. But realize that if the buyer had, say, $750 in the budget, the offer would *not* have been $225. Perhaps $700, but not $225. Even if you haven't heard the buyer's top figure, you definitely know the buyer's range.

The advantage of this technique is obvious. Remember, your range was $200 to $450. Suppose the buyer's range went up to $750. You give a range of $150 to $1500 and the buyer offers $700. Not only are you home free, you can draw on what you have learned the next time you work with this buyer or the next time you are asked to quote prices for a similar job for a different buyer.

What if the figure the buyer gives you is way beneath what

you had hoped for? Simply state the price you think is fair and see what happens; you have nothing to lose. Until the buyer offers your minimum figure, you have nothing to negotiate. If this happens, it may help you to tell the buyer why you have set your price where it is. Sometimes, the buyer will then check with the client or a superior and get you the money you need. If, on the other hand, the buyer offered you a low fee because of inexperience and not knowing the appropriate figure to offer, stating your reasons may cause him or her to improve the offer.

So far, we've discussed two different negotiating strategies: when the buyer names a figure first without any prompting and when you maneuver the buyer into naming a figure first. As discussed, both are strategies to use when you are unsure of what price you can reasonably expect.

The other possibility is for *you* to begin the bargaining, for *you* to name a figure first. You should use this strategy at two times: (1) if you are unsure of the price to expect and all your efforts to get the buyer to tip his hand by naming a figure have failed and (2) you know exactly what price to expect and want to capitalize on the tactical advantage that comes with launching the first salvo.

Before you name a figure, however, remember these two important concepts of negotiation:

1. Once you have quoted a firm price it is almost impossible to increase this price later—even if you discover that the buyer was prepared to pay more.

2. If you are too hard-line in your bargaining and quote an unrealistically high figure, it is equally difficult to lower that price later—and you could ruin the sale altogether (which, in the long run, can be worse than quoting a figure that's too low).

Let's refer again to our hypothetical brochure. Suppose you feel that your "happy" price of $350 is very likely close to the price the buyer has in mind. You want to get $350 for your photograph, but you're prepared to take a little less if you have to, and you realize that the buyer may be prepared to pay a little more. You know, too, that if you name a figure first, you've got to stick with that figure. You decide to quote a price of $450 (your "jubilant" figure).

Give the buyer the $450 figure, but don't justify it. Not yet. Wait for the buyer's reaction. The buyer might very well respond with, "Well, we've been used to paying only $350, but if

that's your price I guess it's not too far out of line." You've just reached your agreement and you both should be happy. On the other hand, suppose the buyer says, "Our policy is to pay $350 for such photos and we never pay any more." *This* is the time to justify your higher price (the photograph is a one-of-a-kind, this is your usual rate, inflation—whatever reasons you think are appropriate and will be effective). The most important thing to remember is: *Don't tell the buyer anything that will prevent you from lowering your price later if you need to in order to make a satisfactory sale.*

Why not? Because if you have to *reduce* your price you might not be able to do so with grace or dignity if you've said the wrong things earlier—and graciously reducing your price in order to salvage a sale can often be more difficult and important in the long run than eking out a few extra dollars.

To illustrate what I mean, let's look at that hypothetical situation again. You ask for $450 and tell the buyer that you won't accept one penny less. Your photography is worth $450 and that's all there is to it. Take it or leave it. Whereupon the buyer says he cannot pay one penny more than $350 (a figure you would be happy to accept). If you then say, I'll take $400—he doesn't believe you. A moment before you've said you won't take a penny less than $450, and now you're saying, in effect, you won't take a penny less than $400. If you weren't really firm at $450, he's got no reason to believe you're firm at the lower price. He's quite likely to hold the line at his $350 offer.

Stage four explains how to keep your options open if you need to lower your price.

Stage Four: Agreeing on Terms

From your point of view, there are two aspects to agreeing on financial terms with a buyer: reducing your price in such a way that you appear professional and still get a price that is satisfactory, and protecting your rights.

With respect to lowering your price, remember two rules:

1. Never paint yourself into a corner from which you cannot gracefully lower your price.

2. Never reduce your price without giving the buyer a *good reason* for doing so.

A good reason is any reason that gives the buyer an explanation for reducing your price other than greed or fear of not

making the sale. For example, you can ask the buyer more questions about the project. "How many brochures did you say you were going to print? Well, I supose if it's only one thousand I can reduce my price to three hundred and fifty dollars." Or, as in classic negotiating where you never give up something (especially money) without getting something in return, you might offer to lower your price to $350 if the buyer will give you a photo credit on the piece. Remember, once you have quoted a price, if you need to lower it in order to make the sale and have no good reason for doing so, your negotiating position will be much weaker and the buyer, if experienced, will soon have you agreeing to sell your shot for your "rock-bottom" price.

If you negotiate well, however, you will quickly discover exactly where the buyer stands—whether the buyer has named the top figure, whether you can push the buyer further, etc.—and you will arrive at a price you can both live with.

There is only one other area of negotiation you need to know about in order to sell your photos as effectively and profitably as you can. This area has to do with the *conditions* of the sale.

PROTECTING YOUR RIGHTS

"Agreeing on terms" can be crucial in making sure that you are actually being paid for what you think you are and not being underpaid because you misinterpret exactly what rights and usages the buyer is purchasing from you.

For example, suppose you agree to sell a photograph to be used on the cover of a book for $500. A few months later, you see your photograph in national ads *promoting* that book, exposure of considerably greater magnitude than you had expected when you sold the shot. Had you known the photograph was to be seen in magazine ads all across the country, you would have asked for a much higher fee and probably would have gotten it. If this happens, it does not necessarily mean that the buyer was trying to cheat you. To his mind, the buyer purchased the shot for a book cover and has every right to use it any way he cares to in promoting that book. Still, you could have received substantially more money had you known when you sold the shot exactly how the book cover would be used. It is always very important during negotiations to spell

out *exactly* which rights you are selling and which ones you are *not* selling.

Exactly what rights, then, are you selling to the buyer? As a general rule, in the business of stock photography buyers are not actually purchasing photographs outright; they are purchasing the *use* of photographs, and it is usually a *one-time* use. That is, they are paying you a fee for a specific use of specific photographs as spelled out on the invoices you send them (see below). In that sense, they are *renting* your photographs from you for an agreed-upon fee and an agreed-upon length of time. The exact nature and terms of the one-time use the buyers are purchasing should be spelled out as part of the negotiations. Just as a two-bedroom apartment rents for more than a one-bedroom apartment, so, too, a photograph used in a brochure with a 10,000-copy print run will "rent" for more than the same photograph used in a brochure with a 1,000-copy print run.

If you are to be paid what your photography is worth, you must establish during your negotiations with the buyer how, when, where, and how many times your photography will be used. Then be sure to "cement" these terms by stating them explicitly in your invoice.

An Invoice that Protects Your Rights

Every invoice you submit should include the following:

1. A description of the photograph
2. A description of the manner in which the photograph will be used by the buyer
3. The length of time and number of times the buyer is allowed to use the photograph
4. The areas and countries where the photograph will be distributed
5. Fee charged
6. Terms of payment
7. Copyright-infringement admonishments
8. Value placed on lost or damaged photographs

Description of the photograph. Write a brief, one-sentence description of the subject matter of the photograph. If you have a numbering system, indicate the photograph's number as well.

Description of the manner in which the buyer intends to use

the photograph. Be as specific as you can. If the usage is editorial, state this. Also, whether the photograph is to be used as an ad, brochure, poster, package, bank statement, etc.

Length of time and number of times the buyer is allowed to use the photograph. Always specify the time period of the sale. If, for example, you sell a shot for a trade ad that will appear ten times in trade magazines, you should state "for a period not to exceed one year" on the invoice. This way, after a year you are free to sell the photograph to someone else for a similar usage. If you do not specify a time period and the buyer only runs the ad nine times, the buyer can keep an option on the photograph open indefinitely.

Areas of distribution of the photograph. If you sell a photograph to be used for a brochure with a 10,000-copy print run, state exactly where the brochure will be distributed. If it is to be used in one state only, indicate this so that both you and your client will know you are free to sell the photo to another buyer elsewhere in the country. On the other hand, if the distribution is nationwide, your options are limited accordingly—and your fee should be higher.

Fee charged. State the specific dollar amount you negotiated for the use of your photo.

Terms of payment. This is the length of time the client has in which to pay your bill. "Net due in 30 days" is the standard term of payment. (Some companies give a small discount for early payment, thus the "net" amount is the gross fee minus the discount.) Include a statement that *payment of the invoice* is what gives the buyer the right to use the photograph. If a buyer uses your photo before payment is made, your copyright may be being infringed.

Copyright-infringement admonishments. The copyright law of 1976 has yet to be fully interpreted by the courts. However, if you place your name, a © and a date on all your photographs, you own the copyright on them and can sue anyone who uses them without your written permission. If the buyer uses your photos in any way beyond those spelled out on your invoice, that, too, can be interpreted as an infringement of your copyright. It's a good idea to include this information on your invoice.

Value placed on lost or damaged photographs. A commonly-used charge to clients who lose or irreparably damage an original color transparency is $1,500 per transparency. This figure may sound high, but if you consider how much

revenue a successful stock photograph can often generate, it is quite realistic. Had the photo been lost through no fault of yours, that income would never have been realized. Place a high value on your color or black-and-white photographs; your clients will do so also and will treat them carefully.

The following sample invoice can be used for almost any situation:

SAMPLE INVOICE

JOHN DOE PHOTOGRAPHY
31 Franklin Road
Milwaukee, Wisconsin 53202

INVOICE

ACME ADVERTISING, INC.
121 Main Street
Racine, Wisconsin 53202

Attention: Ralph Jones

Date: 12/7/80
My Invoice No.: 3002
Your Purchase Order No.: 6011
Your Job No.: SR-702
Your Client: Smith Realty

Photo No. G-576-A (Pine trees by lake at sunset) for one-time reproduction on the cover of a Smith Realty development brochure.

Print run: 5,000
Distribution: Local to prospective buyers in the Milwaukee/Racine area
Duration of authorized use: One year
Terms of renewal: 50% additional for each one-year renewal

Reproduction fee (terms: net 30 days): $350

NOTICE: Payment of this invoice will constitute permission from JOHN DOE PHOTOGRAPHY for use of the above-described photograph(s) only as described above. Any other use without express written consent from JOHN DOE PHOTOGRAPHY will constitute an infringement of copyright and will be treated accordingly.

All photographs remain the property of JOHN DOE PHOTOGRAPHY and must be returned undamaged. Value of lost or damaged photographs is placed at $1,500 per photograph.

9

Personal Agents and Stock Photo Agencies

WHAT'S IN IT FOR YOU?

If you are like most photographers, you probably have a temperament that is better suited to taking photographs than to selling them. Nonetheless, unless you specifically engage someone else to do the marketing for you, how successful you are at selling your photos depends entirely on you. If you decide to sell your photos yourself, you should, of course, use the information in this book to cultivate the various markets. But, if, for whatever reason, you prefer to arrange for the services of either an agent or a stock photo agency to sell your photographs for you, this chapter will help you to make the best arrangement.

What advantages are there to using an agent or a stock photo agency? First, both free you to concentrate strictly on *producing* photographs. Also, they give your work a level and type of exposure you could not provide on your own without a well-established network of contacts and a fair amount of capital. Furthermore, both agents and stock photo agencies are experienced and skilled at negotiating fees and likely to get the most money for your photographs. In addition, they can often give you valuable information about trends in a wider market than you are likely to have access to on your own.

What must you give up in exchange for this representation? With both agents and stock photo agencies you will surrender a percentage of the sale price of your work. In the case of the stock photo agency, you will also be giving up control of your work. When you sell your own photographs, you have absolute control over which ones are placed in front of a buyer. If those same photos are with an agency, you always run the risk that your shots will be overlooked by the person filling the client's request and the order filled with another photographer's photographs, even though yours may have been just as appropriate.

Is it worth it? There is unfortunately no easy answer to that question. Whether or not it is best for you to join forces with either an agent or an agency varies according to your individual ability and willingness to sell your photographs on your own. If you have been able to build a reputation in your area for having, or being able to produce, photographs that art directors want and can use, and if you don't mind continuously "making the rounds" to keep them aware of your availability and skill, then you probably don't need representation by an agent or a stock agency—*for that market.* If your type of photography has broad appeal, however, and might sell well in markets to which you have no access, or if you want to upgrade your list of clients, then a good agent or stock agency may pay off handsomely for you.

Keep in mind, however, that since an agency or agent keeps a good portion of the sale price of any of your photographs they market, if they are no more successful at selling your photos than you are on your own—you're losing money. If using an agency that keeps 50 percent of the sale price of your photographs is to make economic sense for you, that agency must be able to sell at least *twice* as many of your photographs as you can on your own *just for you to break even.* The hope, of course, is that an agency or agent will be able to increase your market so substantially that the 50 percent you receive on their sales of your photos will be many times the amount of the 100 percent you retain when you sell your own photos.

Some agencies, in fact, have such rigid exclusivity clauses in their contracts that even if you do sell one of your photos yourself, you may be required to remit 50 percent of your sale to the agency that represents you. The fairness of this kind of arrangement is debatable, and before you sign a contract with any agency or agent, be sure to read this section thoroughly.

How can you know for sure whether it's appropriate for you to engage outside help in selling your work? In my experience I've found that you will know almost instinctively when you are ready to have a personal agent or a stock photo agency represent you. If you're not sure, it's probably best for you to wait and continue selling your photographs yourself. The more you know about how to sell your photography, the more likely you are to establish a workable, profitable relationship with an agent or a stock photo agency when the time comes to do so.

PERSONAL AGENTS

What is a personal agent? He or she is a marketer and, at times, a hand-holder. Above all else, however, an agent is a business person. An agent can be everything for your career that you are not or don't want to be. If you want to concentrate exclusively on taking high-quality photographs and leave the rest to someone else, finding a good personal agent (or "rep," as they are often called) may solve your problems.

Traditionally, a rep handles *assignments* for photographers rather than trying to sell their photographs. Usually, in fact, a rep will recommend that if you are interested primarily in selling your photographs you will be better off with a stock photo agency.

However, there are some changes afoot. As stock photography becomes an increasingly important part of the photo marketplace, more and more reps are placing increasing emphasis on the stock sales of the photographers they represent. Some reps, in fact, now handle the sale of stock photos exclusively. And some reps, like some photographers, now begin their careers concentrating only on stock photo sales.

Like photographers, reps come in all stages of career development. The best and most successful represent only well-established and highly paid photographers and are superstars themselves. They are so powerful, in fact, that a photographer who is represented by one of these agents is virtually assured of commercial success.

As a beginner or even a somewhat established "comer," it is extremely difficult if not impossible to attract such a rep's attention. If, however, you want to try, get in touch with an organization in New York City called SPAR, which stands for "The Society of Photographers' and Artists' Representatives." For a fee of five dollars they'll send you a directory of their membership which lists reps around the country and their clients and specialties. It also includes a letter of instruction and a form you can use to get your name listed in the classified section of the society's newsletter. Bear in mind that these reps are rarely inclined to pay much attention to unproven talent, but if you feel you have something really special to offer, use the directory to get in touch with the ones who seem most likely to be receptive to your photographs. Remember always to approach these reps with a truly professional presentation; otherwise you'll be wasting your time and theirs. To

obtain the directory, send $5.00 plus a self-addressed stamped business-size envelope with enough postage to cover at least 4 ounces to:

SPAR
Society of Photographers' and Artists' Representatives
P.O. Box 845
New York, New York 10022

At the other end of the spectrum from the superstars are the personal reps, agents who work well with people and who go out into the marketplace to sell a photographer's wares. If those wares turn out to be your photographs and this person is indeed good at what he does, then you're on your way to a successful relationship.

You are essentially partners with a personal rep. The two of you will probably work closely together, pooling your efforts to create a mutually satisfactory whole that is greater than the sum of its parts. With a stock agency, on the other hand, you are likely to be only one of a large number of photographers, and there is much less close communication.

If you are a beginnning photographer and unable as yet to crack the larger markets or attract the services of a stock agency, you can form this kind of partnership with a friend or acquaintance in your own hometown. The person will need to have two important assets: selling ability and enthusiasm. Experience in selling photography is not necessary, any more than it was for you when you began to sell your own work. The methods a personal agent uses are exactly the same as those recommended in this book for you to use when selling your own photos. That is, the agent will need to know the local market, cultivate contacts, build relationships, expand your portfolio, and constantly refine and adapt the presentation to meet the needs of a rapidly changing marketplace.

How much does having a rep cost? Again, the cost to you will be a percentage of sales. Personal agents in New York who represent many of the foremost photographers usually retain 25 percent of any *assignment* they secure. Unlike the rep, who often works out of a small office, as a photographer you will probably have substantial overhead expenses (for example, assistants' fees, studio rent, equipment purchases and repairs, film, and so on) and so this 25 percent commission may represent as much as 50 percent of your net profit.

As mentioned, an agent will sometimes sell a client stock photographs from the files of a photographer client. In such a

case, the agent customarily retains from 35 to 60 percent of the sale price, depending on the terms of the agreement with the photographer. The rep gets this higher percentage because, while the photographer incurs no further overhead in a stock photograph sale (the photograph already exists), the personal agent must work as hard to sell it, as hard as if the agent were securing a brand-new assignment for the photographer.

What constitutes an equitable arrangement between you as a photographer and your rep? In general, an equitable arrangement is one in which you each reap rewards commensurate with your efforts and you each feel it is profitable and in your best interests to pursue a joint goal. In actual practice, most photographer/rep relationships work out to about a fifty-fifty split, with each getting half the income—the same arrangement that exists between most stock agencies and their photographers. However, since it often takes a considerable amount of time for a rep to get the ball rolling, the rep may choose to work for a guaranteed salary and a smaller commission or a guaranteed draw against future commissions. On the other hand, if a rep is semi-established and already represents stock photographs for three or more photographers, the fairest arrangement may be one that gives a larger percentage of sales to the photographer.

The best relationship between a photographer and a rep is a fair one, where each party feels an incentive and neither has the feeling of being taken advantage of by the other. However, no set arrangement works for everyone, just as no arrangement is so iron-clad or effective that it is not subject to revision and modification as circumstances change.

As an inexperienced photographer, how can you best find a "personal agent" to represent you? As we've discussed, most established reps will not consider taking on a photographer unless that photographer is *already* billing approximately $25,000 to $50,000 per year. But that doesn't mean you can't get started on a limited basis with a friend or acquaintance doing some selling for you in your own hometown—someone who seems personable, friendly, outgoing; who's got something on the ball; and who is looking to get into something. Ask him (or her) if he would like to try to sell some of your photographs. If he likes dealing with people and seems to have a knack for selling things, he could get started on a part-time basis to see if he likes it, and wouldn't have to give up his full-

time job, if he has one, until he is sure he can make his living selling photography.

The fact that he has no experience selling photography is not necessarily a problem. Since you have already developed an understanding of your local market, you know enough to show him where to go and how to get started. Teach him the rudiments of photography and films and some of the more subtle aspects of the market that he should know about, and within a few hours he'll be ready to start making phone calls to the local ad agencies, the newspapers; etc. If, indeed, he is on the ball, he'll quickly begin to get a feel for the business and will soon start to cultivate the market in ways that suit his own personality. With luck—and a lot of perseverance—he'll begin to sell your photographs for you.

As in any business venture involving partnership, your relationship will continually evolve, as influenced by the market's needs and your individual goals. As with most endeavors, you and your friend can expect to reap rewards in keeping with the talent and enthusiasm you can muster and the energy you are willing to expend. Remember, some of America's most successful businessmen started with a paper-route.

WHAT IS A STOCK PHOTO AGENCY?

Most photographers who are at all serious about their stock photography begin to think at some point about placing their photographs with a stock photo agency. Whether these photographers are beginners or established pros, they have one thing in common: confusion about just what stock photo agencies are, what they do, and how a stock photo agency can best represent their work. In fact, if a photographer has any information about or conception of a stock photo agency, it is usually wrong. In this chapter, I'm going to try to clear up some of these misconceptions and give you the information you need to know if you decide to market your photographs through a stock photo agency.

Anyone who thinks the business of stock photography can be explained in a few words doesn't know very much about stock photo agencies; there are nearly as many *types* of stock agencies as there are agencies doing business. However, in the

broadest terms, a stock photo agency is a repository or library of photographs (in Europe, stock photo agencies are commonly referred to as "photo libraries") from which people who have use for photographs can purchase those they need. Generally, stock photo agencies keep the work of a number of photographers on file and use those files to fill client requests as they come in.

That's where similarities among agencies end.

Most photographers believe that, despite minor variations in emphasis, all stock photo agencies are pretty much alike. This is simply not true. Even though the agencies themselves are sometimes loath to admit it, they vary widely in everything from subject matter and quality of the photographs they handle to the prices they charge.

Some stock photo agencies have only black-and-white photographs; some have only color.

Some agencies represent the work of thousands of photographers; some just a handful (or even only one).

Some agencies are paid a few dollars for their photographs; others are paid a few hundred or even a few thousand dollars.

Some agencies carry the type of photography encyclopedias would use; others, the type magazines are likely to want.

Some sell almost exclusively to ad agencies and specialize in material specifically geared for commercial usage; others have never sold to an ad agency and probably never will.

Some agencies have been in business for many years and make good use of their expertise by staying right on top of the ever-changing stock photography market; other agencies have been in business for many years and have the cobwebs to prove it.

Some agencies have been in business for just a few years and won't be around for too many more; other agencies have been in business for just a few years and have already changed the complexion of the entire industry.

With all this, it is not surprising that to a photographer new to the area of stock photography, choosing the right stock photo agency to represent your work can seem a formidable task. However, as with so many things, the more knowledgeable you are, the easier it will be for you to make the right choice. And, if you use the information in this chapter to help you choose wisely, your financial rewards can be greater than you ever thought possible.

TYPES OF STOCK PHOTO AGENCIES

There are five basic types of stock photo agencies: archives, editorial networks, specialty shops, "boutiques" and general subject matter agencies.

The archive. These are agencies that stockpile old photographs, usually of historical interest. Buyers wouldn't call an archive for a shot of Fifth Avenue taken last Christmas Day, but they would call for such a shot taken Christmas Day 1927. Archives typically have on file photos of Renaissance paintings, old automobiles, movie stars of the 1930s, antique furniture, and so on.

The editorial network. These agencies receive photos regularly from a worldwide network of photo-journalists who cover fast-breaking news events and who often produce thought-provoking photo essays. The photos these agencies stock are primarily geared to satisfy the needs of the editorial marketplace. In essence, editorial network agencies act as clearinghouses for worldwide photo reportage.

The specialty shop. These agencies are just what the name implies: specialists in some specific subject area. They compile such thorough files on a given subject that photo buyers with needs that fall in such an agency's category will automatically call them. Agencies specialize in photographs of sports, animals, aerials, wildlife, and so on. Whereas a general agency will have generic shots of baseball, for example, the specialty shop will have shots of every team and perhaps every player.

Specialty shops can be extremely important to you if you, too, decide to specialize in one area of photography (see chapter 4 for the advantages of specialization), although the fact that your specialty coincides with that of one of these agencies does not necessarily mean that your photos are best placed there.

The "boutique." This term is borrowed from the world of advertising where an ad agency that is built around the creative talents of one or two individuals is known as a "boutique." Boutiques tend to be small, exceptionally productive, and very much in the vanguard of what is "happening" in the "ad game."

Similarly, in stock photography certain agencies are built around the talents and output of just a few photographers, perhaps even just one. An industrial photographer, for exam-

ple, might have such a sterling reputation and, over the years, have produced such a vast amount of saleable photos that an entire stock photo agency is built around the work of that one photographer. This photographer then carves out a segment of the marketplace, keeping overhead at a manageable level, and proceeds to make a very nice living.

As in the ad-agency business, the quality of the photo "boutique" is directly related to the caliber of the individual photographers who produce its material.

The general agency. If you are at all familiar with stock photo agencies, general agencies are the ones you're most likely to have heard of. These agencies cover the full range of potential photo requests from travel scenics to sports, beauty and mood shots to industrial, food, still-life photos, etc. Often these agencies have large staffs and millions of photos on file.

At first glance you might wonder how specialty shops and "boutiques" can compete against the awesome resources of the general agencies. Specialty shops can often compete successfully because of the great depth of their files in the specialty area. For example, while a general agency may have some wildlife shots in its files, a specialty shop will cover a broad range of animals and the photos will be listed with all the pertinent information—from the location where they were taken to the Latin names of the animals.

The owners of boutiques, on the other hand, can compete because the overall market is so vast that they need capture only a tiny segment of it to prosper. Also, while the photographer whose work is represented by the general agency might consider stock sales a secondary source of income, the photographers of a "boutique" are unusually energetic and productive and often depend on their stock sales for the majority of their income.

It is among the general agencies that the greatest variance in the quality of photography offered and the fees charged exists. Why? There are two reasons: the marketing strategy of the agency's management and the creative input of the photographers it represents.

First, the agency's marketing intention. As in most industries, various competitors jockey for market "positioning." In the automobile industry, for example, Volkswagen positions itself at the economy-minded consumer looking for something to get him from place to place. Some of its competitors would be the low-priced economy cars coming out of Detroit. At the

same time, in the same industry, Cadillac is vying for someone who is also looking for a car and who wants to get from place to place but who wants extras and is willing to pay for them. Cadillac "positions" itself in that segment of the market and competes with, say, Lincoln for those buyers. Thus, even though Volkswagen and Cadillac are in the same industry, they really aren't competing with one another for the same buyers.

Some general stock photo agencies have clients who are primarily interested in buying stock photos as a way to save money. Perhaps an art director has a low-budget, not-too-important job and wants nothing elaborate or expensive, but simply an "adequate" photo. What to do? The art director contacts a stock photo agency that has an emphasis on low-cost photography and accepts a photo from the selection they send.

At the other extreme are the general agencies that emphasize the quality of their photography. These agencies either handle the work of the photographers with solidly established reputations or they spend a great deal of money to produce photography to extremely high standards themselves. These agencies do not expect their clients to come to them to save money; indeed, they often emphasize that their stock shots will cost at least as much as, if not more than, an assignment photograph shot to order. Such agencies are like exclusive restaurants that omit prices from their menus. The attitude is that if you have to ask, you can't afford it.

Why is this important to you? Because if you are going to market your work most effectively with a stock agency, you've got to make certain your work and the aims and attitudes of the agency are in harmony. If you've got photographs that are Cadillacs and you choose an agency that will sell them for Volkswagen prices, you're going to be unhappy. Similarly, if your photos are aimed at a high-volume, low-budget market and your agency is asking Cadillac prices, you're also going to be disappointed. And, perhaps, broke. Before you select an agency to represent you, investigate as many agencies as you can—thoroughly. Only then can you make an educated decision about which agency is best suited to your work and your goals.

This leads to the second reason for the great variance among general subject matter agencies: the creative input of the photographers they represent. Let's face it, all the managerial and marketing expertise in the world is worthless with-

out photographers, and some photographers are better and more industrious than others. Simply because a photographer has built a good reputation in *assignment* photography does not necessarily mean that photographer is skilled at producing good, saleable *stock* photography. In fact, some agencies who highly tout the names of a few prestigious photographers they represent actually sell their stock photographs taken by relative unknowns far more frequently and for better prices. So while you certainly don't want to set photographic standards for yourself that are too low, at the same time, there is no reason for you to feel intimidated merely because an agency represents the work of a very well-known photographer. If you can consistently produce good, marketable photographs that an agency knows it can sell, the agency will be eager to have your work.

HOW STOCK PHOTO AGENCIES OPERATE

Like most businesses, stock photo agencies are a conduit whose purpose it is to place a product (photographs) in the hands of a customer willing to pay for that product. The greater the agency's skill at connecting the right photographs with the right clients, the greater its own financial return and that of its photographers.

The mechanics of connecting buyer with product varies somewhat from agency to agency but generally runs along the following lines. First, the agency attracts photographers to place their work with it, usually on the basis of worldwide exclusive representation. After a photographer's work has been screened, the photos selected are introduced into the agency's files. Once the files have been established and organized, the agency begins the all-important task of attracting clients.

Most agencies do at least some advertising, either in the trade magazines or through direct-mail flyers to selected lists of potential buyers. These promotions range from small black-and-white ads and ordinary flyers sent to a few hundred art directors, to full-page, full-color spreads and highly sophisticated color mailings to many thousands of buyers. In addition, some agencies publish expensive catalogs displaying actual photographs that buyers can select for use. Although this makes it easy for the buyer, the cost of producing and mailing these catalogs (especially if they're in full color) is enormous.

Whether or not it is economically feasible for an agency to publish a catalog depends on the marketing strategies and overall objectives of that agency.

However the agency chooses to attract its clients, if it has done its job effectively, eventually the phone starts ringing and photo orders start coming in. The client usually speaks to a "photo researcher," the person whose job it is to take the client's request for photographs and then go into the files and dig out the photographs most likely to fulfill the request.

Once the researcher has chosen a selection of photographs, they are sent to the client on an "approval" basis, often accompanied by a "service charge" or "research fee." This fee usually ranges from $25 to $100 and is applied against the agency's cost of fulfilling the order. (It also serves to weed out frivolous requests for photos from "browsers".) The agency's photographers normally do not participate in this income as it is considered reimbursement to the agency for expenses incurred.

When a selection of photographs is sent to a client on "approval," the agency will also usually send an accompanying notice that spells out the agency's rights and the clients' obligations. The agency places a value on lost or damaged transparencies (the prevailing rate is $1,500 per transparency) and the client is informed of the obligation to return the transparencies to the agency in good shape. In addition, the agency usually includes some kind of notice that the photos are fully protected under the copyright laws and may not be reproduced in any way without permission from the agency (that is, after paying the agency a fee).

Some agencies also charge their clients a "holding fee" for photographs held "on approval" for longer than a specified amount of time. A charge of one dollar per photograph per day for photos held more than ten working days is common, although as with any business, good clients are invariably allowed a certain amount of latitude in these areas.

The agency hopes, of course, that the client will select one or more of the transparencies for use in its project. If it does, the agency will negotiate a fee for the usage using the principles outlined in chapter 8.

The unused photos are then returned to the agency; the photos that are to be used are returned as soon as they have been reproduced by the client and the originals are no longer

required. If necessary, the client will be reminded that he has not *purchased* the photos in question; rather, he has rented or leased the *use* of them. They remain the property of the agency and/or the photographer and must be returned undamaged. Finally, the client pays the usage fee and the agency pays the photographer.

As with any company, the "personality" of a stock photo agency is very much determined by the people who run it and comprise the staff. For example, the person in charge of screening the agency's incoming material exerts a tremendous influence on the shape and emphasis of that agency. Likewise, the person responsible for setting up and maintaining the files also exerts considerable influence. Why? Because the way photographs are filed—and, as a result, retrieved—is invariably a reflection of the marketing goals of the company.

The photo researcher who fills the client requests as they come in is also in a crucial position. How well this person knows his or her job makes all the difference in how likely the agency is to have its photos selected for use. If an agency has five million photographs among which is the one shot a client needs, but the photo researcher does not send that photograph out, obviously it is not going to be sold. Good photo researchers combine a complete knowledge of their files with an ability to ask a client the questions that will elicit the information needed to fill the request properly.

How does this affect you? The photo researchers are responsible for getting *your* photographs in front of the right buyers. Even if you've got a photograph that is perfect for a buyer, if the photo researcher fails in his or her job, you've lost the sale.

This, then, is essentially how agencies operate; the mechanics in each agency are pretty much the same. It is the specifics of personnel, attitude, and marketing strategies that vary.

HOW TO FIND THE RIGHT STOCK PHOTO AGENCY FOR YOU

Establishing a productive relationship with an agency is a twofold process: First, you must determine which agency is best able to market your particular photographs. Second, you must stir up the agency's interest in your work.

Let's take these two steps one at a time.

Choosing an Agency

The biggest mistake you can make is to assume that all stock photo agencies are alike.

The second biggest mistake you can make is to assume that the big agencies you hear about are the best ones for everyone.

As described above, there are many types of agencies. Like all businesses, each agency has a "personality" that is shaped by the people who run it. Harmonious relationships between agencies and photographers are born when the goals and personality of the photographer are compatible with those of the agency. Many photographers have seen their work languish simply because it was placed at the wrong agency; placed at a more appropriate agency, the same photographs might be tremendously profitable.

For example, suppose an agency's clientele consists of calendar and poster companies who tend to prefer traditional, blue-sky, clear-water, sharp-focus scenics. You, on the other hand, tend to shoot more interpretive, experimental shots that use filters and new angles and approaches. Your shots may be wonderfully creative and eminently marketable—but not with *that* agency. And there's another pitfall here. Even though the agency knows that most of its clients cannot use your work, it also realizes that other agencies *are* selling your kind of photographs and so may decide to deprive these other agencies of your work and to keep some of your photographs on hand just in case it might find a client for them. Bear in mind, unless the agency actively seeks out suitable clients, by accepting your materials (whatever its motivation) and locking you into a contract, it has for all practical purposes taken your photos out of circulation.

Personality, therefore, is important. (We'll talk more about how to find out about an agency's personality later.)

What about size?

There's one agency in New York that boasts that it represents over 3,500 photographers. Here's the good news about that: Any agency that can attract that many photographers must be doing something right. Now here's the bad news: If an agency represents 3,500 photographers, the chances that they'll devote any real attention to your work and your development as a stock photographer—or even remember your name, for that matter—are not very promising.

Other agencies represent just a handful of photographers. The advantage of this is that a small agency is much more likely to be willing to provide you with a truly essential element for your growth as a stock photographer: feedback. But there are disadvantages here, too: with a small agency you have to make very sure that your photos will be marketed as vigorously as those of the other photographers the agency represents. A smaller agency can sometimes become so dependent upon its core group of photographers that for fear of losing them, it will push that group's work with more enthusiasm than that of a newcomer. Unless and until your photographs become equally important to the agency, your work may take a back seat to that of the core group.

Unless you're an established, highly experienced pro, the one area in which you probably need to do the most work is understanding how to take photographs that will be well suited to the needs of the market. Much of this book is devoted to helping you in this area. However, keep in mind that if you join a stock photo agency its staff can also help you learn to take saleable photos. If they are so disposed, the people at a stock photo agency can give you invaluable information about how your photography relates to the market. They will be able to guide you along, nurture your talents, and aid your career immeasurably. *If they want to.*

As a photographer who wants to sell your photos, it is very much to your advantage to receive such feedback. Before committing yourself to an agency, be sure to assess as carefully and realistically as you can where you will fit into that agency's scheme of things and how much time and energy it will be willing to devote to your professional growth. As a rule of thumb, you will probably find that the larger agencies are less likely to help you in this regard than the smaller ones. Another difference between large and small agencies is that while a large agency may accept many of your photographs for its files right off the bat, you may also never hear from them again. A small agency, on the other hand, may take fewer of your photos initially, but it will expect—and may even need—you to submit photographs on a continuing basis.

Besides the personality of the agency and the size of the agency, there is another important factor: the *reputation* of the agency, including its reputation with its clients as well as with the photographers it represents.

If you have been trying to sell your photos yourself, you

have undoubtedly come into contact with buyers who also use stock photo agencies. Ask them their opinion of the agencies, which agencies they use and why. If they say "I use Agency A because I can get a cheap photograph," that tells you something. If they say, "I use Agency B because they seem to have the best selection" or "because the service is immediate and their researchers send me what I'm looking for," that also tells you something. Try to talk with as many buyers as you can. You'll find their opinions will vary, and getting an accurate picture of an agency will require sampling as broad a range of opinion as you can.

Even more important to you, perhaps, is the reputation an agency has among other photographers. If you don't know any photographers who are represented by agencies, either ask the agencies themselves for the names of some of their photographers (although bear in mind that the agency is likely to give you names of only those photographers who are well satisfied with the agency) or contact the nearest chapter of the ASMP, the American Society of Magazine Photographers. (Write the New York headquarters to find out where the nearest chapter is. The address is ASMP, 205 Lexington Avenue, New York, NY 10016). Most photographers who have used a stock agency will be happy to share their experiences and opinions with you—you only have to ask.

After you've learned as much as you can about the agencies that seem most appropriate to represent you and your work, it's time to take the next important step: contacting the agencies themselves.

Getting an Agency to Accept Your Work

Let me tell you four of the ways photographers have initially contacted me at my agency.

Usually, I get a letter saying roughly the following: "I am a photographer. I would like to know what your agency does, who it sells to, how much you sell photos for. Also, please tell me everything there is to know about stock photography." What this person is asking me to do is to write him this book (which is one of the reasons I've written it). For me to sit down and furnish him with the information he has requested would require all my working time and then some.

Or, people phone me saying they would like to come in for an interview. When I ask them some questions about their

work—questions whose answers I know from experience will tell me whether or not it is worth my time and the photographer's to set up an appointment—the photographer haughtily informs me that his portfolio is not for *discussion,* it is for *viewing.*

Or, people send in a sample of their work, often unlabeled, unwieldy and in disarray. Frequently, they will ask for an in-depth critique of their work, as well as an indication of when they can expect their first check.

Or, they show up *unannounced* at my door and exhibit the same persistence as a brush salesman.

If you select any one of these or similar approaches with a reputable agent or agency, it is fair to say that you will not be well-received, if you are received at all.

What then is the proper way to proceed? There are two things to keep in mind:

First, you want to find out if the agency is appropriate for *you* and second, assuming that it is, you want to make it as easy as possible for the agency to view your photographs and decide whether it is appropriate for *them.*

It is very important and very much in your interest to make things as easy as possible for the agency when they consider your photographs. When you submit your photos, you will very likely be one of hundreds, perhaps even thousands, of photographers who are competing for that agency's attention. As a result, any inquiry or presentation that is difficult to understand or appears amateurish will quickly be passed over in favor of a more organized, professional presentation that doesn't require so much time or effort to respond to.

The best way to contact an agency that you think you might want to represent your work is to send the agency a letter and questionnaire, such as the sample letter and questionnaire that follow. Naturally, these are meant to be guides and should be revised as necessary to reflect your special needs and qualifications. But don't be afraid to send a questionnaire to an agency. The agency will be grateful to you for making their job easy, and they will recognize a professional approach.

How to Write a Covering Letter of Inquiry to a Photo Agency

A good covering letter, like a good resumé, should be accurate, brief, and to the point, and at the same time transmit enough information to provoke the reader's interest.

There are three basic points to get across in your letter:

1. Who you are and what your credentials are ("I am one of the top three photographers in the Dallas–Fort Worth area."). If you don't yet have any professional credits, be honest about it ("I am now starting to market my photography and seek to establish a relationship with the agency most appropriate to handle my work.").

Don't misrepresent yourself, but don't be afraid to put things in their best light, either. For instance, "I have done extensive work photographing in the area of institutional asphalt," while hardly likely to bring photo buyers to their feet cheering, is still preferable to, "I had a lot of time to take pictures while I was in San Quentin."

Above all, don't try to sell your work with your words. Your pictures will speak for themselves when it comes time to send them in. At this point, in one short sentence, all you're trying to do is establish who you are in such a way that the agent will read on.

2. That you are including a questionnaire—and why. Briefly explain that you are including a questionnaire because you know that the agent's time is valuable and you want to make things as easy and expeditious as possible.

3. Why you have sent the questionnaire to that *particular* agency. For instance, if you have seen photo credits for that agency in magazines and you feel your work is similar in quality and subject matter to the photos you've seen, say so. Or, if one of your clients has referred you, say so.

Sign you letter politely and professionally—"Sincerely," "Very truly yours," "Best," and so on are all acceptable closings.

To Whom Do You Send the Query Letter and the Questionnaire?

The best way to send your letter and questionnaire is to address it to the appropriate person by name. If you have the name of a specific person obtained either from a client or from one of the reference books that list photography agents (see chapter 7), send the letter and questionnaire directly to that person. If you do not have a specific name, you can address your query to any of the following:

• The President. Your letter will be routed to the appropriate

person, but it may be delayed and you run the risk of appearing presumptuous.

- The General Manager. Again, your query will be routed to the appropriate person, but you won't appear pushy. Keep in mind that some companies do not have general managers and you are placing yourself in the hands of the receptionist, who is responsible for routing the mail and who may or may not be helpful.
- The Photo Editor. All agencies have photo editors (or the equivalent), so your letter should reach that person. Unfortunately, the photo editor is not always the person in charge of new photographers so, once again, you're depending on someone to get the letter to the right place.

Probably your best bet is to send your query addressed to the General Manager.

Here is a sample of how your letter might be worded. Don't forget, though, to tailor the letter to your own circumstances. And above all, be brief.

Acme Photos
641 Madison Avenue
New York, New York 10022

Attention: General Manager

I am a Chicago-based free-lance photographer with special interest in the areas of people and nature. I am not now represented by a stock photo agency and would like to submit a portfolio of my work for your consideration.

Recognizing that it is possible that your agency and my photography may not be suitable for each other, and by way of a preliminary screening so that I don't send you material you can't use, I've enclosed a brief questionnaire and a self-addressed, stamped envelope.

In addition to the questionnaire, I would appreciate it if you would send me any other information you normally provide prospective photographers, especially any information concerning procedures for submitting photographs for your consideration.

Thanking you in advance.

> Sincerely,
> Name
> Address

If your photography files are particularly comprehensive or if you have material in a specific subject area you think the agent might be especially interested in, you can also list your

areas of photographic emphasis on a separate sheet of paper. The advantage to this is that in running down the list the agent may spot a category that sparks an interest (either because the agency emphasizes your area or because it is weak in your area and looking to build its files). On the other hand, you run the risk that the agent will form an overall opinion of your work on the basis of just your list and may decide it is not suited for the agency before really giving it a chance.

Here's the questionnaire:

Sample Questionnaire to Be Sent to Stock Photo Agencies

1. How many photographers do you represent?

() Less than 5 () More than 5 () More than 50
() More than 100 () More than 1,000

2. Are you presently interested in considering the work of new photographers?

() Yes () No () Call me in six months

3. Should I submit photos to you at this time for you to consider?

() Yes () No

If yes, how do you prefer I submit photos?

() In boxes () In carousels () In vinyl sheaths
() Negatives () Contacts () Prints
() Other _____

How many photos should I submit at this time? _____

4. Do you accept

() Only color () Only B&W () Both

If color, do you prefer

() Transparencies () Negatives () Prints

If transparencies, do you accept

() 35mm () 2¼ x 2¼
() 4 x 5 () 8 x 10 () Larger

If B&W, do you prefer

() Contacts () Negatives () Prints

Do you have any specific requirements I should be aware of? (For example, is there a particular film brand you prefer?) _____

5. Which subject areas are you interested in? (If any one category is of particular interest, please so indicate by placing more than one check beside that category.)

() Travel () Sports () People
() Animals () Children () Nature
() Underwater () Aerial () Abstract
() Couples/Romance () Other: _____

6. Which of the following usages does your agency emphasize?

() Editorial usage () Commercial usage
() Equal emphasis on
 both.

7. Do you require an exclusive arrangement?

() Yes, we must be the exclusive agent for all your photos.
() No, but we require exclusive control of all photographs you submit to us and all those that are similar or duplicates (that is, those photos of yours in which we have no interest may be placed with another agency).
() Varies.

8. In which countries do you have offices?

() USA () England () France
() Italy () Germany () Japan
() Australia () Other: _____

Naturally, if the special nature of your work lends itself to your asking additional questions or placing a different emphasis on them, by all means do so. Notice, however, that the questionnaire does not mention certain subjects, such as terms of payment, percentages, and details of contracts. The reason these subjects are omitted is that though you ultimately have the right to this information, at this point such questions are premature. It is only after the agency has indicated interest in representing you that the nitty-gritty financial arrangements are appropriate topics for discussion.

HOW TO SUBMIT YOUR WORK TO A STOCK PHOTO AGENCY

If the responses to your questionnaire have been positive or you know other information that makes you want to submit some of your work to a particular agency, the following basic rules should prevail.

• *Make your work as easy as possible to view.* This may sound obvious, but, to take just one example, many photographers submit their work in the little yellow boxes from Kodak—a method that photo agents dislike a great deal. They have to open the box, straighten out the chromes, figure out what the subject matter is, fumble with the slides on a light box or stack them to be seen in a projector, and so on. Photo agents prefer to receive photos that are neatly organized in the vinyl sheaths that hold twenty slides each. Submitting photos in this manner allows the agent to get an *overview* of the photographer's work quickly—and that not only helps the agent, it helps you. By going through, say, ten vinyl sheaths (200 slides) an agent can get a rapid feel for the subjects that are of interest to you, your general style, and the impression you're trying to get across. Armed with this helpful overview, the agent can then go over individual shots and assess them not only for their own merit but also as part of a general body of work.

It is not necessary for you always to submit photos in vinyl sheaths; however, keep in mind that the easier it is for the agent to view your material and the more your material suits the agent's preferences, the better your chances of having your photos accepted.

• *Treat your photographs with the respect that they deserve—but don't gild the lily.* You know the feeling you have when you see a comedian on stage who is trying just a little too hard to get laughs? You feel uneasy and embarrassed for the comedian. That's what it's like when you try to "dress up" your photographs with fancy mounts or elaborate presentations. A photo agent is not going to market your mounts or elaborate presentations, only the photographs. Present them in their best light, but don't be a stage mother.

• *Never submit any photograph to an agent, agency, or anyone else without your name on it.* This also seems obvious, but some photographers either forget or figure they'll save time by not writing their name on their photos until they are accepted. If any photograph leaves your possession at any time, make certain your name is on it. If you have a large number of photos, buy a rubber stamp (which costs only a few dollars) to help you identify them. Remember, some agencies process millions of photos every year, and it doesn't take long for an unnamed slide to be lost in the shuffle.

• *Label the subject matter of your slides as completely as you can.* As discussed earlier, various agencies have various filing methods, so the more thorough your labelling, the more likely the labelling will be sufficient to meet the agencies' needs with respect to filing categories. Also, some photographs of seemingly routine subjects take on added significance if the location where they were shot is of special interest. For example, a shot of some wild ponies will be enhanced if you indicate that they are the famous Chincoteague ponies of Assateague Island off the coast of Maryland.

• *If any of your photographs have images of recognizable people from whom you do not have a model release, indicate that on the photograph.* (See the section on model releases in "Shooting with Models" in chapter 3.)

• *Enclose a self-addressed, stamped envelope for the return of your material.* This may not be necessary once you have established a working relationship with an agency, but it's important to do the first time you submit a sample of your work. (Don't forget that any competent agency is going to return your shots well-protected with cardboard, so be sure to include enough postage.)

• *If an agency has indicated interest in seeing your work and you are now submitting material, include a note reminding the person of your previous correspondence.* This simple courtesy is one that photographers frequently overlook. While the agent can certainly look up any previous correspondence, the reminder will be appreciated and the agent will be grateful for your consideration. Example: "On March 10 I wrote you concerning my transparencies of the recent total eclipse of the sun. You wrote me requesting that I send you a representative sample, as well as a list of other subject areas I have covered. These are enclosed herein."

TWO WAYS TO GET YOUR WORK REJECTED BY A STOCK PHOTO AGENCY

There are two particularly irksome things that photographers sometimes do when submitting their photos to an agency which will almost certainly cause their material to be rejected immediately.

The first is to demand a monetary guarantee based on the submission of slides to the agency, that is, make it a precondi-

tion of placing your work with the agency that the agency guarantee you a certain number of sales on those photographs and insure you financially against a shortcoming in those sales.

What's wrong with that, you might ask? Doesn't a photographer have a right to demand a return on an investment? Like any other investor, a photographer has the right to *expect* or *hope* for a return on an investment, but to *demand* a return is inappropriate. More important, by making such a demand the photographer betrays the fact that he or she does not understand how the stock photo agency business works. It often takes an agency many months to cultivate a market for a given set of photographs, and, as with any business, certain products do better than others. In fact, sometimes products for which there might have been much initial enthusiasm turn out to be unmarketable and are dropped altogether. Thus, while it is true that you have every right to protect your interests and to require an agency to live up to its end of the bargain, try to remember that you are attempting to forge a *mutually* beneficial working relationship. If the agency feels you will be unrealistically demanding, it is quite likely to reject your work simply in the interest of avoiding hassles that it doesn't feel required to put up with.

The second way that photographers often alienate an agency is equally counterproductive. Sometimes, photographers adopt the attitude that if they agree to let an agency market their work they are doing that agency a tremendous favor. To feel and act this way is to place an exaggerated value on your work and is no more realistic than the comparable attitude of some stock photo agents who assert that "photographers are a dime a dozen." The truth of the matter lies somewhere in between.

As a photographer, you play a role that is so essential to the stock photography business that you should never allow anyone to belittle your function or intimidate you into thinking that photographs you know to be well-executed and intrinsically valuable are anything less than that. Some photo agents believe that they can always find photography and photographers, that the marketing is the most important thing. Since these agents are constantly approached by new photographers hoping to gain entry to the business, they develop the belief that these eager people are interchangeable and, as a negotiating ploy, will try to denigrate their efforts. If you lose one

photographer, they think, there are ten more to choose from. Yes, these agents exist. No, they are not the good ones.

The agents who know the business and are most successful understand that whereas there are countless photographers competing for their attention, the photographer who will be able to consistently produce *marketable* photographs of the sort that I've described throughout this book is a very valuable individual and one worth searching for and worth cultivating once found.

The successful relationship between photographer and agent is one built on the harmony between the talents of the photographer nourished by the feedback from the agent, and the selling and marketing ability of that agent. Neither is doing a favor for the other. Don't believe it if an agent claims to be doing you a favor: I can guarantee that the agent would not believe you if you said you were doing the agent a favor. A photographer and his or her agent need each other and should respect each other. It is only when this is an accepted part of the working relationship that the relationship will be beneficial to either of you.

STACKING THE DECK IN YOUR FAVOR

How to Give Yourself a Strong Advantage When Trying to Get Your Work Accepted by a Stock Photo Agency.

In the profession of photography, just as in any other profession, it is not easy to gain representation by a leading agency in the field. However, there is one factor most photographers overlook which, if remembered, will aid you tremendously in getting the support of an agency: Most stock photo agencies, and certainly the best ones, are more concerned with the photographs you are *going* to shoot than with the ones you have already taken.

This is not to say they are unconcerned with your existing body of work. Quite the contrary. Before they will even consider you, you will have to demonstrate to them that you know how to take good photographs that are likely to appeal to their clients and that you have a significant number of photographs so that, if the agency wants, it can introduce them into its files immediately. However, the smart agent will also be looking at you as a *photographer,* a person who will *continue* to shoot, who *must* continue to shoot and consistently provide the agen-

cy with new material—which it, in turn, needs to remain contemporary and grow. The agent will not only be looking at your existing photography but also assessing how likely you are to respond to feedback and to become a valuable and energetic source of photographs for the agency. After all, the photographers the agent represents produce the agency's product, and the quality of the product is directly and proportionately related to the quality and dedication of the photographers.

It is here that beginners may even have a distinct advantage over seasoned pros. How? Because while the pros may have a larger number of photographs on file and the quality of their photographs may be consistently better than that of the amateur's, the pros may want to sell them to a stock agency primarily because they're now just collecting dust in their files and they figure that if they give them to a stock agency they may someday bring in some extra income. But such photographers have no intention of pursuing stock photography in any energetic way.

Beginners, on the other hand, are eager for all the encouragement and direction they can find. They want to learn all they can, are willing to spend time digesting the feedback an agency will give them, and will view the income they might make from these few photographs happily and, very likely pour it back into producing more photography, thereby enriching their equity in the company while at the same time enhancing the agency's files.

Enthusiasm, a willingness to roll up your sleeves and produce saleable photography, and a general attitude of energy and cooperation can be the single most important factor in an agent's or agency's decision about whether to accept your photos. This does not, of course, mean that if you are not a full-time pro you must be prepared to quit your job, sell your home, and auction your children in order to devote every working moment to the pursuit of your photography. It simply means that if you demonstrate the ability and enthusiasm necessary to produce good stock photos, the fact that you can only work at it part-time will not be held against you. An agent can't expect any more than you can reasonably produce; if you give him no less than your best efforts, the agent will be satisfied.

Of course, if your photographs are particularly saleable, it is possible that more than one agency will be interested in representing you and you will be in the lucky position of being

able to choose which agency you want. Since almost every agency requires an exclusive arrangement on the photographs it accepts, you will probably have to make a decision between agencies. Sometimes this can be a very difficult decision; however, there are certain factors to keep in mind that will help you decide.

Some factors are quite obvious—the terms of the contract (see "How to Avoid Getting Cheated by a Stock Photo Agency," below), percentages, terms of payment, etc.

Most important, however, are your feelings about the agency and your belief that it is the agency which will most successfully market your work. Since, unfortunately, there is no genie around to whisper in your ear, you're going to have to rely on your own basic instincts. How do you really *feel* about the agency? No feeling one way or the other? Then you haven't asked enough questions. Get to know the people involved and a sense of how they regard your work.

In order to make an intelligent and reasoned decision about any agency, you must know the facts, *all of them*. Read *between* the lines. Ask every question you can think of, try to anticipate every situation before signing an agreement with an agency. There can often be a great deal more to what you are signing than meets the eye. *Know the facts, and don't be afraid to ask questions.* Don't be bullied or intimidated. Forging a good relationship with a stock agency can be the best thing you do for yourself. Getting trapped into a bad one can be the worst.

How can you be sure you're making the best decision? Unfortunately, there's no way of knowing absolutely for sure. That's why it's so important to take your time. Investigate fully. Get to know reputations and personalities. Ask yourself who these people are. Are they straightforward? Do they seem fair? Keep your wits about you—and read the next two sections.

HOW TO AVOID GETTING CHEATED BY A STOCK PHOTO AGENCY

If you decide to engage a stock photo agency to market your work, there are certain dangers of which you should be aware. They range from questionable contract terms to outright dishonesty.

Dishonesty? A long-established professional photographer once told me he could not imagine *not* getting cheated by a stock photo agency and that every time an agency had one of his photos, he just hoped he wasn't getting cheated more than the usual amount. This photographer's cynicism was excessive, I think, and his attitude unfair because the overwhelming majority of agents and agencies are honest and honorable. Nonetheless, whether there is a basis in fact or not, photographers tend to be somewhat wary of agencies—and maybe that's not altogether an unhealthy attitude.

To illustrate why, let me present a detailed scenario that points out some of the most important ways a stock agency can cheat you. Studying this scenario will go a long way toward preparing you to recognize some of the ploys you might very well encounter should you come across a stock photo agent of questionable integrity.

Let's assume in this scenario that I am an unscrupulous agent out to get away with anything I can, and you are a photographer who has come to see me about placing your work with my agency. We'll follow the chain of events stretching from your first meeting with me to the ultimate breakdown of our business relationship.

After arriving for the appointment you made a few days earlier, you are ushered into my well-appointed office at a prestigious Manhattan address, and find me wearing a well-tailored business suit and sitting behind a comfortable desk. We engage in a little small talk and after you are relaxed, I eventually ask to see some examples of your work, which you eagerly hand over.

Because photography is my business, it only takes me a few seconds to determine that your photographs are very marketable and promise to generate a substantial number of sales for my agency. Despite my favorable appraisal, I say, "To be perfectly honest with you, I'm not really sure there's any market for what you've got, but I'll accept you on a trial basis, anyway. I really shouldn't, but I feel a responsibility to give inexperienced photographers like you a break. All you need to do is just sign here on the bottom line of this contract."

Since you're cautious by nature, you ask if you can look over the contract.

"By all means," I say. "Take all the time you need. It's the standard contract used in the business."

You look as carefully as you can at paragraph after paragraph of legal jargon, but you're not quite sure what it all means. "What about percentages?" you ask. "If you sell one of my photographs, how much do I get?"

"Twenty-five percent."

Now, to the best of your knowledge, the standard and traditional split is fifty/fifty, and you say so.

"Let's not get hung up on preconceived notions that are completely outdated," is my reply.

"But I've talked to some other agencies and they all offer fifty/fifty."

"Well, that may be true, but if you place your photos with one of those other agencies, they'll be buried under a million other photographs. The chances are your shots will never even see the light of day. Now, when *I* take on your work, I'll really get out there and *push*. I'll have your shots in front of buyers all over America."

"But twenty-five percent . . ."

"Look. I'm revolutionizing this business. Do you have any idea what it will cost me to market your work the way I intend to? Sure, you're making twenty-five percent, but compared to what my agency keeps after we deduct the cost of sales, that's a lot. If you don't *trust* me, just ask any one of the fifty other photographers I represent."

Of course, you don't want to appear to be questioning my honesty. And anyway, this is starting to make sense. After all, twenty-five percent of something is certainly better than fifty percent of nothing. So, taking me at my word, you sign. Which is a big mistake, as we shall see.

Here's what happens next. Let's say I sell three of your photographs—one for a condominium brochure to be distributed locally in Tampa, Florida, one for a real estate hand-out in Boise, Idaho, and one for a store display in Dallas, Texas. For each use I charge $300. Therefore, I make $900 on your photography, of which I owe you $225, according to our contract.

However, I send you a check for only $75. Just a check. No statement, no information, nothing that lets you know which photo has been sold or for what purpose. All that accompanies the check is a note from me, saying, "See, I told you we'd make money for you. Now keep on sending in more photos!"

Since you're happy to have received the money, you load up with film and start shooting like crazy. I'm not worried that

you'll find out I've sold the other two photos because I know the chances of your actually seeing even one of them is negligible.

But suppose you are visiting Tampa and just happen to see a copy of the condominium brochure with your photo in it. When you call me up and question me about it, I have a ready explanation: "You were already paid for that. Remember the $75?"

On the other hand, had you been visiting Boise instead of Tampa, my response still would have been the same: "You were already paid for that. Remember the $75?"

And even if from Boise you were to move on to Dallas and come across the other use of one of your photos (highly unlikely—but possible), there would still be any number of things I could tell you, but most likely I would choose one or the other of the following: I would say, "You were already paid for that. Remember the $75? That was for both the handout in Boise and the display in Dallas. You see, they were sold for $150 each, totalling $300, and the $75 commission was for both of them." Or, I could say, "It just so happens that your commission on that photo is slated to go out Monday, so you should see it in a couple of days."

In this case, let's say I do send you the additional $75 commission. Why would I send you the money when I know I could get away with keeping it? Because I want you to keep sending me photographs, and I know that the best way to encourage you is to send you a few more dollars.

The idea of the extra money pleases you, and you have no reason to suspect that there is anything suspicious going on, but you're a little puzzled as to why you haven't been paid your commission on something that's already been printed and distributed. So you ask.

"We pay quarterly," I explain.

"You mean, I don't get paid my commission until up to three months after you've sold my pictures?"

"Not exactly. It's not so much when we *sell* your pictures as when we're *paid* for your pictures. That can be anywhere from thirty to one hundred and twenty days after we sell them. That means there can be a delay of up to six months between the time we sell a picture and the time you get paid for it. It's all very standard in the business."

Time passes. Every now and then you get a check in the mail from me, but there's still no statement or accounting. So

far the money you've been banking doesn't even cover your expenses to produce more and more stock photography, but perhaps, you say to yourself, that's to be expected, since I have already explained that these things take time, that there's a cumulative effect, and that if you keep producing good photography, eventually you'll do fine.

But you're growing uneasy. You start noticing some of your photographs around here and there, and you think maybe what you're seeing is just the tip of the iceberg, because when you total up the commissions you've been paid, the figure seems unreasonably small. It begins to cross your mind that someone is making an awful lot of money on your photography, but that person isn't you. You begin to think that maybe, just maybe, you're being cheated. What's more, you've talked to some other photographers who have nothing good at all to say about your agency. So you decide to get tough.

"Listen," you say to me. "I don't think I'm being paid all my commissions. And besides, I've been checking around and as far as I'm concerned, that twenty-five percent deal would still stink even if I *were* getting paid what I'm due, which I don't think I am."

"Alright now," I say, "you listen to me. I've been in this business fifteen years. Would I have been around this long if I weren't on the level? I've got a reputation to maintain, you know. Is this the thanks I get for doing you a favor by taking you on? Don't you ever forget: you need me more than I need you."

"That may be, but I don't like the idea of being cheated by you or anyone else. So I'm putting you on notice. I want to be paid my full commissions or I want my photos back."

My response is brief: "You *are* being paid your commissions and, under the terms of the contract you signed, you're not entitled to get your photos back for five years."

All of a sudden the checks you've been getting, small and few as they are, become even smaller and fewer. When you call me, I'm not in. If you ask around the office, nobody knows anything. They all say that you'll have to talk to me. But I'm not in. Ever.

And it may be worse than you suspect. What you don't know is that I've made reproduction-quality duplicates which I'm now selling in Europe, Australia and the Orient. If you think it's unlikely that you'll see something of yours in Boise, try Bangkok. Or Baden-Baden. Or Melbourne.

Eventually, when your suspicions turn to certainty, you decide to get yourself an attorney. But when you explain what you are sure is happening to you, her response isn't support, it's a question: "Can you prove what you're saying? Can you show me a specific instance where you have seen one of your photos and can prove you haven't been paid for it?"

"That's not the way this business works," you reply. "For every photo I see, they probably sell twenty. Every once in a while they send me a token check, but they never tell me what it's for, so they can claim it's for any of the photos of mine I see and call them on. But I *know* they're cheating me. Can't I sue them?"

"Sure you can. If you see one of your photos, and don't think you've been paid for it, you can sue them. But as soon as you initiate a lawsuit, they'll pay you for that one photo. And that payment might amount to—if you're lucky—approximately one-tenth of your legal fees. As for the photos they've sold that you don't ever see, without concrete evidence, you've got nothing to sue for."

"But I *know* they're doing it. Can't I subpoena their records? If I can get hold of their records, I know I can *prove* they're cheating me."

"You've got that backwards. First *you've* got to prove they're cheating you and then, and only then, a judge *might* let us have access to the records—which they could alter anyway."

"But it's so obvious that they're cheating me."

"To *you* it's obvious. To the court it must be proved. And they've covered their bases. Anyway, let's say you *could* prove they've been cheating you. Let's say right there in black and white you've got them dead to rights beyond any shadow of a doubt. You can definitely sue them—theoretically, you can sue them for all kinds of things, including legal fees, punitive damages, and so on. In actual practice, however, the most you can reasonably expect to recover is exactly what they owe you in twenty-five percent commissions on your sales, and probably less in an out-of-court settlement. Sure, you might be extremely lucky and win some punitive damages, but don't count on it. And in the meantime this lawsuit will have dragged on for at least two years, and you will have spent literally tens of thousands of dollars in legal fees. Which you'd be crazy to do. Which they know. Which is why they're not worried."

"What do you suggest I do?"

"Chalk it up to experience."

The picture I have painted here illustrates just about the worst that can happen to you, short of having your work actually destroyed. But the big question is: how can you prevent it from happening? Unfortunately, you can't. It's simply too easy for the agency to cheat you *if it wants to.*

Are most agencies dishonest? Certainly not. As in any industry, there are those few who don't feel bound by the standards of decent, ethical conduct, but the vast majority are run by honest, trustworthy people. Therefore, you would be making a mistake to walk into any agency with a chip on your shoulder or burdened by an automatic assumption that the agency will take unfair advantage of you. I'm advocating caution and good sense, not cynicism or paranoia.

At its best, the relationship between a photographer and an agency should be thought of as a partnership with mutual respect and trust between those partners. Yes, it's true that any agency has the capability to cheat you, but as long as you use basic good judgment, you are not likely to become involved with someone who is dishonest. Granted, it is difficult to make a surefire judgment about someone based on only one or two meetings or letters, but don't altogether discount your gut feelings. Sometimes, everything you're being told can make sense to you, but you simply react badly and you don't know why. Investigate further. And don't think the person who's going to cheat you is necessarily going to be a cigar-chomping, fast-talking slob. Like our "friend" in the scenario, he or she could be a charming, persuasive individual ensconced in an impressive office.

As when you work with a photographer's rep, the ideal is to find that middle ground wherein the stock photo agency knows and appreciates your talent and, at the same time, you have a realistic understanding of your work's value and trust your agent to do an energetic and effective job of selling, while making a reasonable return for the agency.

The first step toward locating a stock photo agent with whom such a relationship is likely to develop is to become sensitive to some fundamental warning signs. While it is impossible to be absolutely certain about a person's integrity on the basis of a few brief meetings, here are some specific warning signals and bits of information that you should find very helpful:

1. If any agent or agency offers you less than a fifty per-

cent commission on the sales of your photos—beware! Fifty percent is standard in the business and has been for years. It is, I believe, fair to both the photographer and the agent. Some photographers feel that fifty percent isn't enough; however, an agency that's doing its job will have substantial costs—overhead for office space, secretaries, researchers to fill orders, etc.—and it's very difficult for an agency to retain less than fifty percent and still make a profit.

The only possible exception to a fifty/fifty split is when photographs are reproduced in and sold from catalogs produced by the agency. These catalogs are sent to many buyers around the country or even around the world and, in general, if the catalog is prepared intelligently, at least some of the photos it contains will sell over and over again, generating large amounts of money for the photographer. Since this marketing method is extremely expensive for the agent, a different split is justified.

Also, bear in mind that with foreign sales the fifty/fifty split is based on what your agency receives. If your agency has brokered your photos to another agency in Spain, two agencies are now involved in the transaction. If the foreign agent sells your photograph for $100, he will keep the first $50 and pass the rest back to your agency. Of that remaining $50, fifty percent or $25 will accrue to you. Thus, in effect, the contract you're signing with your agency, while acknowledging a basic 50/50 split, might very well obscure what happens to that split when translated to international business. Incidentally, there is nothing devious or abnormal about the situation described above. Your U.S. agent is most likely acting in your best interest in opening up overseas markets that you would be unable to tap yourself. The additional layer in the fee split is the price it costs the agent to conduct business overseas. Should you be in a position to tap those markets yourself (for example, if you're an airline pilot who constantly flies to Europe and can *oversee* those agents you can find), you may want to consider offering your U.S. agent *only* U.S. rights.

I have heard of some agencies that seek out "deals" with certain of the large advertising agencies, publishers or any other large users of photography. Here's how the "deal" works. The stock photo agent goes to an advertising agency that it knows to be a consistent user of stock photos. Heretofore, the ad people have been buying their photos from a number of sources. The agent is interested in getting them to use

his agency exclusively. So he offers them a deal. If you pay me $10,000, he says to the ad agency, I'll let you have as many of our photographs as you want for one full year for any use and for one third the normal price. That way you'll have preferential treatment and in the long run you'll save money.

Okay, what's happening here? If the company goes for the deal, that means it will be using a lot of photographs from your stock agency, which is in your best interest. The ad agency will pay your photo agency $10,000 "up front," which is in their best interest. Then, two months down the road, the ad agency selects one of your photographs to use in an ad, and your agency bills them, as agreed, at *one third the normal price.* Which means you get fifty percent of *one third the normal price.* If the normal price was, $300, you should be getting $150. In fact, you're getting fifty percent of only $100, or $50. Do you get the feeling you're being sold down the river? How much of the original $10,000 goes to you?

Again, fifty-fifty is the accepted standard. Beware of anyone who offers less. And even if you decide to accept less on catalog shots, (a) don't accept *too* much less (a 40/60 split is reasonable) and (b) be sure to retain 50 percent on *any* photos the agency holds that are *not* reproduced in catalogs.

2. There is no reason an agency should be unwilling to let you know which of your photos have been sold and for what purpose. You have a right to know what's going on with your photographs, and the agency has a responsibility to keep you informed. It's just not that difficult to do if the agency wants to; however, you may encounter a variety of excuses ranging from bookkeeping problems to a policy of confidentiality.

The area of "confidentiality" merits some discussion. In a highly competitive business such as stock photography, no agency wants to be forced to reveal the names of its clients, even to its own photographers. Just as photographers have been cheated by agencies, so agencies have on occasion been cheated by photographers. This has occurred mainly in situations where the photographer learns the identity of a client whom the agency sells to and then goes directly to the client for future sales, circumventing the agency and depriving it of the agreed-upon 50 percent commission it has earned by virtue of "landing" the client in the first place. Or, even if the photographer is trustworthy, a slip of the tongue at the wrong time and place could provide another agency with the information it needs to "raid" a client.

It may seem unfair that the photographer must place absolute trust in the agency whereas the agency appears not to trust the photographer, but the fact is that in such a highly competitive market, the agency must take reasonable measures to protect its list of clients. As a practical matter, in reputable agencies, as the agency and the photographer come to know and trust each other, this provision is invariably relaxed and information is freely exchanged.

As a rule of thumb, a photo agency should give you enough information for you to keep track of which photos have sold and how they were used, but without identifying the specific client unless there is an overriding reason to do so. Thus, when you receive a statement from an agency accompanying a check, although it will not give the exact name of the client it should indicate the general nature of the usage, for example, pharmaceutical ad, condominium brochure, calendar, or whatever. Not only is it your right to know this information, it will also help you to understand the business and grow as a stock photographer.

At your initial interview, find out just how much information the agency routinely supplies its photographers. Ask to see a typical statement form to a photographer who's receiving a commission. If, as a practice, the agency supplies little or no information, beware. If you have any doubts, try to add a provision to the contract that will satisfy them.

3. Many agencies will lock you into a five-year contract. In other words, once you've signed, you cannot remove your photographs from the agency for five years. The fairness of this practice is debatable. The agency will tell you that it's very difficult to retrieve a photographer's chromes from all over their files, and that's more or less true, particularly in a very large agency. Smaller, more specialized agencies do find it easier to retrieve the work of any given photographer.

But that doesn't mean you have to sign a contract that says the agency doesn't even have to *begin to look* for your photos for five years. More reasonably, the agency should agree to use its best efforts to retrieve your work within ninety days of a written request from you, and to release you from further obligation after that time.

4. Similarly, be very suspicious if the agency wants exclusive rights to *all* your photographs, past, present, and future. The agency has a right to insist that when you place photos with them you not sell or place elsewhere duplicates or photos

from the same shooting, but it is unreasonable for them to insist that you sign away all your rights as a photographer in exchange for their assistance.

5. Be wary if the contract doesn't spell out how long you must wait to be paid after the agency receives its money. For your general information, a minimum time lapse for bookkeeping purposes is about 30 days. Most agencies routinely pay photographers quarterly, which is fine; however, you should be aware that by waiting for your payment, what you are doing is providing the agency with an interest-free loan.

6. Watch out for the agent who is too insistent that you sign up with him immediately. If you have any doubts at all about the language, meaning or implications of the contract you are being asked to sign, use a delaying tactic—say you want to have your lawyer check the contract.

Actually, even if the contract seems perfectly acceptable, obtaining professional help is often the best practice in the long run. The lawyer's fee will represent only a small percentage of what you could lose if you sign an unfair contract. And having time to read the contract carefully without the agent looking over your shoulder may cause you to notice provisions that at first escaped your attention. Bear in mind, too, that a contract is not what the agent *says* it means but what its contents mean *in a court of law.* And you're more likely to obtain an accurate interpretation of that from a lawyer than from the agent.

In summary, stock photo agencies can be of invaluable assistance to you in your efforts to earn a living from your photography, but they can also be in a position to cheat you if they are so inclined. There is no surefire way to determine in advance if a given agency is dishonest, but there are certainly some danger signals that should catch your attention. Remember, though, simply because you see one of the signals does not automatically mean that the agency is trying to cheat you. It *does* mean that you should examine the agency carefully and discuss any reservations and objections with the agent. The agent may have a very legitimate reason for the procedure being followed, or may be willing to make some changes to accommodate you.

Ultimately, it all boils down to making a judgment that takes all factors into consideration. Don't rush into an agreement. Take your time and be certain you are doing the right

thing. It's invariably easier to refuse to sign a bad contract than it is to break it.

STOCK PHOTO AGENCY CONTRACTS: CLAUSES TO INSIST ON, CLAUSES YOU SHOULD NEVER SIGN

Be sure that you do not sign any stock photo agency contract until you understand every provision thoroughly. Contracts vary widely, and two contracts that seem essentially the same could have subtleties and nuances in language that make them considerably different.

Understand what a stock photo agency intends to do for you and what it expects from you. It's almost always true that at the time two parties sign a contract the spirit of optimism and goodwill prevails to such a degree that voicing any skepticism is looked upon as an indication of mistrust. Don't let that happen. Read a contract with the thought in mind that sometimes things *don't* work out. Let the optimist in you believe everything will be great, but keep the cynic right there beside you to take a very hard look at the realities.

Protect your rights; don't sign them away. If you are being accepted by a stock photo agency, don't let the flush of success cloud your judgment. Remember, the most important things are:

- What percentage you'll be paid
- When you'll be paid
- What information and feedback you will be given when your photos are sold
- How long the contract lasts and its terms of renewal
- How quickly you can get your photos back if you want them

Under no circumstances should you sign an agency contract unless it specifies *when* you will be paid for any of your photos sold.

Under no circumstances should you sign an agency contract unless it specifies a reasonable period of time between when you ask for your photos back and when you receive them.

Most important, under no circumstances should you sign a contract that requires you to submit not only all the photos you have shot in the past but also all the photos you will shoot in the future.

Read any contract you are asked to sign carefully, unhurriedly, and with your eyes wide open. It is your own special relationship with your agency that must be spelled out in the contract, and that usually takes a bit of work by both parties.

In order to give you some idea of what to expect, what follows are some of the major terms of a typical agency contract. This contract is not intended to be definitive, nor is it the only contract you're likely to see. It is included simply to give you some idea of how the concepts we've been talking about are likely to appear in an agency contract.

SAMPLE STOCK PHOTO AGENCY CONTRACT

In consideration of the Agency's agreement to use its best efforts to the sale or lease of the Photographer's materials, the Photographer hereby grants to the Agency the following authority and warranties to effectuate this purpose.

1. Photographer hereby represents and warrants to Agency that he/she is and will be the sole creator of all photographs submitted by him/her to Agency; that all such photographs are and will be original photographs and have not and will not have been published prior to delivery to Agency; that none of them do or will infringe upon any statutory copyright, common law right, proprietary right, or any right whatsoever of any other person, firm, or corporation; that they are and will be innocent and contain no matter contrary to law; that Photographer is and will be the sole owner of all such photographs and of all rights herein conveyed to Agency; that all such photographs and such rights are and shall be in all respects free and clear; that Photographer has heretofore, and prior to delivery of any and all photographs to Agency, secured written right-of-privacy releases from all persons depicted in such photographs, and agrees to deliver any and all such releases to Agency on demand; and that Photographer agrees to indemnify and hold Agency harmless from any and all claims arising from the breach by Photographer of any of the representations and warranties herein contained.

2. The Photographer hereby appoints the Agency as his/her sole and exclusive agent and representative with respect to the sale and leasing of all photographs submitted to and accepted by the Agency, throughout the world. Any and all negotiations relating thereto shall be at the Agency's sole discretion without the need for prior consultation with the Photographer. Photographer also agrees that he/she will supply Agency with all "Similars," "Same-Shooting," or duplicate photos of any photos accepted by the Agency, and that no "Similars," "Same-Shooting," or duplicates of those photographs which Photographer has submitted to Agency and which Agency

has accepted will be placed with any other agency or library or otherwise offered for sale or lease by any party except Agency.

3. Photographer agrees that Agency shall not be liable to him/ her, his/her heirs or assigns for any loss or damage to the materials submitted to Agency during the term hereof, unless caused by Agency's gross and willful negligence.

4. Agency agrees to use its best efforts to return photographs to Photographer within ninety days of a written, registered demand therefor. Upon the return of Photographer's photographs, Photographer may thereafter sell, license, or otherwise transfer any of such photographs, except that Photographer agrees that he/she will not sell, license or otherwise transfer any of such photographs without first inquiring of Agency to determine whether Agency has made any sale, license, or other disposition of any other photographs of Photographer which are or had been in Agency's possession, which photographs are similar in style and content and therefore conflicting with photograph which Photographer then proposes to sell, license, or otherwise dispose of. In the event of any such conflict, Photographer warrants and agrees that he/she shall not sell, license, or otherwise transfer such photograph. In the event that it is determined that no such conflict exists, Photographer may at any time thereafter sell, license, or otherwise transfer such photograph, and Agency acknowledges that it shall not be entitled to share in any part of the revenues for such sale. The determination of whether or not a conflict exists shall be made by Agency, whose decision shall be binding and conclusive. However, Agency agrees that it shall not be arbitrary in making any such determination.

Should Photographer request the return of any or all photographs previously submitted to and accepted by Agency, Photographer agrees to provide Agency with all assistance and information as may be required by Agency in locating and removing such photographs from Agency's files.

5. In consideration of the delivery of photographs to Agency by Photographer, Agency agrees to pay to Photographer, and Photographer to accept as full payment therefor, an amount equal to 50 percent of the fee charged to and paid by Agency's customers for the sale, license, or other use of Photographer's photographs. It is understood and agreed that Photographer shall not be entitled to any payment hereunder for any fees charged by Agency which are not paid by Agency's customers. However, Agency agrees to use its best efforts to collect all such fees.

6. Agency further agrees to provide Photographer with payment of due commissions, accompanied by a description of photos sold as well as how such photos will be used, within forty-five days of receipt by Agency of payment from Agency's customer. In the event

of cancellation by Agency's customer after payment has been made to Photographer, Photographer authorizes Agency to deduct the amount paid him/her from future sales of Photographer's photographs.

7. Should Agency through its promotional efforts or otherwise secure for Photographer any photographic assignments, Photographer agrees to payment to Agency an amount equal to 25 percent of Photographer's fee for said assignment.

8. In the event of damage, destruction, loss, or unauthorized use of Photographer's photographs by Agency's customer, Photographer hereby grants the agency full and complete authority to make claims or institute suit in his/her name. All recovery made therefrom shall be apportioned 50 percent to Photographer and 50 percent to Agency, after deduction of collection fees and other expenses incurred by Agency in its efforts to resolve said claims. All settlements shall be at Agency's sole and complete discretion.

9. The terms of this agreement shall commence on the date hereof and continue indefinitely unless and until terminated by either party on not less than ninety (90) days written notice to the other. However, any such termination shall not affect Agency's right to provide its customers those reproduction rights initiated during the term hereof. Nor shall such termination affect Agency's obligation to pay Photographer commissions for its customers' use of such photographs subsequent to the date of termination. The representations and warranties contained in paragraph one shall survive any such termination.

10. It is acknowledged the Photographer is an independent contractor, and nothing contained herein shall be deemed to establish an employer-employee relationship between Agency and Photographer.

11. This agreement shall be binding upon the Agency, its successors, and assigns, and upon Photographer, his/her heirs, executors, and administrators.

12. This agreement constitutes the entire understanding of the parties and may not be altered or amended unless in writing signed by both of the parties hereto.

STOCK PHOTO AGENCIES

Finding the right photo agency to represent your work and then convincing it to accept your material is a crucial step in your career, one that should not be taken hastily or lightly. Above all, *keep asking questions.* Ask questions of the agen-

cies. Ask questions of your fellow photographers, your clients, *anyone* who might be able to give you information to help you make your decision. Filter that information, collate it, mull it over. Get professional help in legal matters and *never* sign anything you don't *completely* understand.

The following is a list of some of the better known stock photo agencies in the United States. This list is by no means exhaustive; it is not intended to be, nor could it be. Agencies come and go, they expand or cut back, they change their staffs and their marketing emphases. In short, stock photo agencies are subject to the same forces and imperatives as any other business.

The agencies listed here tend to be the largest of the "General" agencies described in Chapter 9. Most of them are interested in new photographers and new material—after all, that's their business. If you decide to contact one or more of them—or any other agency not listed here—you should do so only in a thoroughly professional way as described in chapter 9. Don't waste their time and they won't waste yours.

Stay alert to new agencies, new developments, new trends. Check your reference books; talk to people; ask questions.

In addition to this list, you can use a variety of other methods to locate the names of agencies to which to submit your work. Your local library probably has a copy of the *Business to Business Yellow Pages* for New York City, which lists more than seventy-five agencies under the heading "Photographers' Agencies." The yellow pages from other major metropolitan areas, especially Los Angeles, have similar, though shorter, listings. There may well be an agency in your own town. Check your phone directory under Photography or Photo Agencies or Photo Agents. Your library may also have one or more of the various books (described in chapter 7) that provide general lists of photography markets. When you do find something promising, call up and start asking questions.

Remember that while any agency can provide you with comprehensive background information on its policies and marketing goals, no agency—despite the rather extravagant claims of some—is *the* agency for *all* photographers. You are looking for the agency that is most likely and most qualified to look after *your* interests. Making the right decision means making a decision that will yield positive results—financially, professionally, and personally—so choose carefully.

LIST OF STOCK PHOTO AGENCIES

ALPHA PHOTO ASSOCIATES
251 Park Avenue South
New York, New York 10010
(212) 777-4216

AMERICAN STOCK PHOTOS
6842 Sunset Boulevard
Hollywood, California 90028
(213) 469-3980

ANIMALS ANIMALS ENTERPRISES
203 West 81st Street
New York, New York 10024
(212) 580-9595

PETER ARNOLD, INC.
1500 Broadway
New York, New York 10036
(212) 840-6928

ASSOCIATED PICTURE SERVICE
Northside Station, Box 52881
Atlanta, Georgia 30355
(404) 948-2671

BETTMAN ARCHIVE, INC.
136 East 57th Street
New York, New York
(212) 758-0362

BLACK STAR
450 Park Avenue South
New York, New York 10016
(212) 679-3288

CAMERA CLIX
404 Park Avenue South
New York, New York 10016
(212) 684-3526

CANDIDA PHOTOS, INC.
4711 West Byron Street
Chicago, Illinois 60641
(312) 736-5544

BRUCE COLEMAN, INC.
381 Fifth Avenue
New York, New York 10016
(212) 683-5227

CYR COLOR PHOTO AGENCY
Box 2148
Norwalk, Connecticut 06852
(203) 838-8230

DESIGN PHOTOGRAPHERS INTERNATIONAL
521 Madison Avenue
New York, New York 10022
(212) 752-3930

A. DEVANEY, INC.
415 Lexington Avenue
New York, New York 10017
(212) 682-1017

LEO DEWYS, INC.
60 East 42nd Street
New York, New York 10017
(212) 986-3190

FOCUS ON SPORTS, INC.
222 East 46th Street
New York, New York 10017
(212) 661-6860

FREELANCE PHOTOGRAPHERS GUILD
251 Park Avenue South
New York, New York 10010
(212) 777-4210

EWING GALLOWAY
342 Madison Avenue
New York, New York 10017
(212) 986-2910

GLOBE PHOTOS, INC.
404 Park Avenue South
New York, New York 10016
(212) 689-1340

IBID, INC.
125 West Hubbard
Chicago, Illinois 60610
(312) 644-0515

THE IMAGE BANK
88 Vanderbilt Avenue
New York, New York 10017
(212) 371-3636

IMAGE PHOTOS
Main Street
Stockbridge, Massachusetts 01262
(413) 298-5500

JOAN KRAMER & ASSOC., INC.
5 North Clover Drive
Great Neck, New York 11021
(212) 224-1758

FREDERIC LEWIS, INC.
15 West 38th Street
New York, New York 10016
(212) 921-2850

MAGNUM PHOTOS, INC.
15 West 46th Street
New York, New York 10036
(212) 541-7570

MONKMEYER PRESS
15 East 48th Street
New York, New York 10017
(212) 755-1715

PHOTOFILE INTERNATIONAL LTD.
76 Madison Avenue
New York, New York 10016
(212) 989-0500

PHOTO RESEARCHERS, INC.
60 East 56th Street
New York, New York 10022
(212) 758-3420

PHOTOUNIQUE
Suite 340, Building 2
Arrow Press Square
Salt Lake City, Utah 84111
(801) 363-5182

SHOSTAL ASSOCIATES, INC.
60 East 42nd Street
New York, New York 10017
(212) 687-0696

STOCK PHOTOS UNLIMITED, INC.
29 West 38th Street
New York, New York 10018
(212) 765-8928

THE STOCK SHOP, INC.
279 East 44th Street
New York, New York 10017
(212) 687-8080

TAURUS PHOTOS
118 East 28th Street
New York, New York 10016
(212) 683-4025

WEBB PHOTOS
1999 Shepard Road
St. Paul, Minnesota 55116
(612) 647-7317

WIDE WORLD PHOTOS, INC.
50 Rockefeller Plaza
New York, New York 10022
(212) 262-6300

WOODFIN CAMP & ASSOCIATES
415 Madison Avenue
New York, New York 10017
(212) 489-7676

Index

ABOUT THE AUTHOR

As the cofounder and executive director of Photofile International, Ltd., a prestigious Madison Avenue stock photography agency, Henry Scanlon has spent years cultivating markets for the scores of photographers his agency represents. His innovative methods have opened up new vistas of photo sales to photographers at every level of experience, from beginners to top professionals.

As a photographer's agent, Scanlon represents some of Manhattan's most successful assignment photographers and is a member of the Society of Photographers' and Artists' Representatives (SPAR). Daily, Scanlon deals with art directors and photo buyers from some of the world's largest advertisers.

As a successful photographer in his own right, Scanlon's work has appeared in nearly every major magazine in the country.

Over the years, Scanlon has counseled hundreds of photographers on the intricacies and realities of marketing photographs and photographic services. His techniques have shown that even photographers without "a name" can quickly learn to sell their photos—not for pennies but for hundreds and sometimes thousands of dollars, each.